Photojournalism

Other Publications:

This volume is one of a series devoted to the art and technology of photography. The books present pictures by outstanding photographers of today and the past, relate the history of photography and provide practical instruction in the use of equipment and materials.

LIFE LIBRARY OF PHOTOGRAPHY

Photojournalism

Revised Edition

BY THE EDITORS OF TIME-LIFE BOOKS

TIME-LIFE BOOKS, ALEXANDRIA, VIRGINIA

For information about any
Time-Life book, please write:
Reader Information, Time-Life Books,
541 North Fairbanks Court,
Chicago, Illinois 60611.

TIME-LIFE is a trademark of
Time Incorporated U.S.A.

Library of Congress Cataloguing in Publication Data
Time-Life Books.
 Photojournalism.
 (Life library of photography)
 Bibliography: p.
 Includes index.
 1. Photography, Journalistic. I. Title. II. Series.
TR820.T55 1983 070.4'9 82-19149
ISBN 0-8094-4428-3
ISBN 0-8094-4429-1 (lib. bdg.)
ISBN 0-8094-4430-5 (reg. bdg.)

ON THE COVER: The photojournalists'
tradition of being on the spot to capture
the critical moment of a crisis is
represented by a key frame from a
sequence that was shot by Egyptian
photographer Nakram Gadel Karim
during the assassination of President
Anwar Sadat on October 6, 1981. The
mortally wounded Sadat is covered
by the pile of chairs at center while the
assassins press their attack, one at
right spraying gunfire over the dais.

Contents

Introduction

As the original edition of this book was going to press, one of its editors chanced to take a walk with one of the world's greatest photojournalists, Alfred Eisenstaedt. The two men tramped for a number of miles through woods and along the seashore, Eisenstaedt lugging a heavy bag that held two cameras and numerous lenses, the editor empty-handed. As it happened, the light that day was not interesting and Eisenstaedt did not take a single picture. However, he was ready, as he always is. He has carried a camera everywhere for nearly half a century, and has taken numberless memorable pictures, many of which he had no idea he would get when he started out. The editor—who seldom carries a camera except when he decides "to go out and take pictures"—owns a slender file of memorable shots but a very large collection of missed opportunities.

Many amateurs possess the technical skills and the imagination of professionals, and certainly all the equipment they need. But they don't take as good pictures. This stems largely from a difference in attitude. Professional photographers must sell their pictures. Thus, they must think constantly about them. And the professionals who are photojournalists not only must be ready for whatever may come along, they also must learn to stand outside themselves, to think like an editor, to ask themselves if what is framed in the viewfinder is a useful picture, if it helps to tell the story. That, after all, is what photojournalism is—making photographic stories out of events and their impact on people.

The disciplines of photojournalism can improve the work of any photographer, for though they are sometimes hard to practice, they are not hard to learn. First, do what Alfred Eisenstaedt does: Carry a camera. Second, go where the action is. The action may be only a sunset; however, if it catches the photographer empty-handed, or at home watching television, it will go unrecorded. Third, try to turn single pictures into multipicture stories and to anticipate events in order to build up such stories. Fourth, be critical of the results: If the pictures are below par or just plain dull, put them aside. Be ruthless in selection, particularly when making up slide shows of color transparencies. The photographer who does all these things will be practicing photojournalism—consciously or not. And that practice will make him or her a better photographer.

A fifth precept of photojournalism is perhaps more difficult to master—finding the one moment that sums up the mood or meaning of an event. Developing an eye for this critical moment is a matter of instinct, practice—and opportunity. The great news pictures in the first chapter of this revised edition of *Photojournalism* were captured by people who made it their business to be where things were happening, and were able to get the event on film in spite of minor distractions or serious danger.

The new edition also includes reports on developments in the field of photojournalism, from the increased use of color in the news to the role of photo agencies as distributors of photographers' work and the emergence of newspapers as a distinguished medium for picture stories. In short, photojournalists are busier than ever—and readier than ever to be in the right place at the right time.

The Editors

Covering the News 1

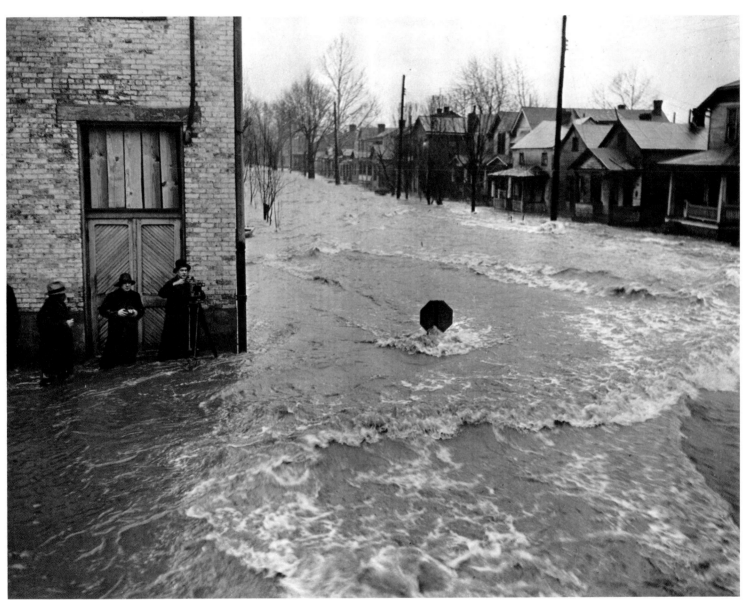

PHOTOGRAPHER UNKNOWN: *Photographers covering Ohio River flood,* 1937

Reporter with a Camera

We take photographic reporting for granted today. When a war breaks out, men land on the moon, a woman takes her place on the Supreme Court or a football championship is won, we expect to see pictures of the event in the next newspaper or magazine that we buy. And spot news is only one of many courses on our accustomed pictorial menu. The fare may include reportage on anything from the migration habits of polar bears to slum conditions in New York or religious rites in Mecca. Our appetite for the fruits of photojournalism is so great that reportorial pictures appear on book jackets, calendars, postcards and advertisements— in short, virtually everywhere that ink meets paper.

Photojournalism shows us things that we would not ordinarily see; it takes us to places where we would not normally go; it explains the enormously complicated warp and woof of the world. No locale is too distant, no conditions are too arduous to deter the photojournalist. Sometimes, of course, their dauntless curiosity gets them in trouble. Francis Miller of the Houston *Press* got his comeuppance some years ago when he was covering a trial in a Houston courtroom where cameras were not permitted. He had, in past adventures, secreted his miniature camera in a flamboyant necktie, an elegant cigarette case or a hollowed-out novel. Unfortunately, a member of the underworld who was familiar with these exploits happened to be at the trial, and he cried out, "Hey, Miller, where you got the camera hid this time?" No pictures were to be had that day.

That anyone would even want a picture of a sensational trial is a relatively new idea. News and pictures were not always regarded as natural partners. The beginnings of photojournalism can be seen in the drawings and cartoons that occasionally appeared in the drab 18th Century press. Benjamin Franklin, when he was publishing the *Pennsylvania Gazette* in the 1750s, printed a woodcut of a snake chopped into many pieces over the caption, "Join, or die." That was scarcely spot news, but it at least touched one of the major concerns of the time: the necessity of unity in the American colonies. In 1770 after the Boston Massacre, Paul Revere, who was not only a patriot and silversmith but an able engraver, produced a dramatic plate showing British troops firing on a crowd of civilians. The engraving would have made a dandy news picture— if it had only been printed in a newspaper. But Revere did not see fit to give it to the *Boston Gazette*. He merely sold individual copies of it for eight pence apiece, and gave the *Gazette* a small, dull picture of five coffins, memorializing the citizens killed in the massacre.

What is very likely the first specimen of the modern news picture appeared in *The Illustrated London News* in 1842, the year of its founding *(opposite)*. Prophetically, in view of the nature of so many of the news pictures that have followed it, it showed an act of violence— a would-be assassin firing a pistol at Queen Victoria. Although daguerreotypes had then been known for a few

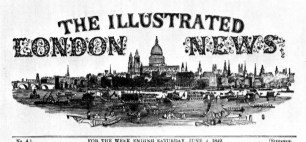

The first spot news picture ever to appear in a newspaper was a drawing in The Illustrated London News of an assassination attempt on Queen Victoria on May 30, 1842. The Queen and her consort, Prince Albert, were riding in their carriage in London when a young man suddenly drew a pistol from his waistcoat and leveled it at them. An alert constable saved the Queen's life by knocking the weapon from the man's hand.

years, there was no camera that could possibly have caught the action. The picture was simply an artist's version of what had happened.

The Illustrated London News picture was not hailed by everyone as a triumph. Soon William Wordsworth, Poet Laureate of England, took to grumbling about pictures in the press. Wordsworth thought illustrations of that sort were in exceedingly poor taste and that people who were fed a diet of pictures might forget the important things, reading and writing. He said so in a sonnet called "Illustrated Books and Newspapers," which goes, in part:

Now prose and verse sunk into disrepute
Must lackey a dumb Art that best can suit
The taste of this once-intellectual Land.
A backward movement surely have we here,
From manhood, — back to childhood . . .
Avaunt this vile abuse of pictured page!
Must eyes be all in all, the tongue and ear
Nothing? Heaven keep us from a lower stage!

Wordsworth's reaction was soon echoed across the Channel. When a famous French tragedienne known simply as Rachel died on January 4, 1858, a photographer sneaked into her bedroom and took a picture of the corpse. An artist's rendition of the picture appeared in a newspaper a few days later — and the family of the actress were so outraged that they brought suit and won damages for "invasion of privacy."

In addition to a lack of enthusiasm in certain quarters, picture journalism faced other obstacles, among them the problem of how to get the picture onto the printed page. Woodcuts were the standard means of reproduction, both in England and the United States, where *Frank Leslie's Illustrated Newspaper* and *Harper's Weekly* got into the business in the 1850s. Although woodcutting would seem to have little to do with photography, the two were associated for many years, and it is well to have a look at the process.

At first photography was not involved at all. In reporting a news event, an artist would go to the scene and make a rough sketch. From this he would make a finished drawing suitable for woodcutting, in which straight, heavy lines were emphasized and shadows were indicated by many small, separate strokes. Next he would copy the drawing, sometimes in reverse, on a smooth block, usually of boxwood, and a skilled craftsman would then cut away all of the surface except the lines that were to be printed. The finished block was pressed into soft clay, and a cast was made by pouring molten type metal onto the fresh impression. This cast — or stereotype — could be put on a newspaper or magazine press and would make thousands of copies.

When the camera came into widespread use in the 1840s, photographs did not revolutionize picture journalism—far from it. The engraving and printing processes of the time could not reproduce a photograph on ordinary paper, alongside ordinary type, on an ordinary press. Only the full tones of the photograph, the solid blacks and blank whites, could be rendered. The intermediate shades of gray—called halftones—could not. Consequently, photographs had to be converted into drawings and then into woodcuts before they could appear as news pictures *(right and opposite)*. The photograph merely furnished material for the artist, taking the place of the on-the-scene sketch the artist had formerly made.

Advances in technology were required before photojournalism could become a major force, and the necessary inventions did not come into widespread use until the turn of the century. Meanwhile, since illustrations in the press were still held in Wordsworthian contempt by many, the popular taste for them had to be cultivated. The cultivation was done in large part by one man, Joseph Pulitzer, who in 1883 bought the money-losing New York *World* and within three years turned it into the most profitable paper ever published. Revered today for his endowment of the Columbia School of Journalism and the Pulitzer Prizes, he was also the grandfather of all sensationalists. He splattered his pages with stories of blood and crime, for which he invented the X-marks-the-spot diagram: "A) Door stained with blood B) Window stained with blood C) Bed covered with blood D) Table set and covered with blood. . . ." Pulitzer also regaled his readers with pictures of criminals or suspects—very accurate pictures, it turned out. In 1884 a detective in Montreal arrested a New York stockbroker who had fled to Canada after indictment for fraud, recognizing him from a *World* woodcut. In the same year Ontario police, using another *World* picture, put the arm on a notorious fugitive fence named "Marm" Mandelbaum. Rejoicing, Pulitzer said, "Thus, while we are contributing our share toward the advancement of American art and are educating as well as amusing our numerous readers, we are subserving the cause of public justice. . . ."

Pulitzer recognized, too, that pictures of noncriminals may be of legitimate news interest, and began to print portraits of ministers, teachers, lawyers, actors and political figures. But when he went so far as to display a gallery of pretty young women from the neighboring city of Brooklyn, "Ladies Who Grace and Adorn the Social Circle," he ran into trouble. *The Journalist,* a trade paper that worried about the morals of the press, felt "the *World* made an error of no small magnitude when it published its series of Brooklyn Belles. . . . On Monday morning after the objectionable pictures appeared, the studio of the photographer who made the pictures from which the drawings were obtained was thronged by an anxious and angry crowd of fathers, brothers, husbands and lovers, all breathing dire vengeance upon the photographer. . . ."

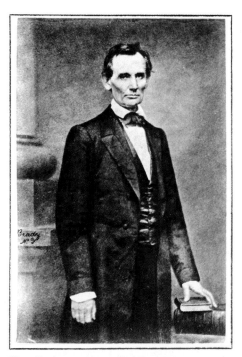

When this photographic portrait of Abraham Lincoln was made by Mathew Brady in 1860, the picture could be reproduced on the printed page only by first converting it into a woodcut, as Harper's Weekly did for the cover of its November 10 issue (right). The woodcut contained every detail of Lincoln's pose, but the engraver exercised artistic license on the rest of the picture. He supplied a new background, with draperies and a scenic view, and he did not compensate for the reversal that occurs in printing, causing the reproduction to become a mirror image of the original photograph.

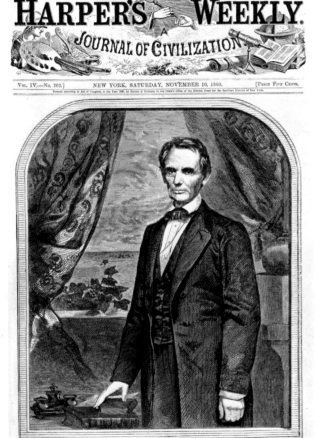

HARPER'S WEEKLY.
A JOURNAL OF CIVILIZATION.

Vol. IV.—No. 202.] NEW YORK, SATURDAY, NOVEMBER 10, 1860. [Price Five Cents.

HON. ABRAHAM LINCOLN, BORN IN KENTUCKY, FEBRUARY 12, 1809.—[Photographed by Brady.]

"It is a piece of glaring bad taste for a newspaper to invade the sanctity of the home circle and hold up to public gaze and mayhap ridicule the portraits of young ladies who in no wise court publicity, and in whom the public has no interest except as they are pretty women. . . .

"It is just this sort of journalism that fosters the idea in the minds of the general public that a newspaper man has no conscience, and that when he enters the house it is a good time to lock up the spoons."

The photographer evidently escaped from the affair with his life—there is no record that he was even horsewhipped—and Pulitzer went on printing pictures of ladies who adorn the social circle. He had noticed that, as he put it, "in the midst of all the newspaper interviewing, editorial twaddling and legal flap-doodling touching the artistic presentation . . . we have received no complaints from the charming and worthy ladies whose portraits graced our pages."

The *World* soon became so heavily illustrated that pictures were among its most important elements—pictures of sidewalk peddlers, trained dogs, German bands and President Chester A. Arthur's wardrobe exclusive of his underwear. The *World* even got hold of Arthur's hand-written notes for a speech and printed them in facsimile, explaining that this was done so that readers "may become familiar with the chirography of the President of the United States."

As Pulitzer warmed up the audience, technology weighed in with a number of innovations that really got photojournalism moving. In the closing years of the 19th Century there came into common use better portable cameras and easier-to-handle plates, as well as roll film. *Blitzlichtpulver*—a mixture of magnesium powder, potassium chlorate and antimony sulfide that gave a brilliant flash of light when ignited—was invented in Germany and was soon being used to make pictures at night or in dim interiors. But what mattered most was the perfection of a means of reproducing photographs on the printed page directly, without having to enlist an artist to convert them into woodcuts. Inventors had been working on such a technique for years. Their aim was to find some way of reproducing on newsprint the grays—or halftones—of photographic images. The solution (illustrated on the following pages) was to use a ruled glass screen to break up the image into myriads of dots, some tiny, some large. On January 21, 1897, the New York *Tribune* published the first halftone reproduction to appear in a mass-circulation daily paper; it was a rather dull photograph of Thomas C. Platt, a New Yorker who had just been elected to the United States Senate. Ten days later, the paper deepened its commitment to the new process by publishing pictures of grim, dirty tenements that housed many of the city's poor. For the first time, a mass audience was seeing pictures that carried the convincing sense of realism unique to photography; no artist or engraver was acting as a middleman between the readers and the facts recorded by the camera.

It might be expected that the halftone process would sweep through journalism; it did not. Publishers thought their readers would consider the halftone a cheap substitute for hand art. Also, newspapers had a substantial investment in the artists and engravers who had drawn news pictures: In 1891 there were 1,000 artists turning out more than 10,000 drawings a week for the press. They continued to copy photographs for several years after the halftone had been proved practical. When the battleship *Maine* was blown up in Havana harbor in 1898, Pulitzer's *World* was on the streets five days after the incident with "the first actual photographs of the wreck"—which were in fact carefully drawn simulations of photographs. A week passed before the papers offered halftones made from the photographs themselves.

But after a few years of hesitation, the press embraced halftones with all its heart, and by 1910 the old hand engraving was headed for oblivion. Actual views of the great events of the day became regular front-page fare. When the *Titanic* sank in 1912, the papers were filled with halftones showing the passengers who had been aboard and the rescue efforts that took place in the freezing North Atlantic. When American troops were sent to Europe in 1917, photographers were on hand to record their arrival. The Sunday rotogravure section of *The New York Times,* in particular, devoted much of its space to photographic coverage of World War I developments. When President Woodrow Wilson signed the Treaty of Versailles in 1918, two other New York papers joined in a bold attempt to beat their competitors with pictures of the event. The photographs were carried to New York by the first blimp ever to cross the Atlantic.

Photojournalists also began to probe into the darker side of society. No one stirred the American conscience more effectively than freelance photographer Lewis W. Hine. A series of his pictures in the magazine *Charities and the Commons* in 1908 showed how millions of immigrants had to live in overcrowded slums and eke out pitiful wages at enslaving jobs. While Lewis Hine and other muckraking photojournalists peered at America's depths, other photojournalists began to venture far afield. The *National Geographic,* a rather stodgy journal that came out at unpredictable intervals at the turn of the century, ran its first halftone in 1903—a picture of Philippine women working in a rice field. The response was so favorable that the magazine soon had swarms of photographers circling the globe to bring back pictures of exotic lands and cultures.

But serious edification of the public was not the only concern of the growing corps of photojournalists. The lessons learned by Joseph Pulitzer were put to good use. The year 1919 saw the appearance in New York of a paper with a word-and-picture tabloid format, the *Illustrated Daily News* (later called the *Daily News*). The front page of the first issue offered a huge picture of the Prince of Wales announcing his forthcoming visit to Newport. The back page was entirely devoted to photographs of beauty-contest entrants. Subsequent

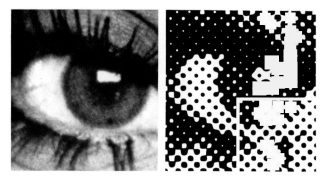

How the halftone process converts the continuous shades of gray in a photograph into distinct units of black and white that can be printed with ink on paper is illustrated in these details of a picture of actress Sophia Loren. First, the original (above, left) is rephotographed through a "screen"—a plate of clear plastic crosscut with a grid pattern. The grid, by optical principles still not fully understood, breaks the continuous tones of the picture into dots (above, right). This scheme of dots is then transferred chemically onto a printing plate.

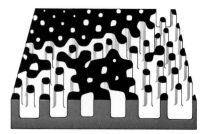

This detail of the printing plate, which shows the portion of the picture outlined at top right, indicates how the chemicals have etched a pattern that conforms to the dot scheme. Only the dots transfer ink to the paper in most printing processes. Since the dots are larger and thus their edges closer together in areas that were dark in the original, those areas transfer more ink to the paper—and print darker —than other sections, approximating the shading in the original photograph.

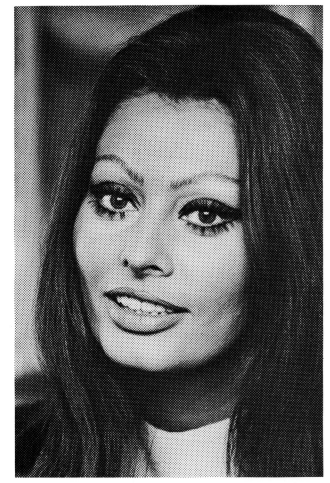

This picture has purposely been made with a very coarse screen so that the dot structure of the image can easily be seen. Greater fidelity to the original can be obtained by using a more closely ruled screen, thus increasing the number of dots in the picture. Ordinarily, black-and-white reproductions in the Life Library of Photography are made with a 150-line screen (one ruled with a grid of 150 lines per inch); the dots in them can be detected only with a magnifying glass, making the pictures virtually indistinguishable from the originals.

issues more than lived up to this zesty overture, and by 1924 the *Daily News* had the largest circulation of any newspaper in the United States, titillating an eager public with well-illustrated stories on marital problems, crime and sex. But for sheer sensationalism, it paled beside another tabloid of the '20s, the New York *Evening Graphic*, which carried the themes of sex and violence about as far as they could go (readers nicknamed it the Pornographic). The *Graphic's* main contribution to photojournalistic history was the composo-graph—a fake picture made by pasting several photographs together. One of the most famous composographs was inspired by the attempt of a wealthy manufacturer, Edward West "Daddy" Browning, to leave his 15-year-old wife "Peaches" on the ground that Peaches had insisted that her mother live with them; it showed the couple cavorting in a bedroom, with mother eaves-dropping outside the door.

In their sensationalistic heyday, the tabloids would do just about anything to get a genuine shocker of a photograph. A case in point is the New York *Daily News* photograph of Ruth Snyder dying in the electric chair. Mrs. Snyder, who was convicted of murdering her husband in a thunderously publicized "love-triangle" trial, was sentenced to be electrocuted in Sing Sing Prison, New York. Although pictures of people being executed were prohibited—not by law, but by custom and the warden's directive—the management of the *News* decided to photograph the event.

Getting a reporter on the scene was not difficult; pencil reporters are invited to executions. Camera reporters, however, are not, and the *News* photographer had to smuggle his camera into the electrocution room. Because the faces of *News* photographers were well known to the police, the editors decided to fetch an outsider, Tom Howard of the *Chicago Tribune*, to do the job. Howard was brought to New York a month ahead of time and installed in a hotel room, where he whiled away his time practicing sneak shots with a miniature camera. The camera, which was not loaded with film but with one glass plate smaller than a matchbook, was taped just above Howard's left ankle; thence a cable release ran up his trouser leg into his pocket. Howard aimed the camera by pointing his foot.

In addition to importing Howard and rigging the camera, the editors of the *News* somehow got hold of blueprints of the electrocution room—it was necessary to prefocus the camera, and therefore some idea of Howard's position in relation to the chair was needed. On the night of the execution Howard walked into the room, well-nigh as familiar with it as with his own parlor, and took his predetermined place. When Mrs. Snyder was killed by temporarily being incorporated into a 2,200-volt circuit, Howard lifted his trouser leg and exposed the plate. If the picture *(overleaf)* seems a trifle blurry, it is not because Howard flinched; not at all. It is because he coolly exposed the plate

17

three times, for a total of about five seconds, to catch Mrs. Snyder's attitude as the current was applied, cut off and reapplied.

The temerity of Tom Howard and his co-conspirators in capturing people and events on film has characterized modern photojournalists ever since — and especially a peculiar subspecies known as *paparazzi,* who concentrate on catching jet-setters and celebrities off guard.

The *paparazzi* got their name from Federico Fellini's classic film, *La Dolce Vita.* One of the minor characters in the film is an irksome photographer named Paparazzo, who dashes about taking pictures of people in embarrassing situations. Fellini selected the name Paparazzo because, he explained, "it suggested a buzzing, stinging, annoying sort of insect, which was the idea I wanted to put across." An Italian word with a similar sound, *pappataci,* means "gnat."

Often, the buzz of the real *paparazzo* cannot be heard until it is too late. French siren Brigitte Bardot found this the case when she saw pictures of herself in the nude splashed across the pages of the Italian magazine *Playmen;* an enterprising *paparazzo* had tracked her to a holiday villa outside Rome and caught comely views from 600 feet away with a 640mm telephoto lens. Another target of *paparazzi,* Elizabeth Taylor, hired detectives to protect her from them, but one determined snoop lowered himself by rope onto her hotel terrace to get pictures of the actress dining with her fourth husband, Eddie Fisher.

The *paparazzi* show equal skill at operating in the open. Racing on motor-scooters from airport to restaurant to nightclub, they stick close to the heels of their famous prey. When the actor Ernest Borgnine quarreled with his wife on the streets of Rome, sufficient *paparazzi* were on hand to turn night into day with their popping flashbulbs.

Working in the sensationalistic tradition of Pulitzer's *World,* the New York *Graphic* and other tabloids, the *paparazzi* raise anew the question of the proper limits of photojournalism. It is not an easy question. News photography has never found a final answer to the conflict between two fundamental rights: the right of the individual to privacy, and the right of the public to be informed. As far back as 1890, Samuel D. Warren and Louis D. Brandeis, later a Justice of the Supreme Court, noted in the *Harvard Law Review* that it had become possible "to take pictures surreptitiously." The technology of photography and printing had come so far that "instantaneous photographs and newspaper enterprise have invaded the sacred precincts of private and domestic life; and numerous mechanical devices threaten to make good the prediction that 'what is whispered in the closet shall be proclaimed from the housetops!' "

The article was wonderfully prescient. The authors had never heard the word *paparazzo,* and the most surreptitious photograph that could have been taken in a closet in 1890 would have been accompanied by a blast of *Blitzlichtpulver* sufficient to burn off a man's beard. Yet Brandeis and Warren could see,

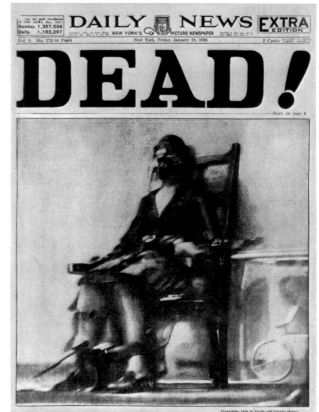

RUTH SNYDER'S DEATH PICTURED!—This is perhaps the most remarkable exclusive picture in the history of criminology. It shows the actual scene in the Sing Sing death house as the lethal current surged through Ruth Snyder's body at 11:06 last night. Her helmeted head is stiffened in death, her face masked and an electrode strapped to her bare right leg. The autopsy table on which her body was removed is beside her. Judd Gray, mumbling a prayer, followed her down the narrow corridor at 11:14. "Father, forgive them, for they don't know what they are doing?" were Ruth's last words. The picture is the first Sing Sing execution picture and the first of a woman's electrocution. ...

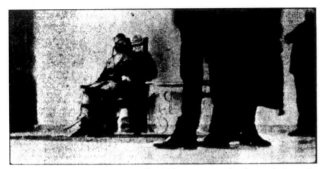

One of the most sensational news photographs ever published—and one of the first made with a concealed camera—is the picture of the electrocution of murderess Ruth Snyder that the New York Daily News spread across its front page on Friday, the 13th of January, 1928 (left). The close view reproduced by the News was greatly enlarged from a portion of a small negative, which is printed in its entirety above. Most of the negative shows only the legs of witnesses because the secret camera was strapped to the ankle of the photographer—but the close-up gives a vivid view of Mrs. Snyder.

across the years, that a reasonable limit had to be placed on the news camera.

Today it is generally held that public figures—politicians, actors and other celebrities who thrust themselves into the public eye—are fair game for photojournalists at virtually all times. They cannot plead for publicity in the morning and expect not to be photographed in some embarrassing circumstance later in the day. There are many others who cannot claim total privacy from the news media—criminals, people accused of crime and people involved in accidents or disasters. However sad it may be, such individuals, in the words of one judge, "are subject to the privileges which publishers have to satisfy the curiosity of the public as to their leaders, heroes, villains and victims."

"The curiosity of the public" really refers to the public's right—indeed, its demand—to be informed. And it was the earnest and unstinting efforts of committed photographers to satisfy this demand that established photojournalists as legitimate news reporters and won them the following they enjoy today.

The public's admiration for photojournalists stems in no small part from amazement at the way they get their jobs done. The men and women who take news photographs have an uncanny ability to be in the right place at the right time, and a knack for extricating themselves from sticky situations with body, soul—and film—intact. Scrappers one and all, they go to enormous lengths for the scoop. In 1924 a photographer named Bob Dorman, working for a news-feature service called Newspaper Enterprise Association (NEA), arrived in Boston Harbor on a U.S. Navy destroyer with film of the landing in Labrador of U.S. Army fliers who were on the first around-the-world flight. Also aboard were photographers from competing agencies and newspapers. As the ship entered the harbor, Dorman secretly transferred to a waiting speedboat to beat the others ashore, then raced to a nearby airfield where he hopped a chartered plane to New York. During the flight, he placed his exposed glass-plate negatives and film pack in a length of inner tube, which he then sealed and inflated. Over Manhattan's East River the plane swooped low and Dorman tossed out the inner tube. A pair of colleagues in another speedboat retrieved it and rushed it to the NEA office, two blocks away, for processing. The glass plates had been completely smashed, but the film pack was intact—and Dorman had scored a beat.

Given such energy and panache, it was not long before an elite group of globe-trotting photojournalists achieved a status equal to that of the celebrated figures they photographed. In their heyday, *Life* and *Look* each supported staffs of 30 to 40 photographers whose exploits captured the public's imagination. Alfred Eisenstaedt, the famed *Life* staffer often referred to as the father of photojournalism, would shoot a picture from the highest ledge of a skyscraper, or climb 150 feet to the top of a tree filled with snakes, flies and giant mosquitoes to record the quintessential view of a South American rain forest. With the

modesty of the mild-mannered reporter who really was Superman, Eisenstaedt commented simply: "That was where the pictures were."

But the public's admiration extends beyond hero worship. Talented photojournalists are respected most for the sensitivity and perception of their photographs. Standing invisible at the heart of human drama, the best of them record vast truths and minute details with instinctive certainty, capturing the one instant that speaks to millions.

It is because of their peculiar talent that photojournalists survived the advent of television in the early 1950s. Television provided instant images to a society that was disinclined to wait for information; the images were clear, continuous and promised, before too long, to arrive in the den in living color. The public was hooked, and the picture magazines suffered. In 1971 *Look* folded, followed a year later by *Life;* photojournalists began to look for other work.

Eventually the novelty of television wore off and the impact of a good still image was not forgotten. Readers of magazines and newspapers alike demanded pictures more vivid than anything shown on the evening news. Picture magazines made a comeback (*Life* was successfully revived in 1978), newspapers made dramatic advances in the quality and quantity of their picture stories — and the lives of news photographers became even more hectic. Two developments made it all possible: the growth of picture agencies and tremendous advances in the technology of electronic picture transmission.

Today's most successful photojournalists work for one of several picture agencies, most based in Paris with branches in large cities all over the world. The people who run the agencies function, in the words of one of their own ranks, like chess masters playing 100 games at once. They keep track of world events, direct and follow photographers' movements around the globe, line up buyers for the pictures the photographers shoot, and distribute the desired pictures to the appropriate publications in time to meet their deadlines.

The agencies provide photojournalists with steady, lucrative work and a certain amount of guidance, but they in no way reduce their frantic pace — photographers still have to appear miraculously in the right place at the right time. A paragraph from the journal of one agency photographer reads: "Early in December 1978: Pakistan, two weeks. Then to Iran for Christmas. Two months there during the revolution followed by a week in Europe getting back to the U.S. New York for three days and then to Florida for 10 days to do a baseball story. A week in Utah on a continuing thing that I have been doing on the Mormons. Returned to New York and Washington for a couple of weeks." It is no wonder that the same photographer described his personal life as "all screwed up." Another photojournalist queried on the same subject replied, "My personal life? It doesn't exist. It's a catastrophe."

Yet the rewards are great. The men and women at the top of their profession

earn international respect as well as handsome incomes. Furthermore, overnight fame for the photographer can come as suddenly as the outbreak of revolution or the execution of a single prisoner of war: If the photographer is there to record it, the picture can be all over the world within minutes.

The instant transmission of images began in the early 1930s, when pictures were first transmitted by wire. Within 40 years the industry progressed through transmission by telephone and radio, to systems involving the use of satellites and laser beams. In most modern systems, a photographic print is now scanned by a laser beam, which translates the picture's various shades into electronic impulses of different intensities. These impulses are transported by telephone line or satellite channel to their destination, where they enter a receiver and are retranslated into an image that can be engraved and printed in the same way as a regular photographic print. In all, the state of the art has undergone an enormous change from the homing pigeons that used to shuttle film from one city to another in the 1930s. (Some transmission problems have been more difficult to overcome than others, of course. As recently as 1982, *Time* still chartered helicopters to leapfrog the snarl of Manhattan's rush-hour traffic to deliver picture layouts to the engraver, 30 miles away on Long Island.)

The growing demand for high-quality color photos by news publications poses no problem for sophisticated systems. Color film can be separated and sent as three black-and-white prints; or a color print can be sent three times through yellow, cyan and magenta filters for black-and-white separations. In either case the separations are engraved in the normal way when they arrive.

On the receiving end, picture editors work in electronic darkrooms equipped with computers that assign digital values to the electronic impulses coming in. The digitized information, displayed as a picture on a computer-terminal screen, can then be altered by keyboard command. Photos can be cropped, lightened, darkened, enhanced—in short, changed in any of the ways possible in a traditional darkroom.

So far, this exotic transmission process is only used with prints. It is still necessary to have film developed and prints made before the photographer can send anything over the wire. Some photojournalists are equipped with darkroom kits and portable transmitters for sending black-and-white photographs over any telephone line, but color film must be sent—one way or another—to a reliable lab for the more complicated processing it requires.

Soon, however, it will not even be necessary for a photographer to develop and print a roll of film before transmitting it. The camera industry promises new equipment that captures images on light-sensitive electronic chips. With that advance, pictures will be sent directly from camera to computer, and the transmission of a photographic image will be as quick as the reflex that caught it— as immediate and unerring as the perception of a great photojournalist. □

The Critical Moment

Great news photos distill the confused brew of human affairs. They extract from a war the one moment that speaks for all the horrors of all the battles; they record the personal tragedies that police and rescue squads respond to every day; they bear witness to the extraordinary events—pioneering expeditions, catastrophes, victories—that decide the flavor of an entire era. Yet photojournalists are not historians, discerning the great currents of an age from a detached vantage point. Instead, they swim in the roiling sea of events along with their subjects, obtaining their insights through a combination of careful planning, quick reflexes—and sheer luck.

As shown by the portfolio on the following pages, the subject matter of photojournalism is as varied as human experience itself. The critical moment caught by a photojournalist may be the detonation of a terrorist bomb *(right),* the tears wept at a great man's funeral, or the proof of the incredible strength of a hurricane. But all these news photos have one trait in common: They catch the essence of an event, and thereby leave an indelible mark on the mind of the viewer.

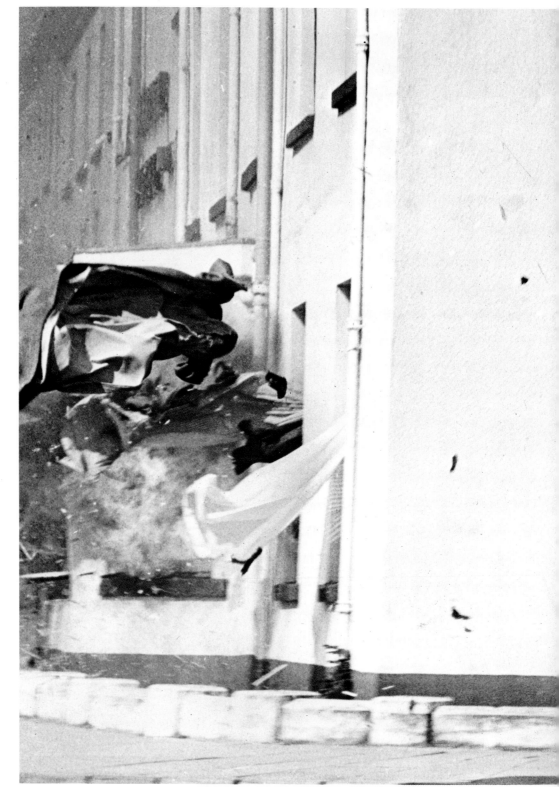

The explosion of one of eight bombs planted in a hotel in Northern Ireland by Irish Republican Army terrorists spews curtains, glass and splintered furniture out the hotel windows, knocking aside two policemen trying to save trapped guests. Another guest, a West German journalist and freelance photographer, escaped after the second explosion, grabbed a camera and shot this picture from behind a wall across the street. The photograph won the World Press Photo Spot News award for 1979.

CLAUS BIENFAIT: *Explosion at Ballycastle,* Ireland, 1979

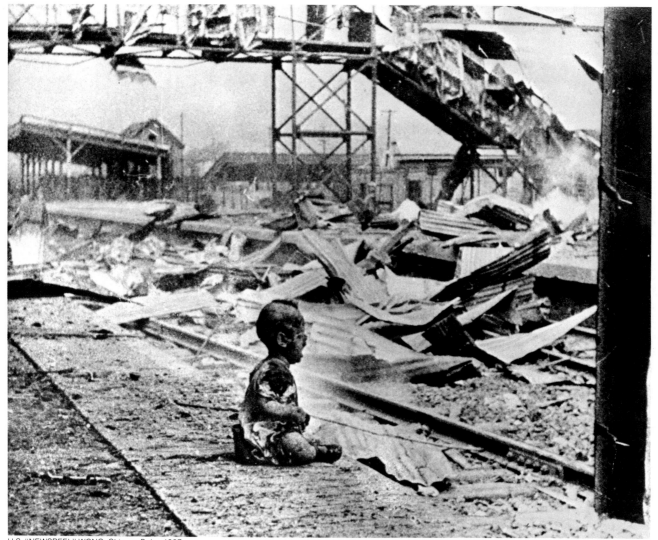

H.S. "NEWSREEL" WONG: *Chinese Baby,* 1937

Moments after his mother was killed by Japanese bombs, a Chinese baby sits crying at a Shanghai railroad station in 1937. The attack was filmed by one of Hearst Metrotone's star newsreel photographers with a 35mm movie camera. This frame, reproduced in magazines and newspapers, stirred up international outrage at the slaughter of Chinese civilians.

A terrified South Vietnamese girl, victim of a mistaken ▶ napalm attack by her own country's air force, flees naked down the road after ripping off her burning clothes. The image, a powerful distillation of the War's effect on the civilian population, earned 22-year-old wire-service photographer Huynh Cong Ut both the Pulitzer Prize for Spot News and the Netherlands Press Photo of the Year Award in 1973.

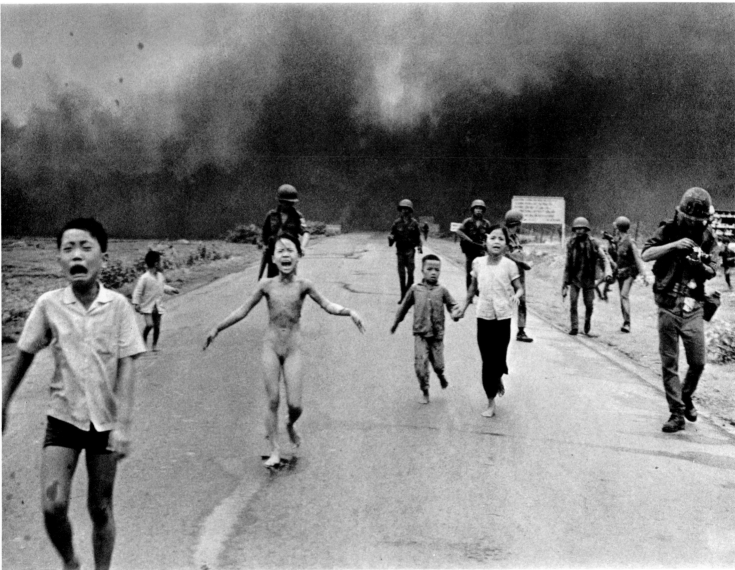

HUYNH CONG UT: *The Terror of War*, 1972

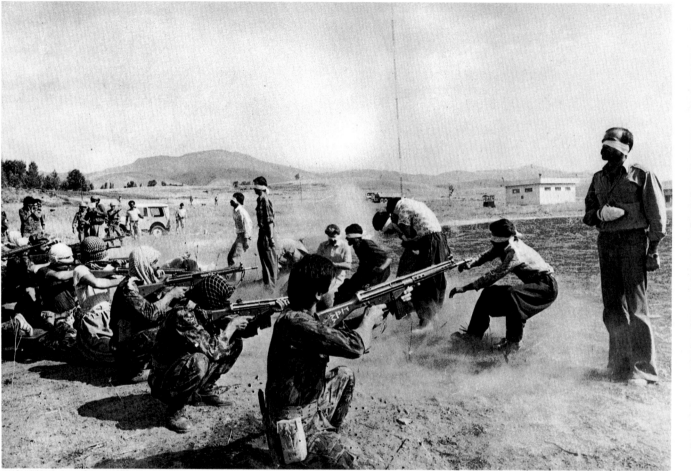

ANONYMOUS: *Firing Squad, 1979*

Amid gunfire and crumpling bodies, a police officer who had served the deposed Shah of Iran stands defiant moments before his own execution by a firing squad ordered by the Ayatullah Khomeini. The picture won several awards, including a Pulitzer Prize; but because wire-service editors had withheld the photographer's name for his own protection, the prize was officially awarded to Anonymous.

While the body of a Palestinian girl lies nearby in ▶ a Beirut street, a group of young Christian Phalangists, a right-wing Lebanese faction, gloat after a looting spree in the wake of a Phalangist attack on an enclave of Palestinian refugees. The boys' youth —and their utter disregard for an innocent victim —underscored the tragedy of the Christian-Muslim civil war in Lebanon.

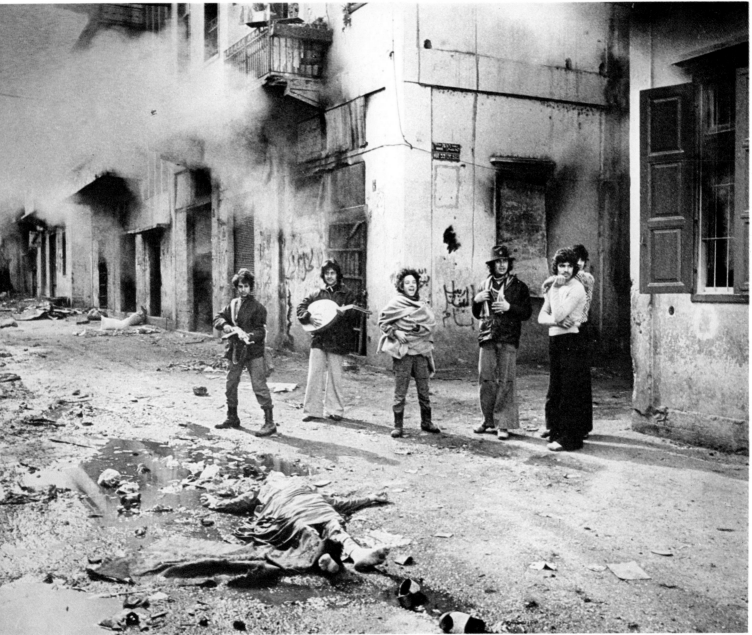

DONALD McCULLIN: *Christian youths celebrate a combat victory in Lebanon,* 1976

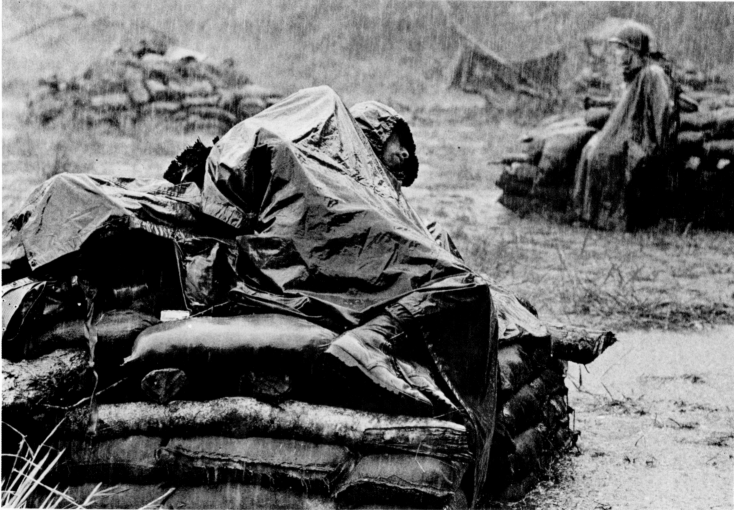

TOSHIO SAKAI: *Dreams of Better Times*, 1967

While a companion keeps watch in the background, an exhausted GI attempts to sleep on a pile of sandbags, a poncho his only shelter from the torrential rains that flooded the soldiers' bunkers during Vietnam's summer monsoon season. This portrayal of the dreary hardships endured in a battle zone was taken by a Japanese photographer who was seeking ways to document the War "indirectly."

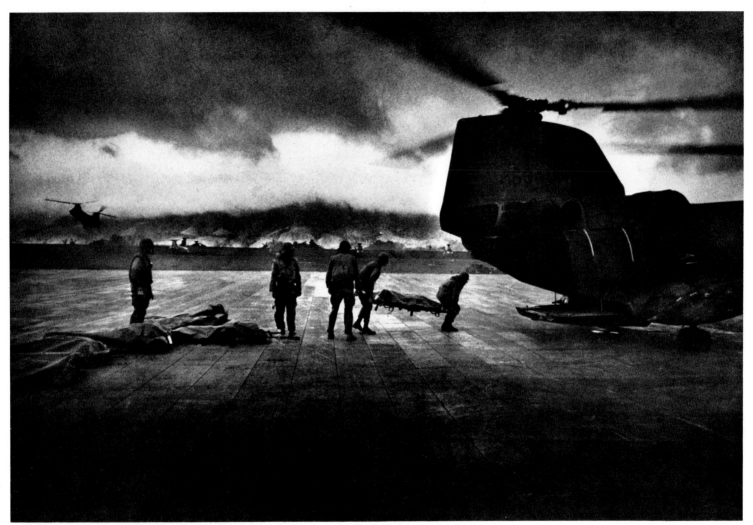

DAVID DOUGLAS DUNCAN: *Khe Sanh, South Vietnam, 1968*

After a day of shelling by the enemy, U.S. Marines at the besieged garrison of Khe Sanh load the bodies of slain comrades onto a helicopter for shipment home. One small airstrip was the only way in to or out of the advance fire base, but danger and isolation were not new to the photographer, whose combat coverage began with Life during the Korean War.

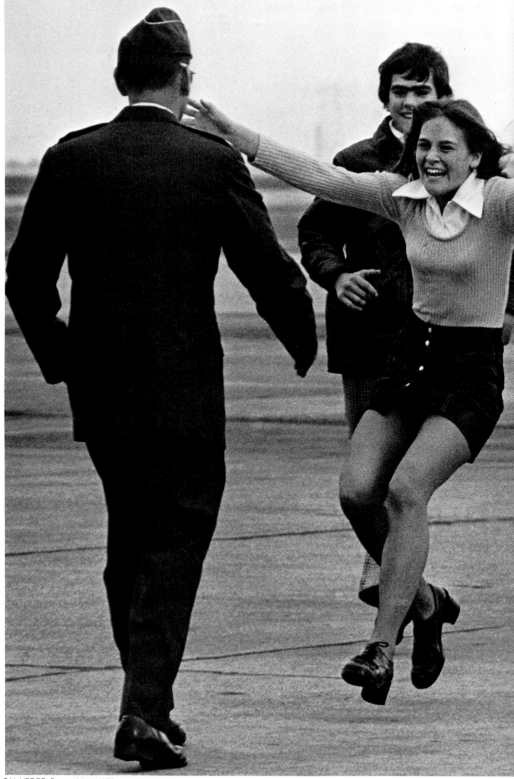

SAL VEDER: *Burst of Joy*, 1973

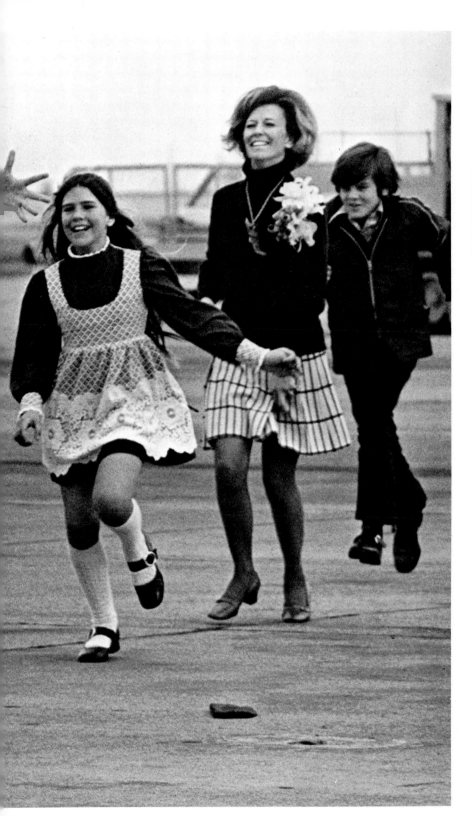

The wife and children of a United States Air Force pilot fling themselves across the airport runway to greet him on his return home from more than five years in a North Vietnamese prison camp. Photographer Sal Veder's timing for this shot was split-second perfect: The older daughter's welcoming arms are stretched their widest, and her brother's smiling face—about to be obscured by her forward movement—is still clearly visible.

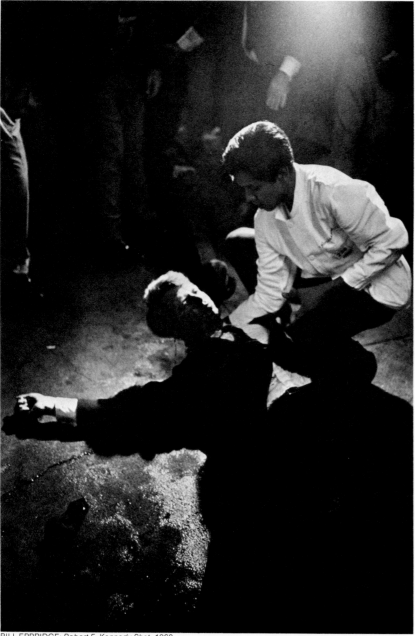

Senator Robert F. Kennedy lies in a pool of his own blood on the floor of the Ambassador Hotel in Los Angeles, semiconscious and rigid as his life ebbs away. A 24-year-old Jordanian immigrant named Sirhan Sirhan had shot him twice with a .22-caliber pistol moments after Kennedy thanked supporters for helping him win the crucial 1968 primary election in California.

BILL EPPRIDGE: *Robert F. Kennedy Shot,* 1968

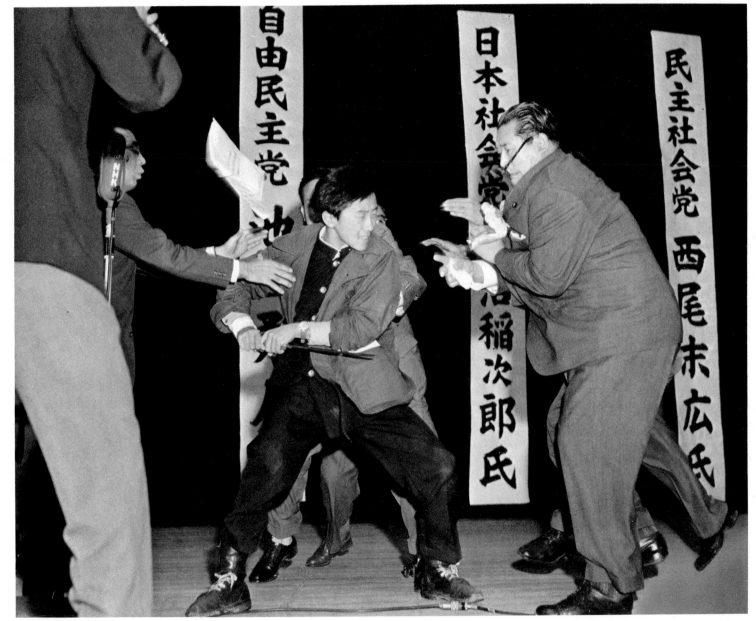

YASUSHI NAGAO: *Inejiro Asanuma and Assassin*, 1960

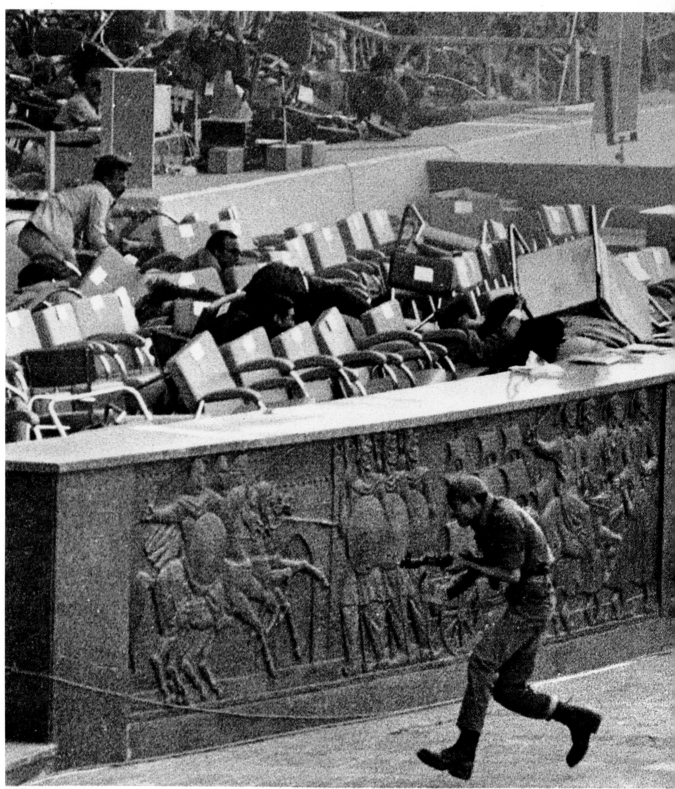

NAKRAM GADEL KARIM: *The Assassination of Anwar Sadat*, 1981

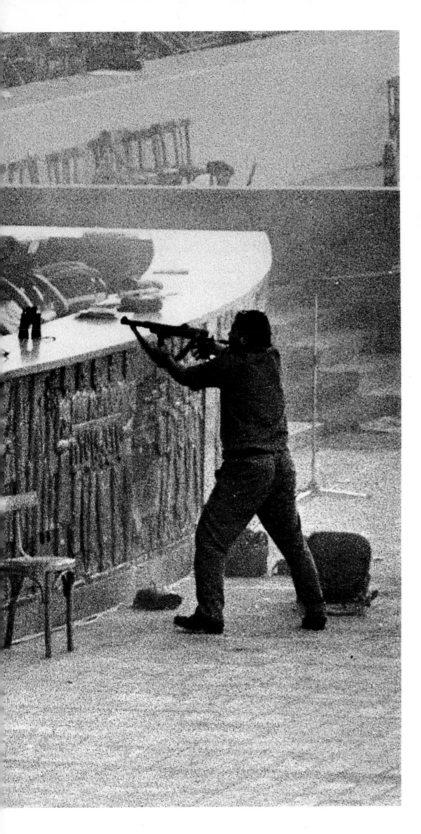

During an attack on Egyptian President Anwar Sadat in the course of a military review, security guards and officials crouch to protect themselves as one assassin sprays gunfire over the dais and another moves to the left. Sadat, already wounded and dying, is covered by the pile of chairs at center. The photographer remained in position on a platform 30 feet away and shot frame after frame of the bloody confusion.

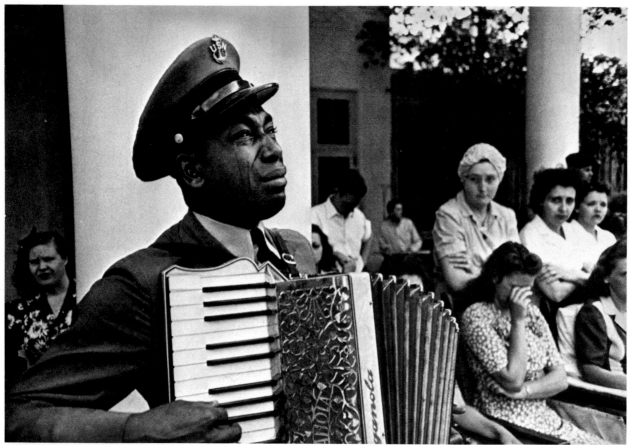

EDWARD CLARK: *Weeping for F.D.R.*, 1945

When Franklin D. Roosevelt, who had guided the United States through the Depression and World War II, died of a stroke in Warm Springs, Georgia, in April 1945, the sense of bereavement felt by millions was summed up in one emotion-filled picture: a weeping Navy musician, Chief Petty Officer Graham Jackson, playing *Going Home* as the body began the journey back to Roosevelt's home in Hyde Park, New York.

Bridging three reigns and grieving for the end of ▶ one, England's Elizabeth II, Queen Mary and the widowed Queen Consort watch as the coffin of George VI is carried into Westminster Abbey. The new Queen's father died on February 6, 1952, after occupying the throne through 16 of the most tumultuous years in English history.

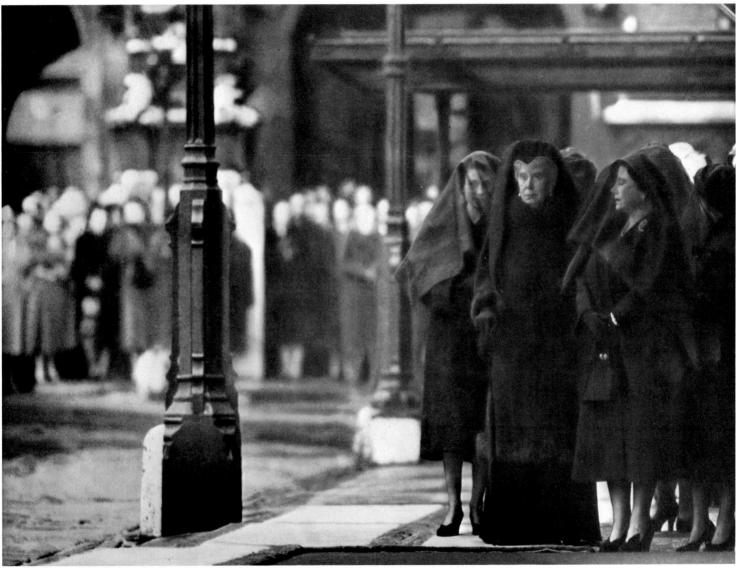

PHOTOGRAPHER UNKNOWN: *Bereaved Queens*, 1952

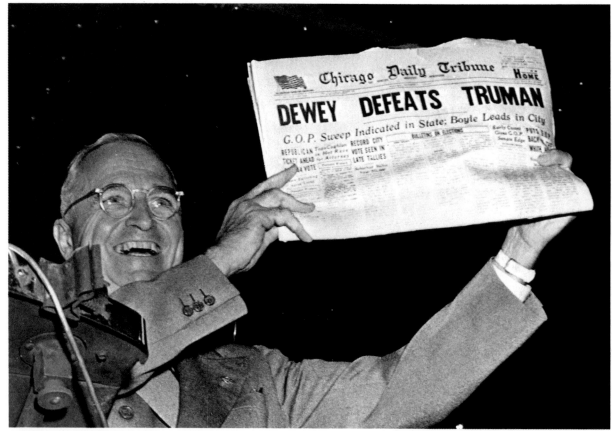

AL MUTO: *Truman Defeats Dewey, 1948*

It was a foregone conclusion that Harry S Truman would lose to Thomas E. Dewey in the 1948 Presidential election—and the Chicago Daily Tribune even headlined his defeat while votes were still being counted. President-elect Truman later showed the headline to cheering supporters with the relish of a man who has had the last laugh.

As his tearful wife looks on, Richard Nixon—the ▶ first American President forced to resign—delivers a farewell address to his staff. Harry Benson, on assignment for People, carried only two cameras, three extra lenses and no tripod so that he could move about freely for the shot he had in mind. "I knew they would all be upset," he said, "and I wanted to get Pat looking at him as he spoke."

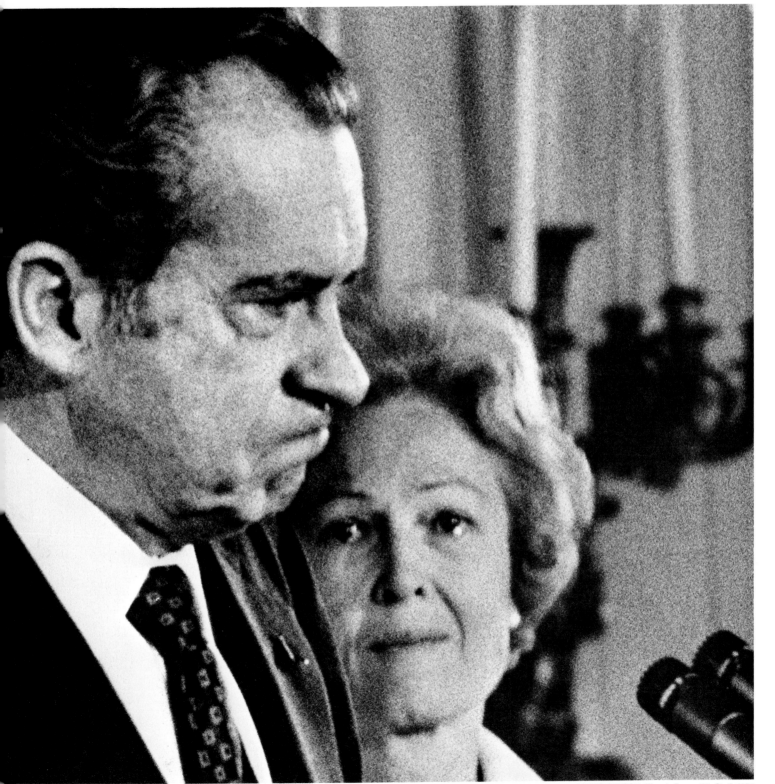

HARRY BENSON: *Nixon's Farewell to Staff*, 1974

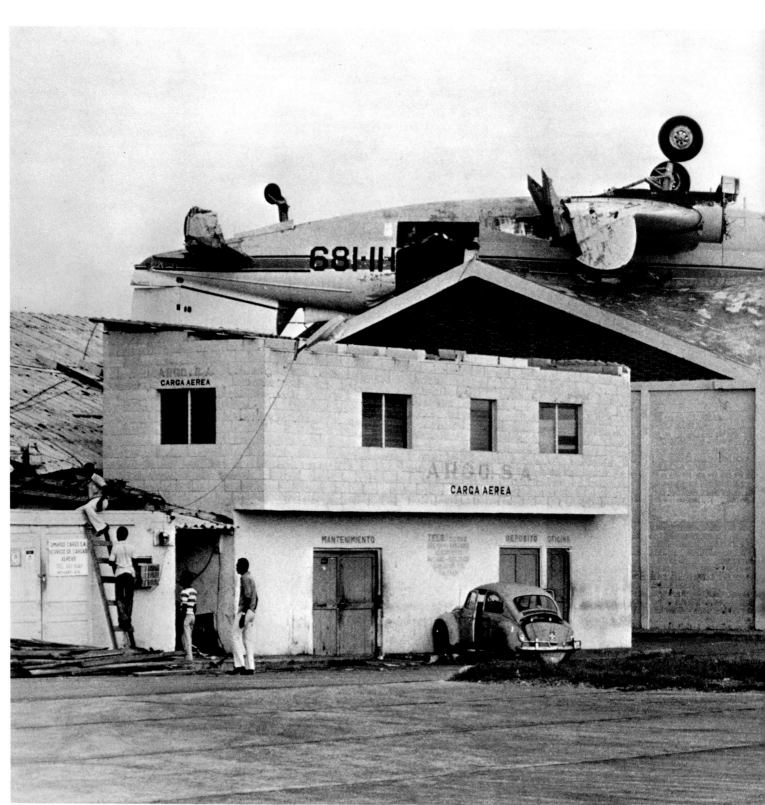

CHIP HIRES: *Aftermath of Hurricane David,* 1979

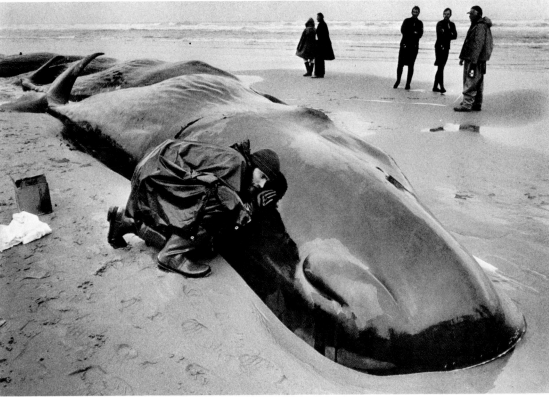

CHARLIE NYE: *Sounds of a Dying Whale, 1979*

◀ *A plane resting belly up on top of a warehouse at the Santo Domingo airport proclaims the overwhelming strength of natural forces. The 15-ton cargo plane was deposited on the roof by Hurricane David, one of the strongest storms of the century. Measuring some 300 miles across, with an eye 30 miles wide and 150-mile-per-hour winds, it left an estimated 2,000 people dead and 200,000 homeless in the Dominican Republic alone.*

On a drizzly Sunday in June, a marine biologist monitors the raspy breathing of a sperm whale beached on the Oregon coast, one of 41 that swam ashore in a phenomenon that scientists cannot explain. Attempts by environmentalists to drag the creatures back into the water failed and all the whales were lost. Charlie Nye traveled 60 miles to record the helplessness of sympathetic humans confronted with the animals' suffering.

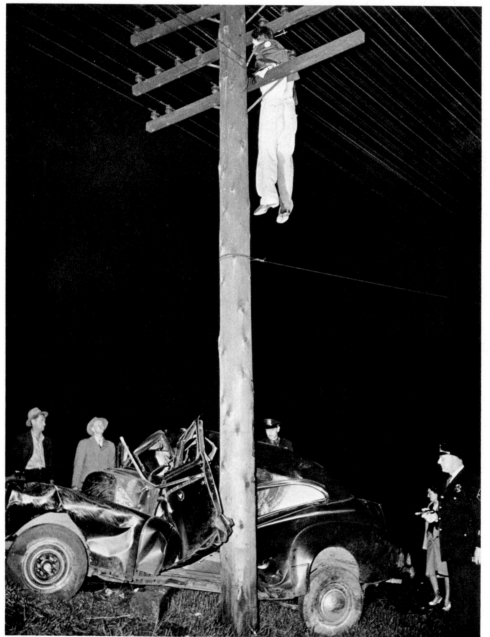

Killed instantly when his speeding automobile struck a telephone pole near Cheektowaga, New York, a motorist hangs suspended in a grisly embrace of wires and crossbars. Photographer William Dyviniak recorded in one tragedy the horror of all United States highway accidents.

Plunging toward her death, a 35-year-old ▶ divorcée is frozen in the act of suicide by the camera of news photographer I. Russell Sorgi of the Buffalo Courier-Express. She had leaped from the eighth-story ledge of a hotel despite policemen's attempts to dissuade her.

WILLIAM W. DYVINIAK: *Automobile Accident, 1945*

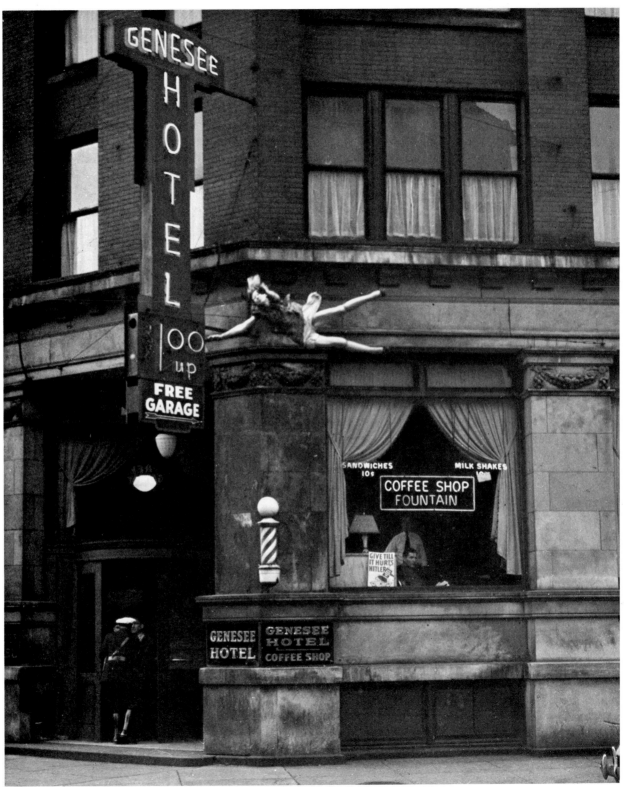

I. RUSSELL SORGI: *Suicide,* 1942

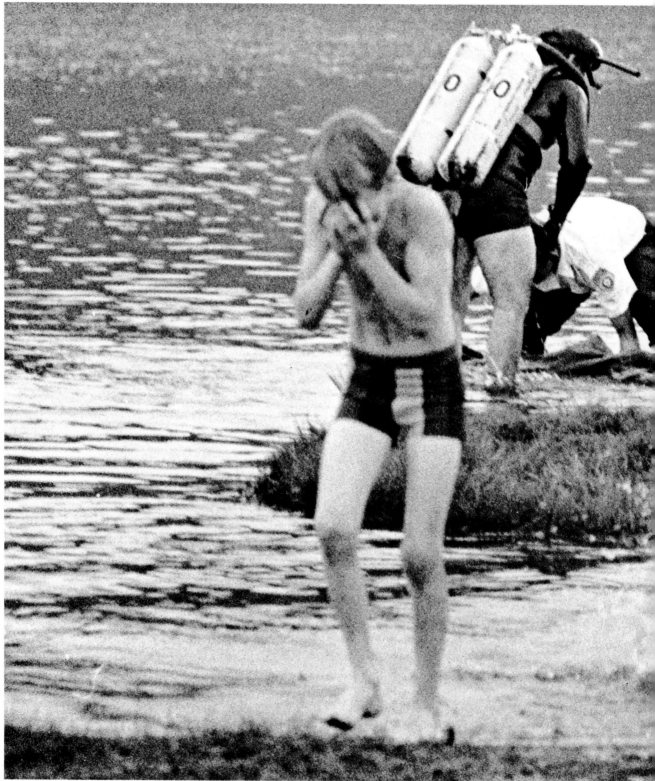

MITCHELL C. ABOU-ADAL: *Beach Tragedy*, 1972

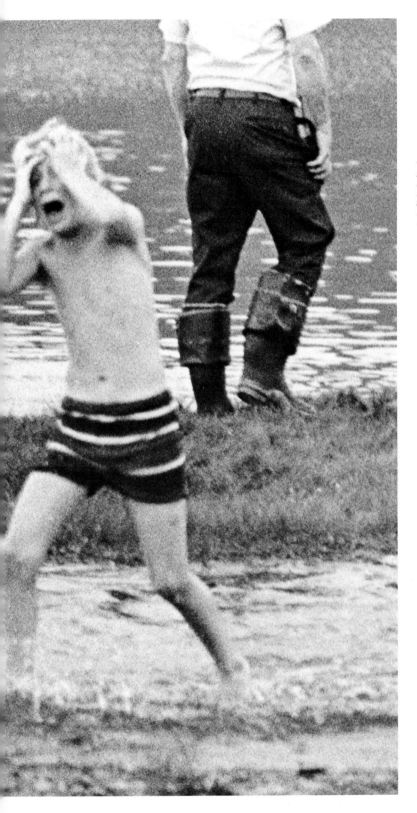

Two anguished young brothers turn away from the sight as rescuers pull the body of their playmate from a Massachusetts pond. The brothers had gone for a soda and returned to find their friend missing. When they called for help, the local news photographer heard the police report, went to the scene — and recorded the terrible end to the boys' outing.

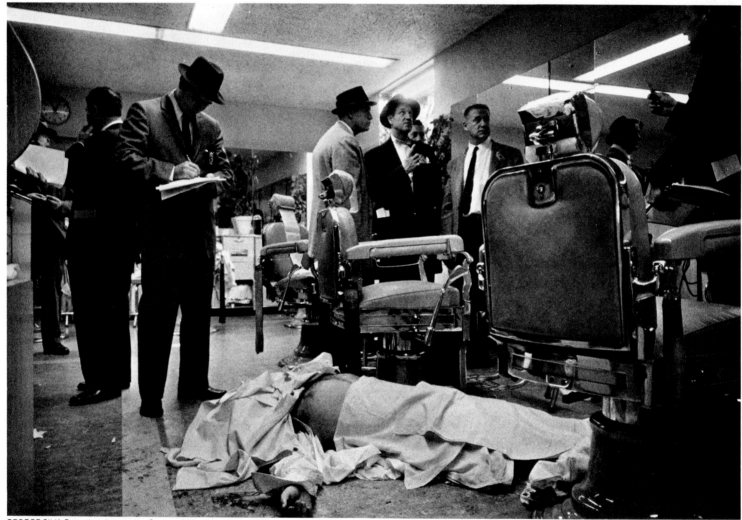

GEORGE SILK: *Detectives Inspect the Corpse of Albert Anastasia, 1957*

*New York police had been trying to put Albert
Anastasia behind bars for years, but it was
gangster justice that finally caught up with him,
as shown in Life photographer George Silk's
picture of detectives at the scene of his slaying.
Anastasia, chieftain of a Brooklyn murder ring,
had been shot by fellow thugs while having his
hair cut in the barbershop of the Park Sheraton.*

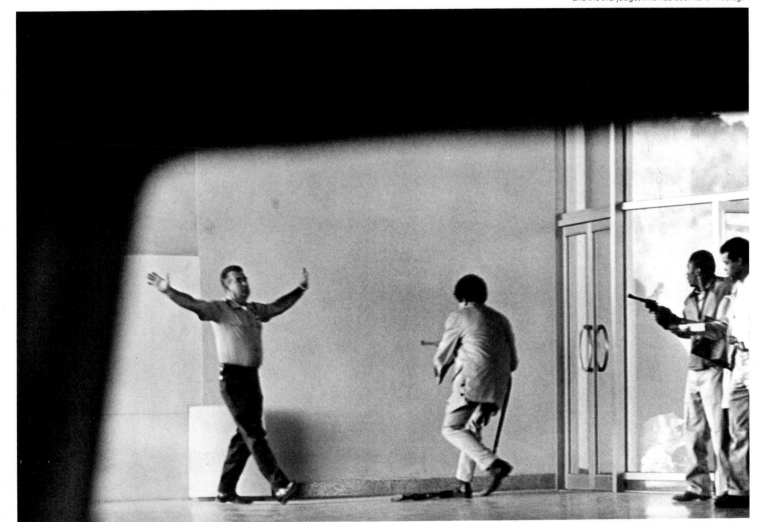

ROGER BOCKRATH: *San Rafael Breakout*, 1970

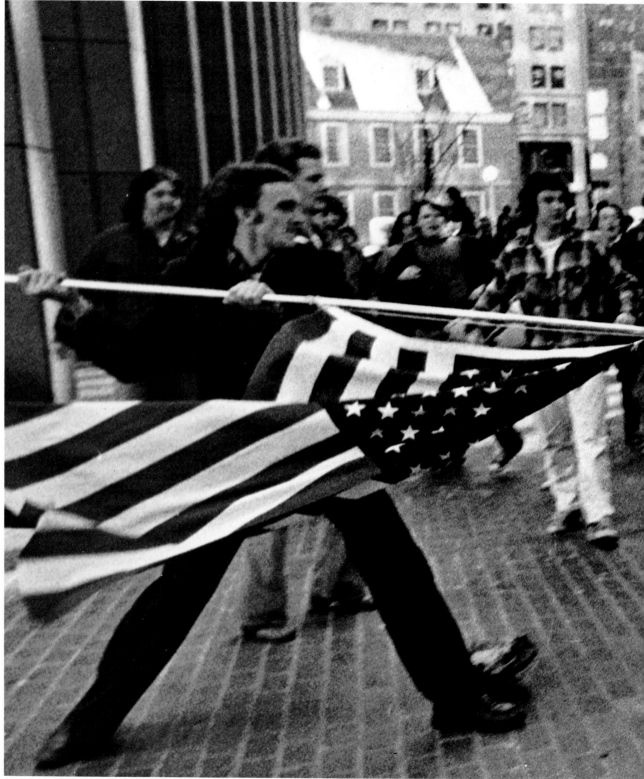

STANLEY FORMAN: *The Soiling of Old Glory*, 1976

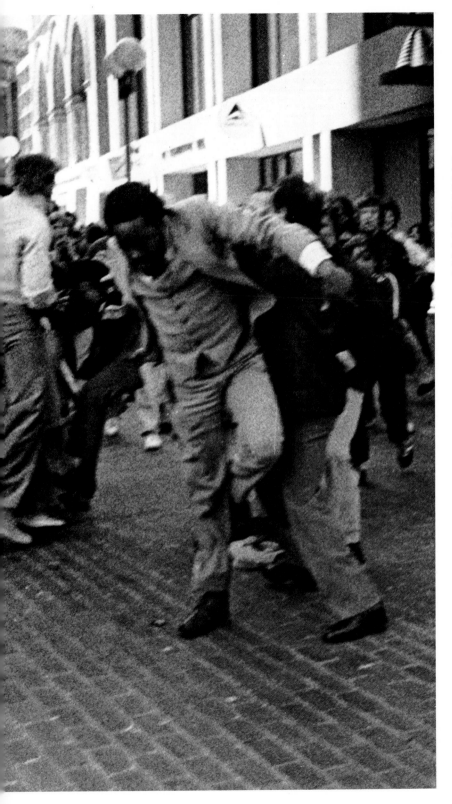
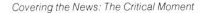

During an antibusing demonstration by high-school students in Boston, a white youth wielding an American flag like a lance jabs at a black lawyer who is pinioned by other demonstrators. The youths had just finished pledging allegiance to the flag when the man happened by. Stanley Forman, who was photographing the scene with a motor-driven camera, stopped when it began to make "a funny sound." He turned off the motor and began shooting single frames, a precaution that saved this picture: It was the last shot he made on the roll before switching cameras, and it earned him a Pulitzer Prize for the second year in a row.

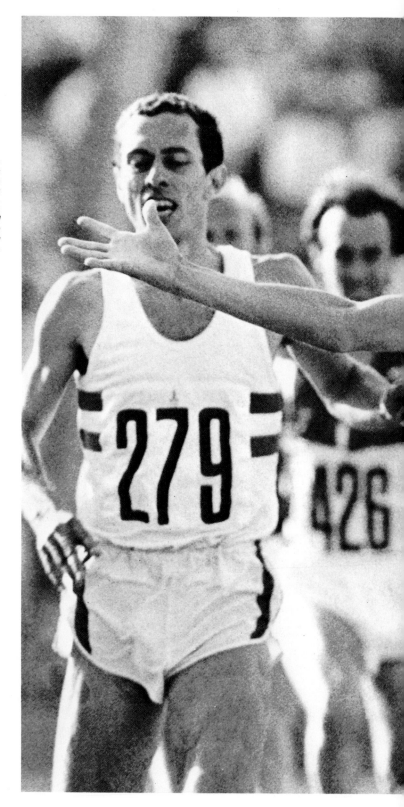

Supreme effort contorts the features of Britain's Sebastian Coe as he outkicks East Germany's Jurgen Straub (338) and fellow Briton Steve Ovett (279) to win the 1980 Olympic gold medal in the 1,500-meter race in Moscow. Joe Marquette, on assignment for UPI, made the shot from 200 yards away, using a 600mm lens and a high-powered motor drive that shoots 10 frames per second. With 36 exposures on the roll, he had only three seconds of shooting time; this was frame 30.

JOE MARQUETTE: *Sebastian Coe Winning in Moscow,* 1980

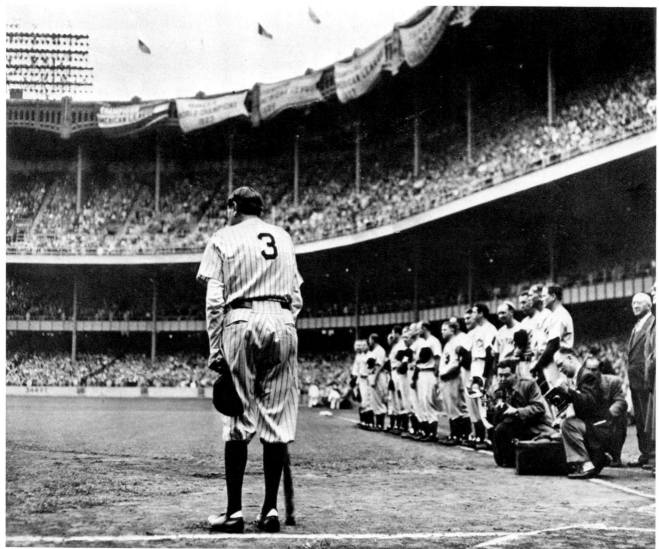

NAT FEIN: *Babe Ruth Bows Out,* 1948

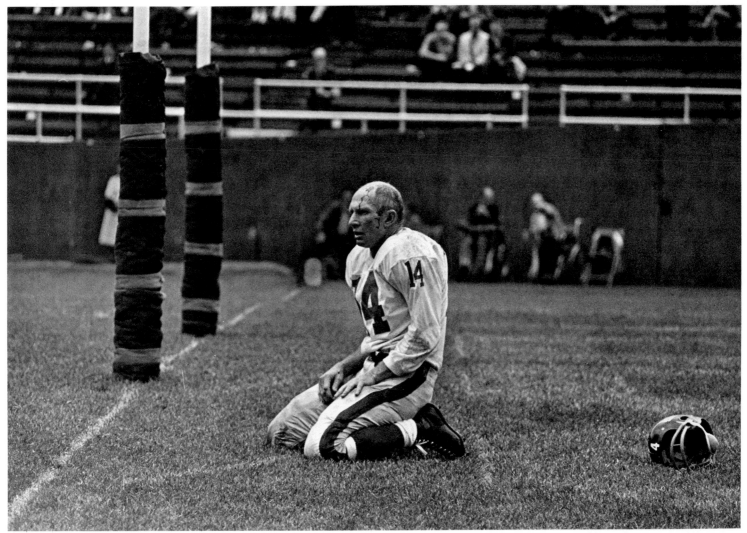

MORRIS BERMAN: Y. A. Tittle, 1964

◀ Fans jammed Yankee Stadium in 1948 to say good-by to Babe Ruth, mortally ill with cancer after 22 years of matchless heroics in baseball. New York Herald Tribune photographer Nat Fein stood to the left of the Yankee bench to include in his picture members of the Babe's old team, the cheering crowd and the famed number 3 of his uniform, which was then forever retired.

With the stunned look of a gladiator who realizes his competitive days are numbered, veteran New York Giant Y. A. Tittle kneels on the turf after a crushing tackle in 1964 by a 270-pound Pittsburgh Steeler. Tittle gamely played out the rest of the season, but it was his last.

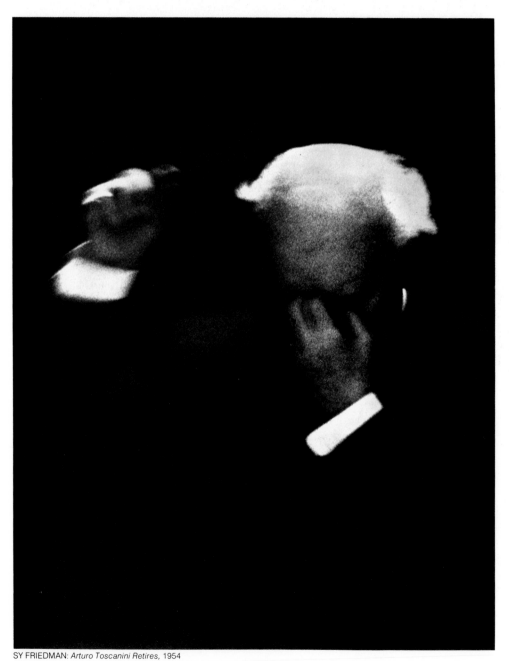

Overcome with emotion during his farewell concert in 1954, Arturo Toscanini, the great conductor of the NBC Symphony, tries to remember his place in the score. Before the last notes had been played, he dropped his baton and left the stage of Carnegie Hall, weeping.

Ignoring the scowl of a bystander, two ▶ fashionable ladies, weighted down with jewels and swathed in ermine, arrive for the opening of the 1943 Metropolitan Opera season. Because of the wartime blackout, news photographer Arthur Fellig, better known by his nickname, Weegee, was not able to see his subjects clearly. But, as he later explained, "I could smell the smugness, so I aimed the camera and made the shot."

SY FRIEDMAN: *Arturo Toscanini Retires,* 1954

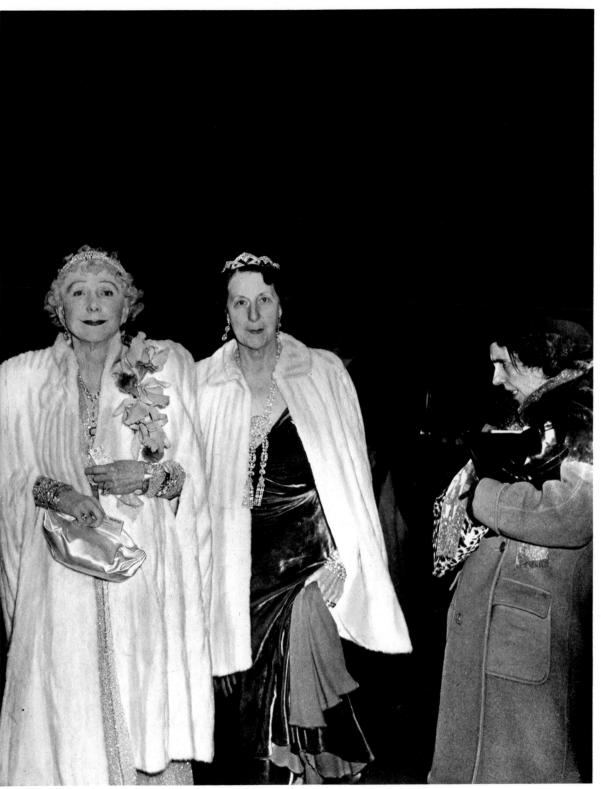

WEEGEE: *The Critic*, 1943

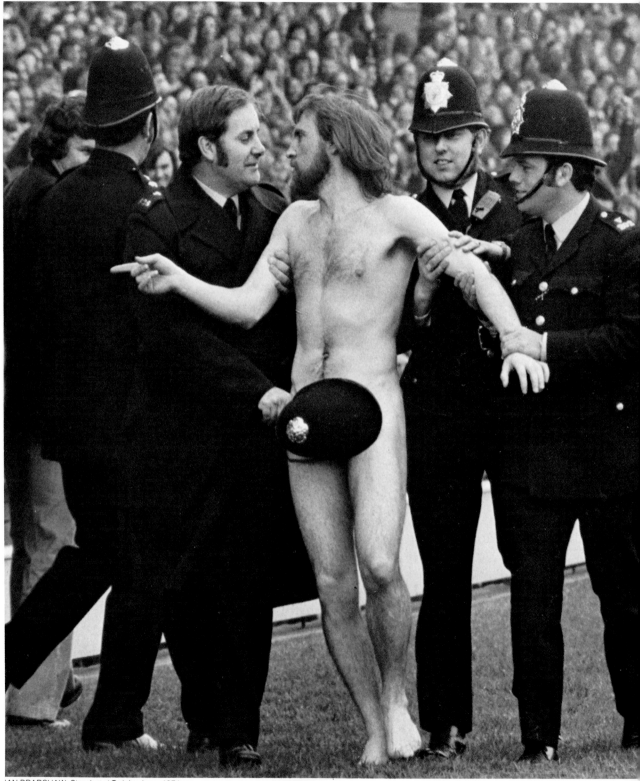

IAN BRADSHAW: *Streaker at Twickenham, 1974*

As a distressed official rushes up with a coat, a bemused bobby uses his helmet to shield a "streaker" seized after running naked onto an English rugby field in front of 50,000 fans. Sunday Mirror photographer Ian Bradshaw's problem in shooting the unexpected scene was not just to capture the instant when all the principals came together in a telling composition, but to make a picture that his newspaper would find publishable. "The policeman's helmet," Bradshaw recalled, "was not always covering the private parts."

The Impact of Color

The wide use of color photographs in news magazines is relatively recent. As late as the mid-1970s, *Time* and *Newsweek* were printing only a handful of color pages per issue; but by the end of the decade *Time's* color pages had more than tripled, and color was in the ascendancy at *Newsweek* as well. A number of technological advances—notably computerized separation procedures—have improved the quality of color reproduction and have made it possible for weekly magazines to include coverage in color of late-breaking events that once would have had to run in black and white.

Color's impact is immediate, spelling out tragedy in a fiery streamer against a bright blue sky *(right)* or serenity in the muted tones of twilight *(pages 66-67)*. Often color is the key to expressing the nature of an event. The photograph on page 65 of a student holding up bloody hands would be meaningless if shown in black and white, despite the anguish on the student's face. Similarly, it is the contrast of yellow markers against a uniformly gray landscape that brings home most forcefully the devastation and death wreaked by the eruption of Mount St. Helens *(page 63)*.

But color is a difficult medium, lending itself too easily to garish overstatement or prettifying triviality. The challenge facing photojournalists who shoot in color is to produce images with both impact and insight. The best of them do just that.

The roar of exploding fuel tanks brought photographer Hans Wendt sprinting around a building from another assignment, to find a 727 jet going down in a stream of fire after a midair collision with a small private plane. "I lifted my camera and shoved the lens setting to infinity," said Wendt, who snapped two quick frames before the aircraft plunged into a San Diego suburb; 144 people died in the disaster, one of the worst in U.S. aviation history.

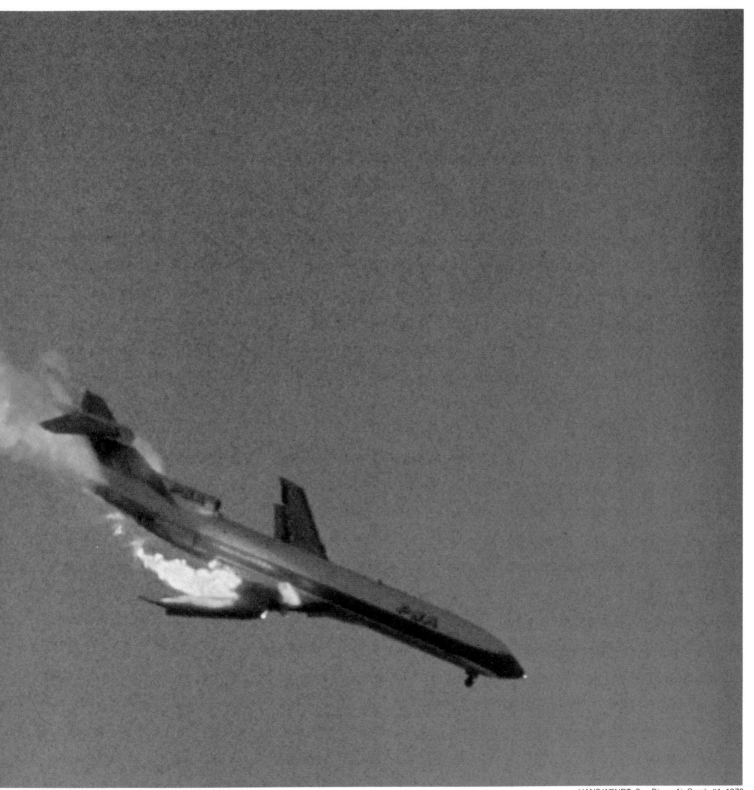

HANS WENDT: *San Diego Air Crash #1,* 1978

Four U.S. Marines struggle to recover the body of a comrade during furious ground fighting in Vietnam in October 1966. Life photographer Larry Burrows, who made this picture and the one opposite, was the first photojournalist ever assigned to cover a war in color. Through careful composition and muted hues, Burrows demonstrated that color war photography need not be lurid to be gripping.

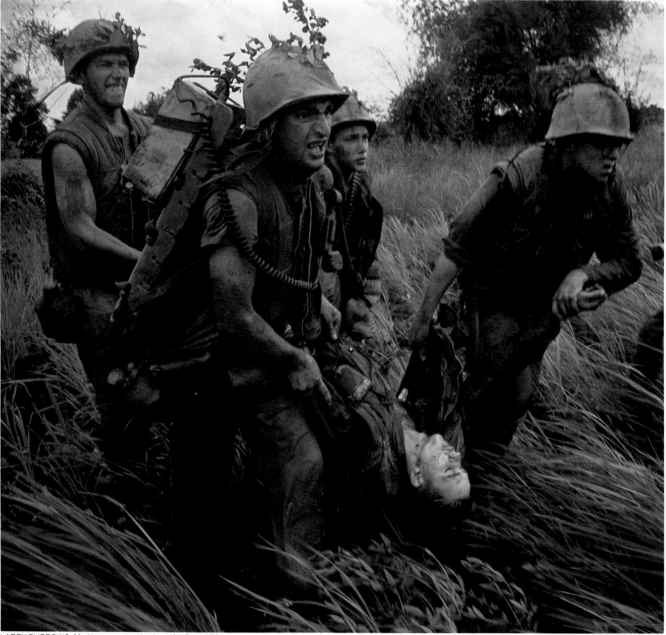

LARRY BURROWS: *Marines recover a body under fire, 1966*

The pale, blank face of a man in shock dominates this Larry Burrows photograph of the wounded being treated at the front. Burrows focused on people rather than on bombs, and his understated images are classic studies in compassion. The only three-time winner of the Robert Capa Gold Medal, Burrows died in action in 1971; his last Capa Medal was awarded posthumously.

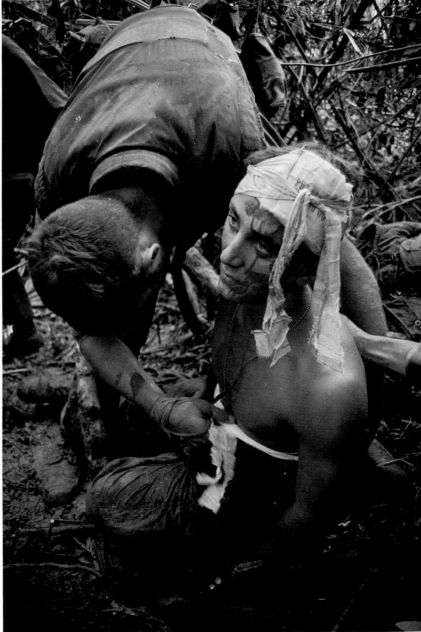

LARRY BURROWS: *A GI casualty at the DMZ,* 1966

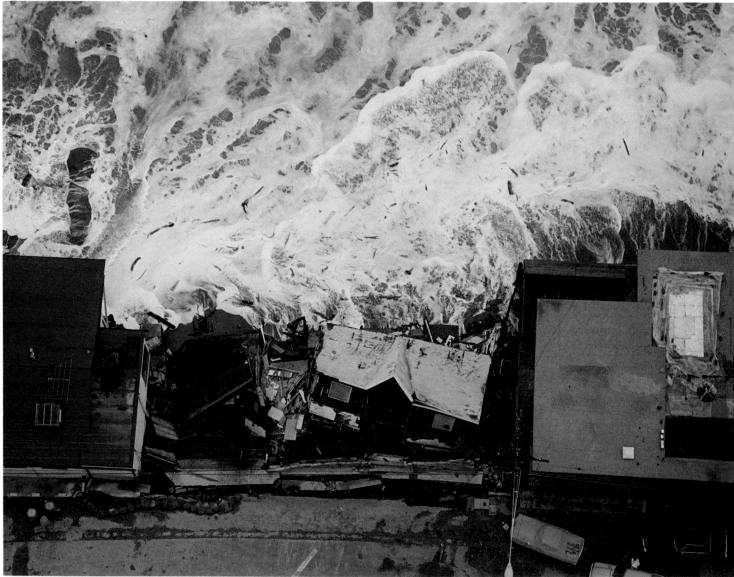

HARALD SUND: *Flood in Malibu*, 1980

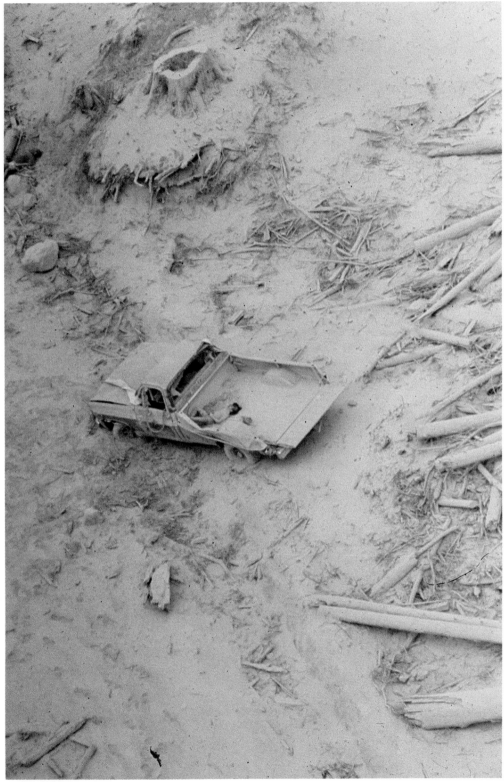

As delicate-looking as fine lace, powerful Pacific surf attacks a beach house in Malibu, California, during a series of severe winter storms that laid siege to the West Coast early in 1980. Harald Sund, on assignment for Life, took this aerial shot from a helicopter 600 feet above the waves. In black and white, the chaotic image would be hard to decipher; in color, the details of the damage are evident.

Two yellow markers, signifying that the body of another victim has been found, are the only intense color in this monochromatic landscape blanketed by gray volcanic ash from Mount St. Helens. On May 18, 1980, the mountain exploded with a force 500 times that of the atom bomb dropped on Hiroshima, leveling trees up to 17 miles away and taking 61 lives, including that of the 11-year-old boy found in this truck.

JOHN T. BARR: *Andy,* 1980

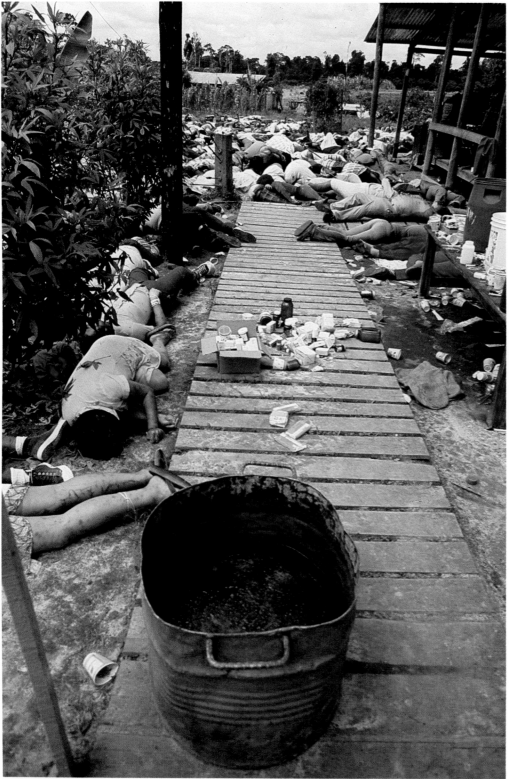

The horror of the deaths of some 900 members of the Peoples Temple in Jonestown, Guyana, in November 1978, is summed up in the deceptive innocence of a vat of sweetened purple liquid. David Hume Kennerly, on assignment for Time, wanted a shot that would draw the viewer in without dwelling on the bloated bodies of those who had died in a ritual mass suicide-murder after drinking the cyanide-laced potion. He used a wide-angle lens to keep both foreground and background sharp, and used color to focus on the poisoned purple brew.

DAVID HUME KENNERLY: *Cult of Death,* 1978

At a demonstration one day before the Ayatullah Khomeini returned from exile in Paris to take command of Iran, a pro-Khomeini student brandishes hands wet with the blood of a comrade who has just been shot by government troops loyal to the deposed Shah. David Burnett, who has won awards for his moving photographs of refugees in Cambodia, recorded the incident in a vivid image that owes all of its impact to color.

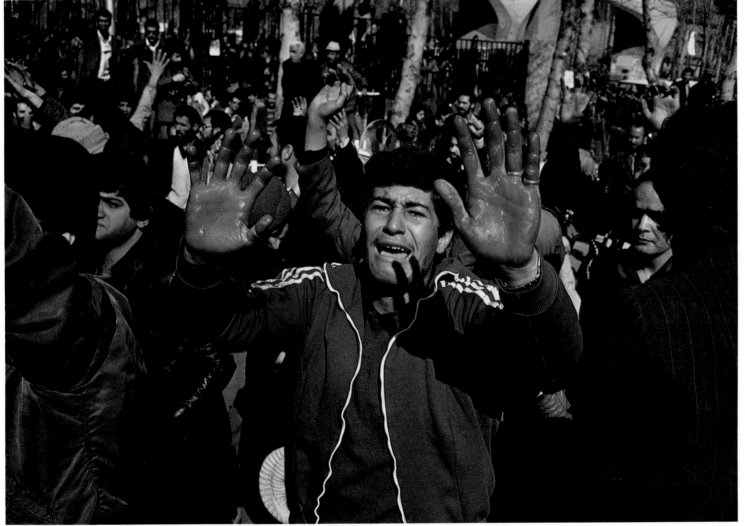

DAVID BURNETT: *Outraged Demonstrators,* 1979

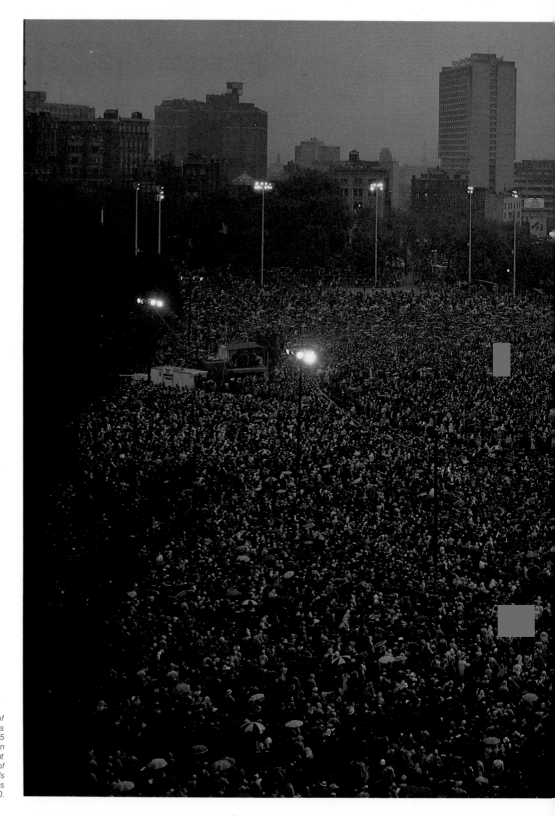

A serene, magical blue permeates this shot of rain-drenched Boston Common during a Mass celebrated by Pope John Paul II. Using a 4 x 5 view camera and daylight film, Henry Groskinsky, on assignment for Life, waited for the brief period at dusk when waning daylight and artificial light are of equal intensity. Thus he recorded not only details in the lighted stage and the background buildings but all the muted colors in the throng of 400,000.

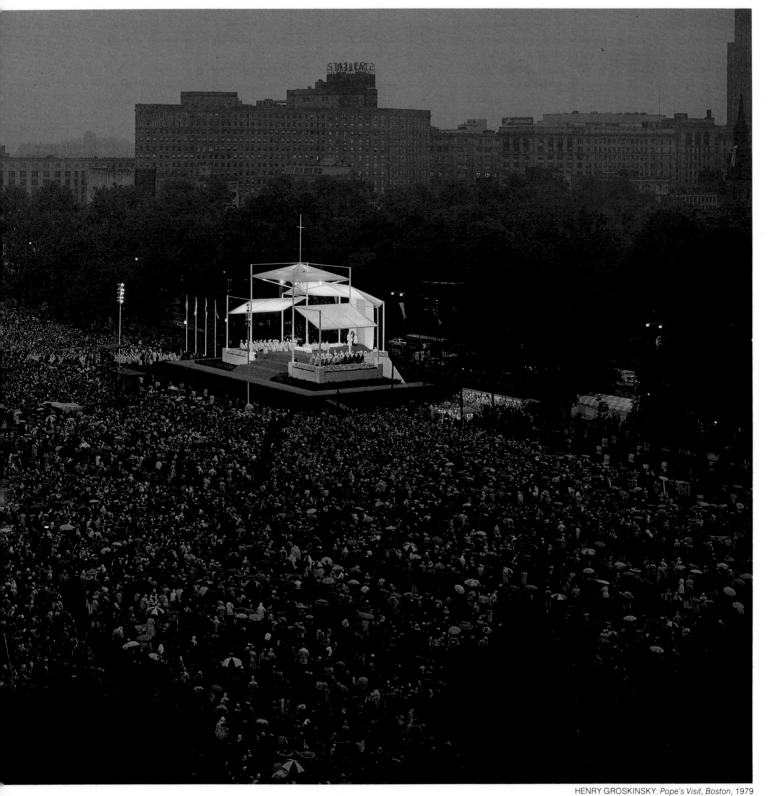

HENRY GROSKINSKY: *Pope's Visit, Boston,* 1979

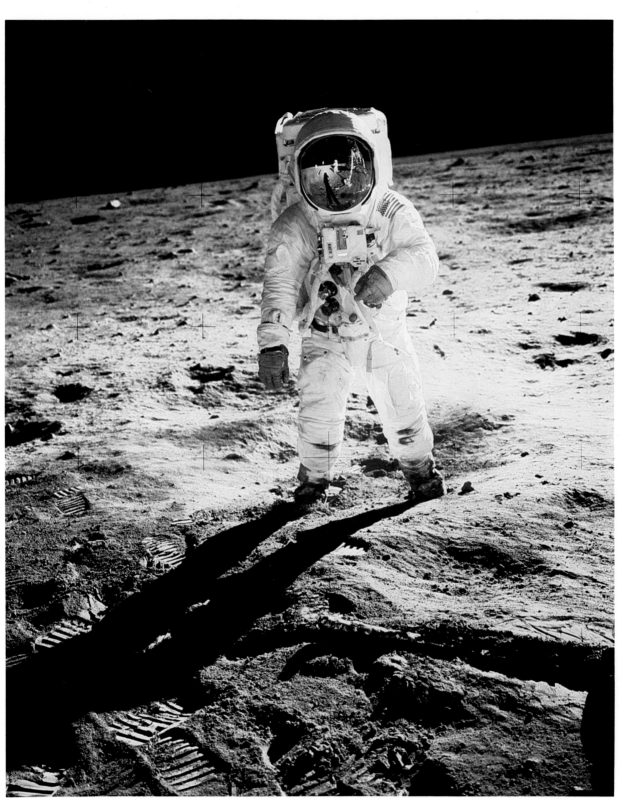

NEIL ARMSTRONG: *Buzz Aldrin on the Moon,* 1969

◀ *Silhouetted against the blackness of space, astronaut Edwin E. (Buzz) Aldrin Jr. stands for a historic portrait taken by fellow lunar voyager Neil Armstrong with a specially designed Hasselblad camera. Aldrin's white uniform, with the red-white-and-blue flag bright on the shoulder, is the major splash of color in the dusty moonscape.*

A camera mounted only 300 yards from the launch pad caught the billowing clouds of exhaust as the space shuttle Columbia lifted off on its maiden voyage in 1981. Triggering the shutter with a sound sensor mounted on the bottom of a galvanized bucket, three Miami News photographers got some of the best pictures made of the launch.

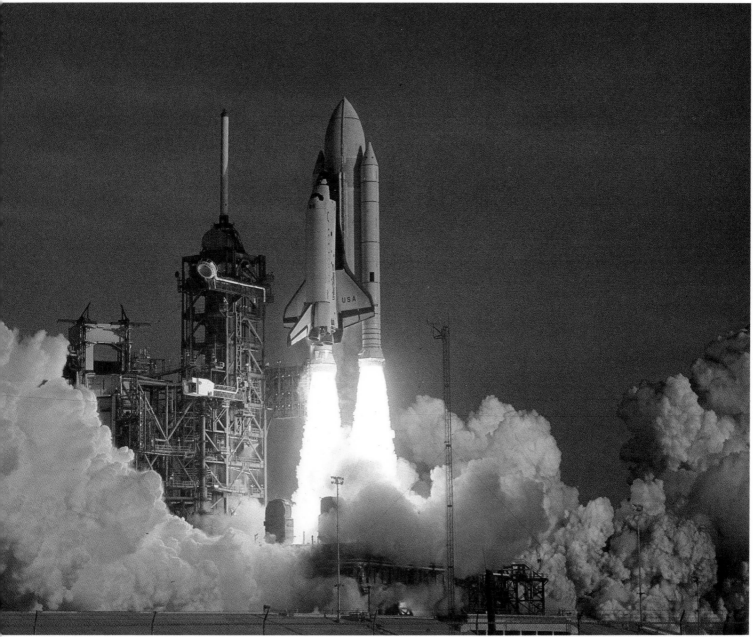

CHARLIE TRAINOR, BILL REINKE, GARY MONTANARI: *Hail Columbia*, 1981

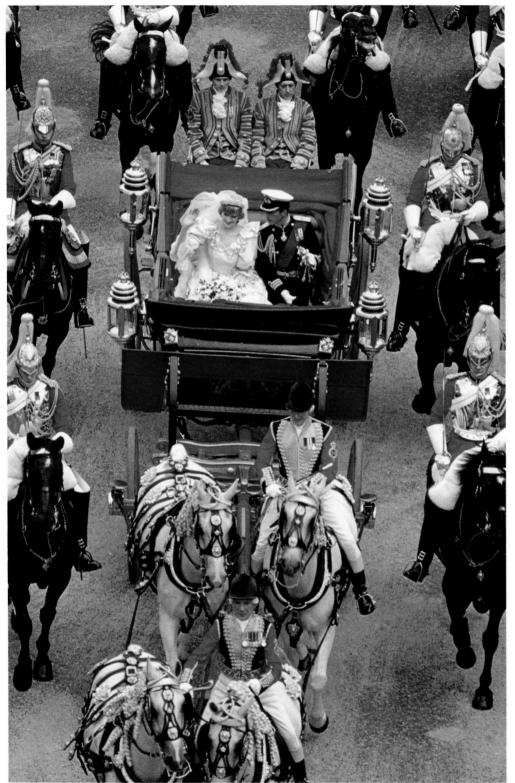

Surrounded by the brilliant crimson and gold of their mounted escort, Britain's Prince Charles and his bride return from the wedding ceremony at St. Paul's Cathedral. Photographer Ian Berry of London's *Sunday Times* stationed himself near Trafalgar Square at 7 a.m. and waited six hours for the royal procession to pass by in all its gleaming splendor.

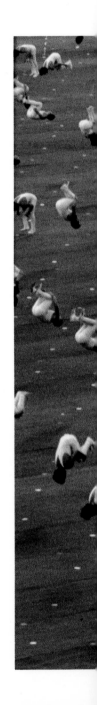

IAN BERRY: *Royal Wedding,* 1981

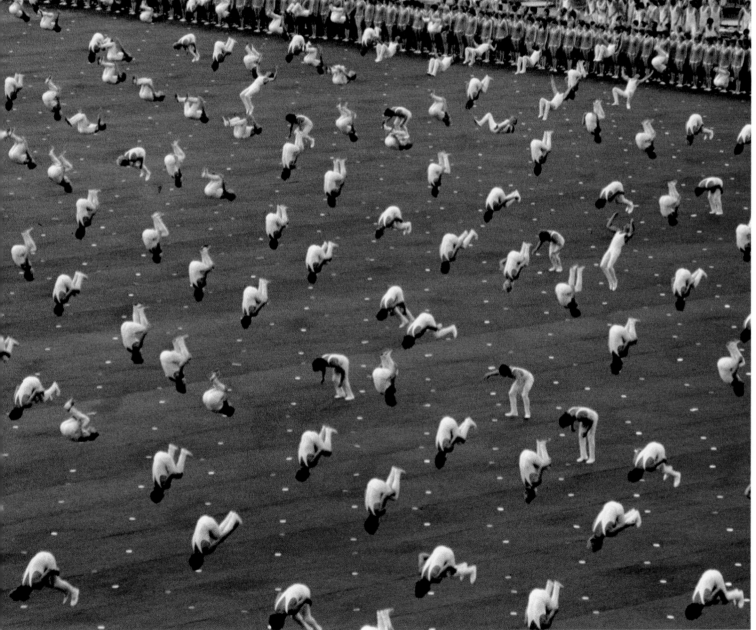

HEINZ KLUETMEIER: *Opening Ceremonies, Moscow Olympics,* 1980

TONY TRIOLO: *Roberto Duran vs Wilfred Benitez, 1982*

Against the smoky blue haze of Las Vegas' Caesars Palace, Wilfred Benitez of Puerto Rico (opposite, right) delivers a jarring right to the head of Panama's Roberto Duran—who finally lost the fight and retired from boxing. Sports Illustrated's Tony Triolo was not sure he had got the blow on film: "In sports photography," he says, "a split second can mean the difference between a boring picture and one with impact." Here, color suffuses Triolo's well-timed shot with vivid ringside authenticity.

Jubilation explodes as the buzzer sounds the victory of a scrappy U.S. hockey team over the favored Soviet squad at the 1980 Winter Olympic Games at Lake Placid, New York. Heinz Kluetmeier of Sports Illustrated froze the moment in the triumphant, upraised arms of a player kneeling on the ice, the happy melee behind him, and the American flag that is seen fluttering in the stands.

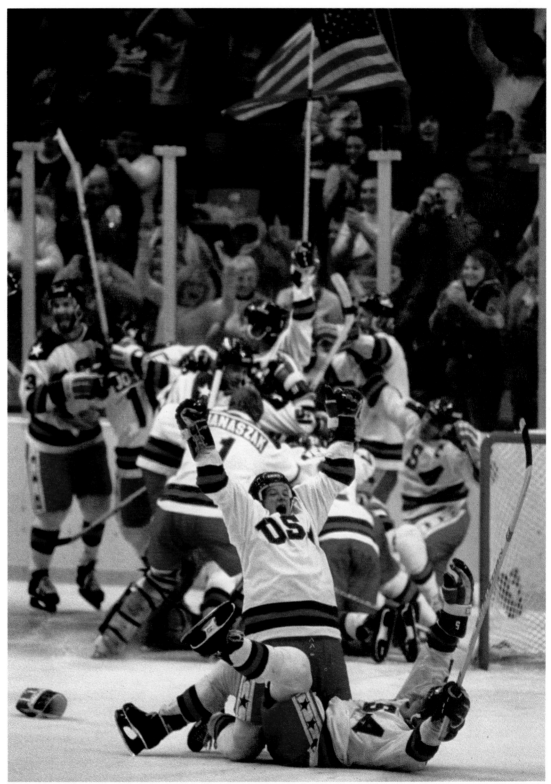

HEINZ KLUETMEIER: U.S. beats U.S.S.R. en route to Olympic gold medal, Lake Placid, 1980

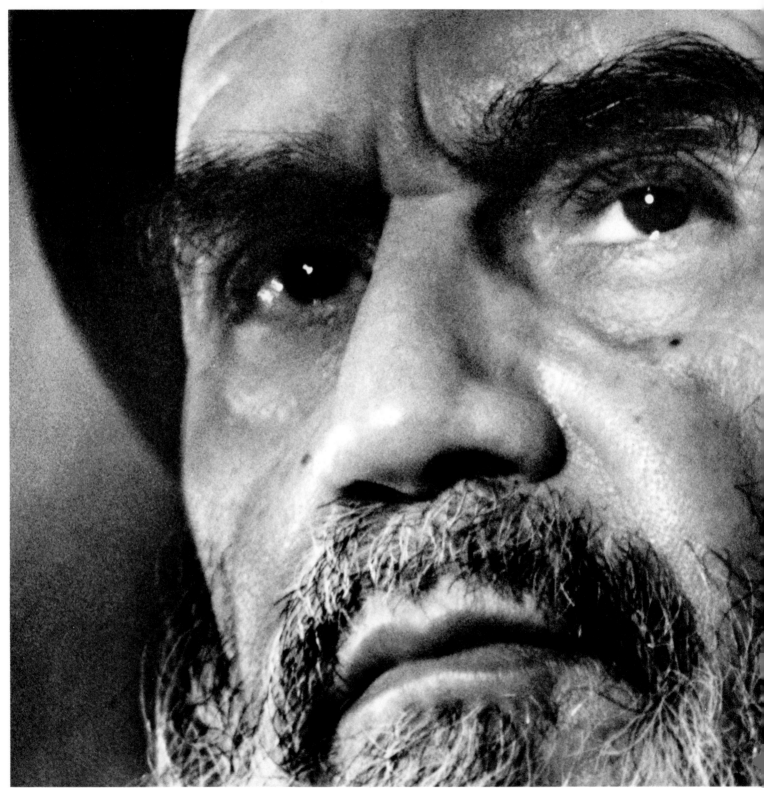

DAVID BURNETT: *Ayatullah Khomeini,* 1979

74

The Portrayal of Personality

The kinds of people who appear repeatedly in the news cover a wide spectrum, from athletes, actors and artists to politicians, wealthy socialites and those who are simply "well known for being well known." Photographing these celebrities with an eye to revealing something about them is a very different task from that of covering the news events such figures generate. A picture of an Olympic runner crossing the finish line to win a gold medal, or of an assassination victim lying sprawled on the floor, is a record of a specific public moment; it is not a portrait of an individual. The picture at left, on the other hand, is such a portrait. Although taken at a public event— a news conference— the stunning close-up is a revealing character study of a single-minded religious leader.

On the whole, the photojournalists who take pictures of public figures have more leisure to plan their shots than do those who cover breaking news. They are also generally more interpretive in their work, choosing a camera angle *(pages 166- 167)* or lens *(left)* to make a statement about the subject's inner spirit.

Another key to determining how a photographer proceeds is the relationship he or she has with the subject. In an atmosphere of mutual cooperation, the photographer may be able to place the subject in a setting that creates or enhances a mood, or may be able to make candid, unposed shots at will. Even if the relationship is marked by antagonism and mutual lawsuits, the approaches taken can range from mild obtrusiveness to physical confrontation. Whatever may be the technique or approach, the goal is the same: a portrait that is not merely a likeness but a perceptive study of someone who dominates the news.

"A medieval mind accented by vengeful eyes" is how one journalist described this remarkable portrait of the Ayatullah Ruhollah Khomeini taken in Tehran at a press conference soon after his return from 15 years in exile. Using a 200mm lens with a 2X extension ring, David Burnett of CONTACT captured the inflexible determination that marks both the man and his militant Islamic crusade.

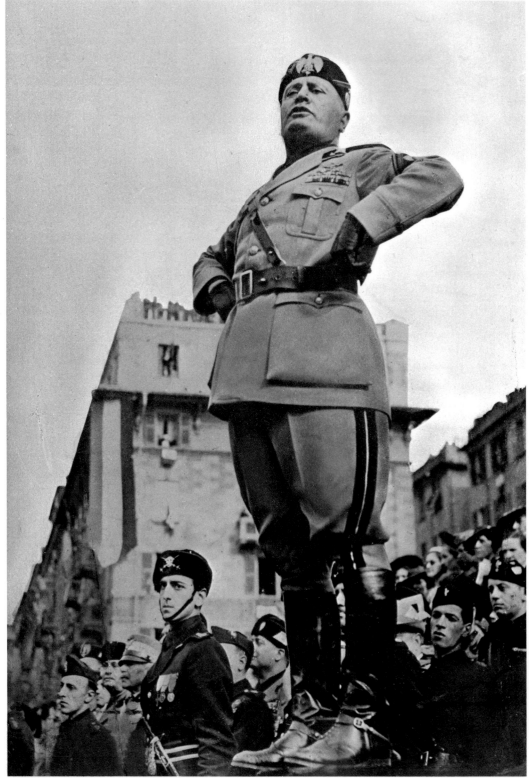

All swagger and bluster, Italian dictator Benito Mussolini addresses a crowd in 1938, wearing the uniform of the Fascist militia that he founded. The pose betrayed the bravado of Mussolini, who had dodged the draft before World War I and later, when he joined the Army, rose to the unexalted rank of corporal.

PHOTOGRAPHER UNKNOWN: *Benito Mussolini, 1938*

Simplicity and great moral force were the essential traits of Mohandas Gandhi, shown reading in his home at the age of 76 in this classic picture by Margaret Bourke-White of Life. Although he was the leader of India's long struggle to win independence from Britain, Gandhi spent one hour every afternoon working at the spinning wheel in the foreground.

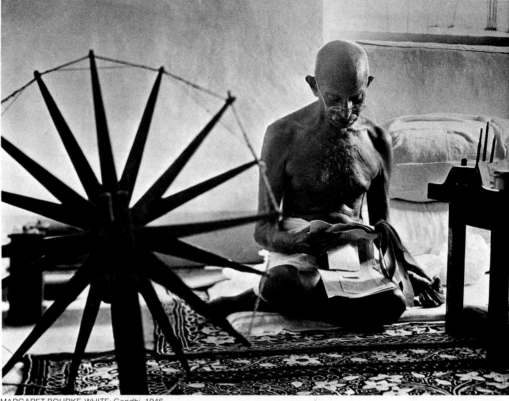

MARGARET BOURKE-WHITE: *Gandhi,* 1946

Cigarette holder cocked jauntily above a half-smile, President Franklin D. Roosevelt is a vision of confidence at a Democratic fund-raising dinner in 1938. Although the United States was mired in a recession at the time, Roosevelt characteristically took the offensive in his speech at the dinner, inveighing against the selfish "handful" of big businessmen who wanted to run the country for their own good.

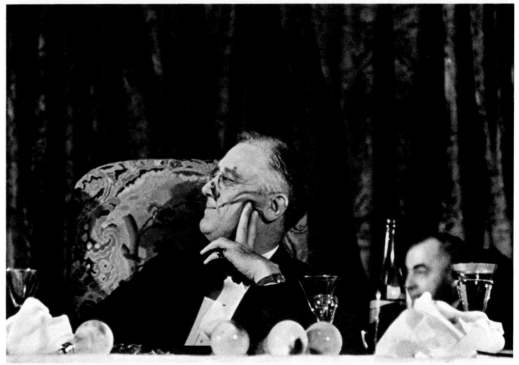

TOM McAVOY: *Franklin D. Roosevelt,* 1938

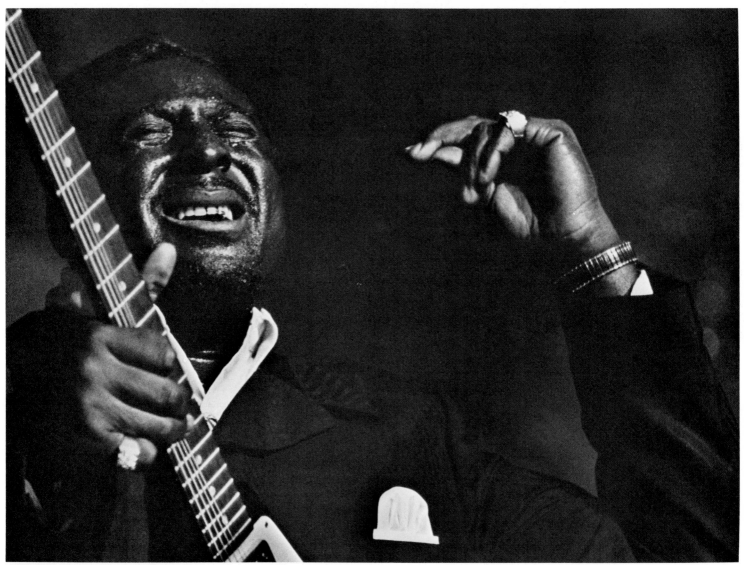

VALERIE WILMER: *Albert King, Odeon Theatre, Hammersmith, London, 1969*

Blues singer Albert King—eyes closed, fingers snapping, vibrating with energy—is caught in a moment of utter communion with his music. Valerie Wilmer made the photograph during a King concert at London's Odeon Theatre as part of an essay on black music and musicians, onstage and off.

At the Greek Theater in Los Angeles, Bette Midler ▶ cranks out a song in the brassy, outrageous style that is her trademark. Martha Hartnett, on assignment for the Los Angeles Times, made the shot under ambient stage lights, using an 85mm lens and Tri-X film, which was pushed to ISO 800/30°

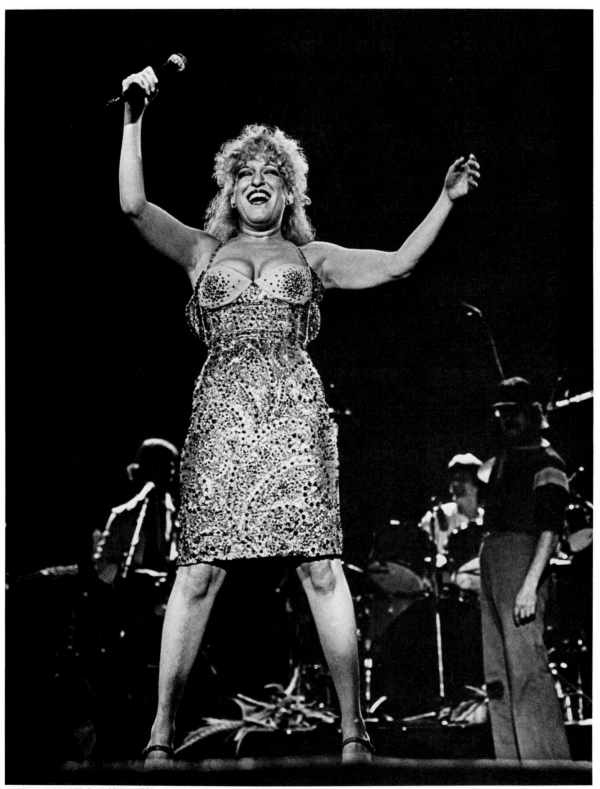

MARTHA HARTNETT: *Bette Midler*, 1979

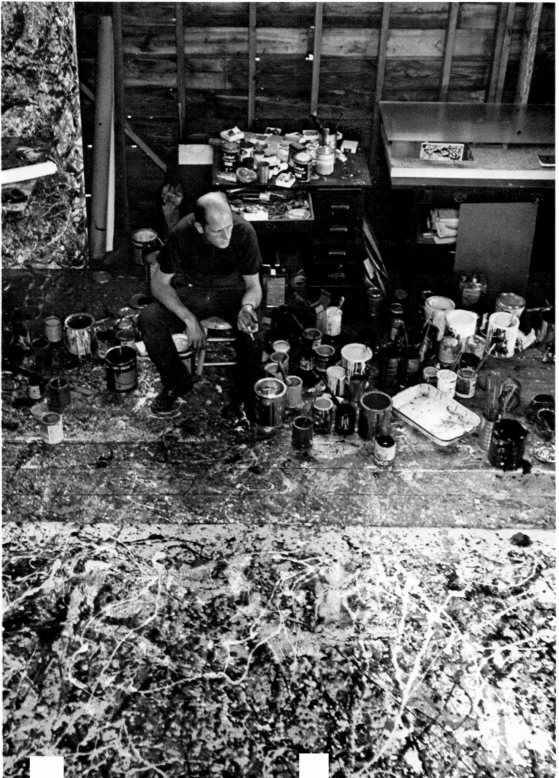

HANS NAMUTH: *Jackson Pollock, East Hampton,* 1950

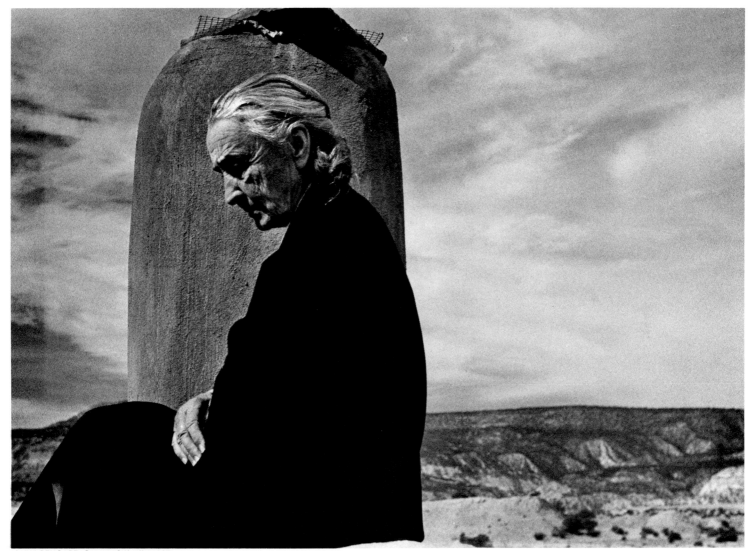

JOHN LOENGARD: *Georgia O'Keeffe, 1967*

◄ *An exhausted Jackson Pollock regards a just-finished canvas on the floor of his Long Island studio. "My most lasting impression of Pollock was his silence," recalled Hans Namuth, who made this portrait and hundreds of others of the artist in the early 1950s. "The feelings that he could not vent in words were expressed in his painting."*

Sere and self-contained as the desert that has been source and subject of her painting for four decades, Georgia O'Keeffe contemplates the view from the roof of her New Mexico ranch. "This is my kind of world," she has said. "I don't need to see many people to live"—an aspect of the artist John Loengard aptly conveyed in this portrait for Life.

This grainy wire-service picture of actors Richard Burton and Elizabeth Taylor conveys the glamor that adheres to the couple despite Taylor's exhausted stare and Burton's frown of annoyance. Taken in 1973 during a brief reunion in their on-again-off-again marriage, the shot was made by an unknown photographer through the window of Burton's departing limousine at Rome's Ciampino Airport.

Life dubbed this photograph of John F. Kennedy Jr. ▶ sprawled on the sidewalk outside a Manhattan nightclub "a classic paparazzo picture." Emerging from a party celebrating his 18th birthday, Kennedy and his friends tangled with photographers lying in wait for him. In the ensuing fight, Kennedy was knocked down, and Richard Corkery of the New York Daily News caught the moment in a skewed shot.

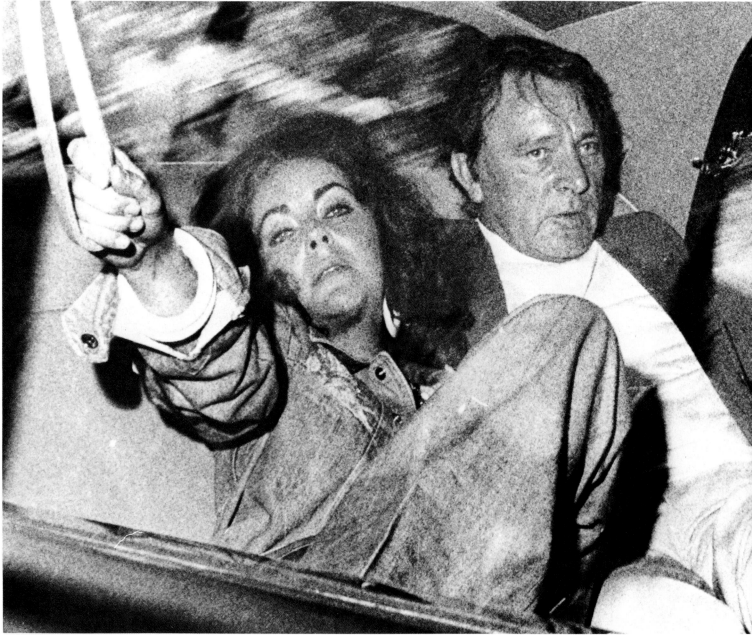

PHOTOGRAPHER UNKNOWN: *Elizabeth Taylor and Richard Burton*, Rome, 1973

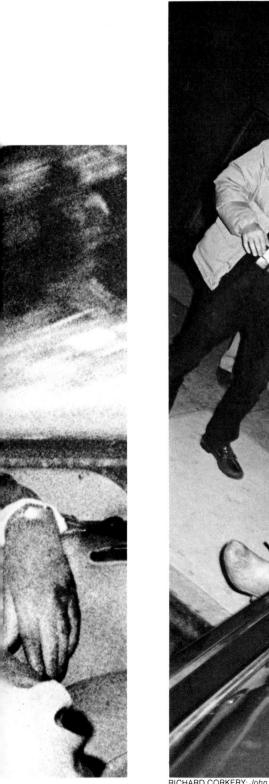
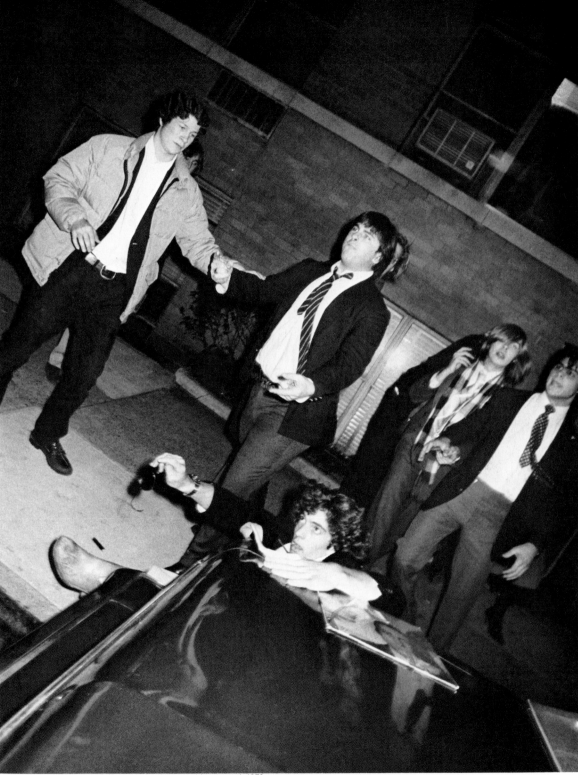

RICHARD CORKERY: *John F. Kennedy Jr. tries to avoid paparazzi,* 1978

Popular ventriloquist Edgar Bergen lifts his cheeky alter ego Charlie McCarthy out of the little dummy's plush-lined travel case in this candid shot by photojournalist Mary Ellen Mark. A friend of Bergen's daughter Candice, Mark took the nostalgic portrait at Bergen's home in Los Angeles about a year before his death and Charlie's retirement to the Smithsonian Institution in Washington, D.C.

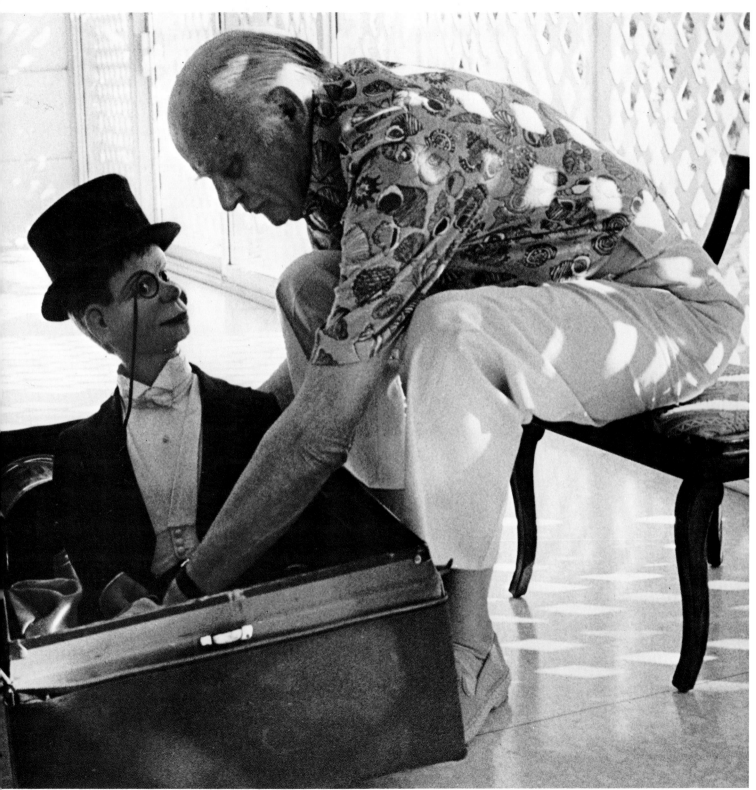

MARY ELLEN MARK: *Edgar Bergen with Charlie McCarthy*, 1977

Poet Robert Penn Warren confronts the world directly — a man who knows exactly who he is and where he stands. Photographer Annie Leibovitz made the portrait at his home in Connecticut as part of a Life photo essay on 11 American poets. "The business of his taking his shirt off is just a metaphor" for the poet's emotional nakedness, Leibovitz said.

Standing in the snow outside his Vermont home, ▶ Russian Nobel laureate Aleksandr Solzhenitsyn, who spent 11 years in confinement before being exiled for his dissident views, clasps his hands to his chest and draws a deep breath of winter. Harry Benson recorded the spontaneous gesture for Life just as Solzhenitsyn remarked, "The air is so free."

ANNIE LEIBOVITZ: *Robert Penn Warren, 1981*

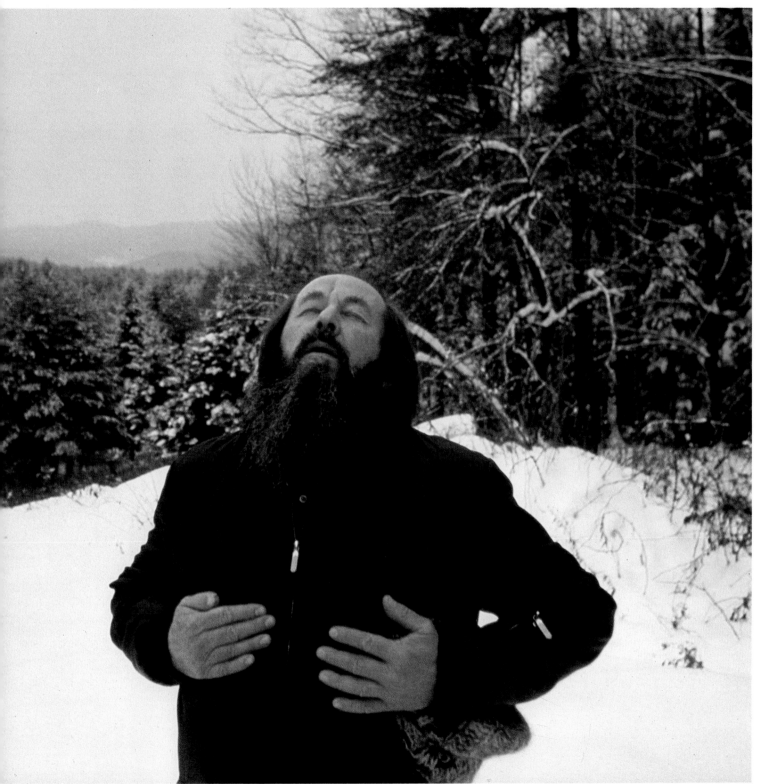

HARRY BENSON: *Aleksandr Solzhenitsyn in exile*, 1981

*Actress Meryl Streep, costumed as the
mysterious Sarah in the movie version of John
Fowles's novel The French Lieutenant's Woman,
finds a private retreat in the branches of a massive
beech. This contemplative portrait, made on
location in Dorset, England, appeared in a Life photo
essay on the highly acclaimed actress.*

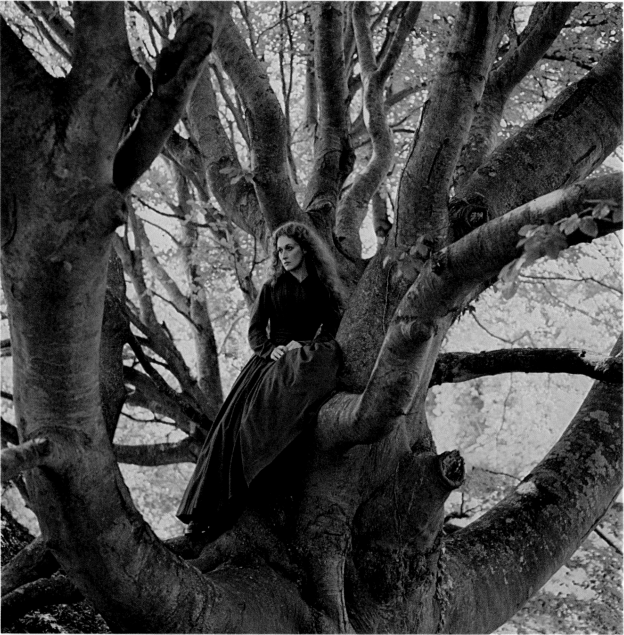

SNOWDON: *Meryl Streep as Sarah in The French Lieutenant's Woman, 1980*

Stories in Pictures **2**

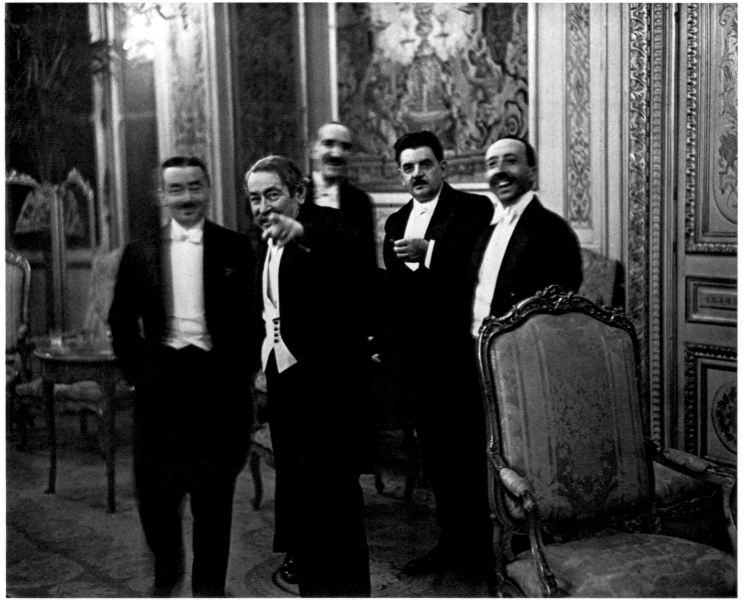

ERICH SALOMON: *The Photojournalist Caught in the Act*, 1931

The Photo Essay: A New Way to Communicate

The photo essay is one of the most complex end products of photography, involving as it does the use of several pictures and the talents of more than one person—an editor in addition to the photographer, and usually a design artist as well. Like everything else in photography, it had to endure a growing-up period that was partly dependent on improvements in cameras and film, partly on a gradual realization of the potential that existed in the form itself.

Creating a photo essay requires the organization of a number of pictures on a single theme so that they give a fuller, more intense view of their subject than any single picture could. The subject can be anything—an idea, a person, an event, a place—and the organization can be either chronological or thematic. The form itself is flexible; what matters is that the pictures work together to enrich the theme.

There is nothing original in telling stories with pictures. This was done on Egyptian tombs and is still being done in comic strips. In photography the wherewithal for making photo essays existed as early as the work of Mathew Brady in the American Civil War, and certainly existed in the more personalized work of photographers like John Thomson in London and Ernst Höltzer in Ottoman Persia, one of whom set out to capture the plight of the poor of his city, the other a record of a vanishing way of life. But not until the 1880s and 1890s, when the development of the halftone *(pages 15-17)* made it possible to reproduce photographs on printing presses, was it realized that the striking images by a Brady or a Höltzer could be used to tell stories or develop large ideas.

At first photographs were used singly and, even when grouped, did not attempt to form a coherent narrative. It was many decades before editors began to fit pictures together in a meaningful way and the photo essay—in a very primitive form—was born. These early efforts, while unimpressive to modern eyes, were wonders of novelty and interest at the time. For readers of *The Illustrated London News* during World War I, the mere presence on a page of a number of photographs of the conflict was fascinating—even though the bulkiness of cameras and the slowness of lenses resulted in pictures that were mostly static shots of soldiers, sometimes posed in camps in England.

In 1925 came another breakthrough, the invention in Germany of small cameras, scarcely larger than today's 35mm, with very fast lenses. This enabled the user to take pictures unobtrusively and under low-light conditons. People were caught off guard, no longer posing for the camera but acting naturally—doing awkward, funny, dangerous, *real* things. Candid photography came into being, and with it, in German picture magazines, the first glimmerings of a true photo essay. It was possible now to photograph the circus in action, to explore in depth the lives of ordinary people, to peep uninvited behind the closed doors of diplomatic conferences, as the pioneering photojournalist Erich Salomon did so often. (He was caught in the act once at a Paris state dinner in 1931

by French Premier Aristide Briand, who pointed an accusing finger and gave Salomon the great picture reproduced on page 91.)

The editor now became an important element, sending photographers off on specific assignments—often with scripts detailing particular shots to make—confident they would come back not just with pictures but with a "story." And it was the editor who shaped that story by deciding which pictures to use and how to use them: large or small; in sequences for dramatic effect or for information; to inspire humor, anger, curiosity, disgust. This set up a great tension between editor and photographer—the one clamoring for better, more exciting, more "sequential" and meaningful pictures, the other moaning that masterpieces were being discarded or subjected to a constricting layout. In a sense, both were right: The layout of the pictures had become nearly as important as the pictures themselves.

It was against this background that *Life* was launched in 1936. In its pages, during the next several decades, the photo essay came into its finest flowering. The tension became more productive. Editor prodded photographer. Photographer responded by probing more deeply and more imaginatively into the subject at hand. *Life,* and other magazines that followed it, took maximum advantage of every technique in printing, photography and design to exploit their large page size.

Today the photo essay is thriving—and not just in picture magazines. By the mid-1970s, daily and weekly newspapers in several regions of the United States were running photographs that often approached the quality of those in the large-format picture magazines: dramatic without being sensational, concerned with the human consequences of an event rather than focused only on the instant of action. This bold new movement in newspaper photojournalism was sparked by Rich Clarkson, director of photography of the *Topeka Capital-Journal* from 1958 to 1981. Clarkson instituted a program of on-the-job training for photographers, in which novices and pros alike would absorb his people-oriented doctrine for a three-month period while covering a regular beat. As the movement spread, newspapers began to run pictorial special reports, often featuring the photo essays in a separate section of the paper, with a lead-in photograph on the front page. These sensitive and perceptive photographs continue to be produced by men and women who, as one Clarkson protégé put it, are not "walking cameras, but thinking cameramen." □

A Crude Beginning in Grouped Pictures

But for the problem of printing, both of the 19th Century's pioneer war photographers, Mathew Brady and Roger Fenton, could have seen their work published in magazines, since each had a distinguished large-format periodical already in being to contribute to: *Harper's Weekly* in America, and *The Illustrated London News* in England. Both journals used pictures, and they would have printed photographs if they could. Instead, the photographs had to be converted to woodcuts.

When World War I broke out, the halftone process was already well developed and picture journals became voracious consumers of photographs. But the pictures were generally staged, like the one at right of a Tommy in a gas mask, which *The Illustrated London News* ran on its cover.

Photographs such as this, while they conveyed the atmosphere of war, could not capture the action; that would have to wait for faster, smaller cameras. Still, editors did the best they could, assembling spreads like the one at far right, which, with its jumble of crowds, marching troops and people waving from the tops of buses, does give an idea of the tumult of Armistice Day in London in 1918. But that is all it does. No attempt is made to tell a complete story or to emphasize a particularly good picture. All are the same size, arbitrarily arranged in an overall design that calls attention to itself, rather than to the development of any story line inherent in the pictures.

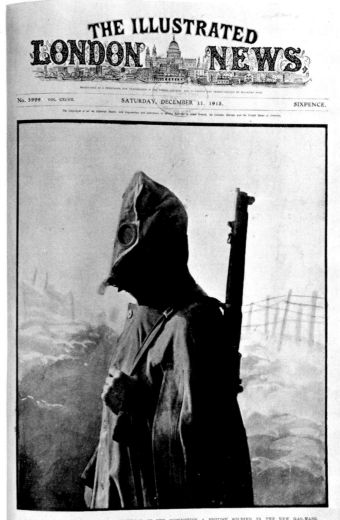

THE MODERN MAN-AT-ARMS: LIKE A FAMILIAR OF THE INQUISITION—A BRITISH SOLDIER IN THE NEW GAS-MASK.

ARMISTICE DAY IN LONDON: STREET SCENES ON NOVEMBER 11 DURING THE CELEBRATION OF THE ALLIES' VICTORY.

PHOTOGRAPHS BY TOPICAL, FARRINGDON PHOTO. COMPANY, ILLUSTRATIONS BUREAU, I.N.A., C.N., AND S. AND G.

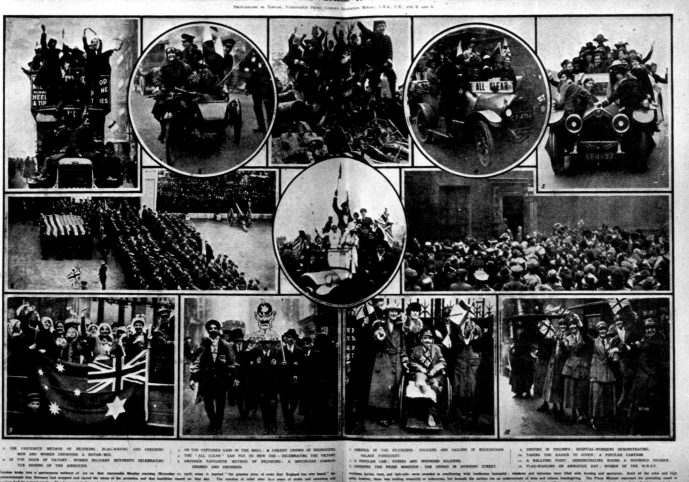

1. THE FAVOURITE METHOD OF REJOICING : FLAG-WAVING AND CHEERING 3. ON THE CAPTURED GUNS IN THE MALL : A CHEERY CROWD OF YOUNGSTERS. 7. AMERICA IN THE REJOICINGS : SOLDIERS AND SAILORS IN BUCKINGHAM 9. DRIVING IN TRIUMPH : HOSPITAL-WORKERS DEMONSTRATING.
 MEN AND WOMEN CROWDING A MOTOR-'BUS. 6. THE " ALL CLEAR " CAR PUT TO NEW USE :- CELEBRATING THE VICTORY. PALACE FORECOURT. 10. TAKING THE KAISER TO COVER : A POPULAR CARTOON.
2. IN THE HOUR OF VICTORY : WOMEN MILITARY MOTORISTS CELEBRATING 5. ANOTHER FAVOURITE METHOD OF REJOICING : A MOTOR-CAR COMMAN- 3. A POPULAR CAR : NURSES AND WOUNDED SOLDIERS. 11. A RALLYING POINT DEMONSTRATING ROUND A WOUNDED SOLDIER.
 THE SIGNING OF THE ARMISTICE. DEERED AND CROWDED. 8. CHEERING THE PRIME MINISTER : THE CROWD IN DOWNING STREET. 12. FLAG-WAGGING ON ARMISTICE DAY : WOMEN OF THE W.R.A.F.

London broke into a spontaneous outburst of joy on that memorable Monday morning (November 11, 1918) when it learned " the greatest piece of news that England has ever heard." The announcement that Germany had accepted and signed the terms of the armistice, and that hostilities ceased on that day. The reaction of relief after four years of strain and mourning and waiting had its natural result. The long-pent feelings of a people which, throughout the war, had never indulged in jubilations over incidental successes, found expression at last in the hour of final triumph. London quickly became the scene of an improvised carnival. Happy crowds thronged the streets cheering, singing, waving and wearing innumerable flags. Vehicles of all sorts— omnibuses, lorries, vans, and taxi-cabs—were crowded to overflowing with vociferous humanity ; windows and balconies were filled with bunting and spectators. Amid all the noise and high spirits, however, there was nothing unseemly or indecorous, but beneath the surface ran an undercurrent of deep and solemn thanksgiving. The Prime Minister expressed the prevailing mood in the few words he spoke to the crowd from his windows in Downing Street. " You are entitled to rejoice," he said. " The people of this country and the people of the Dominions and of our Allies have won a victory for freedom as the world has never seen. You have all had a share in it. Sons and daughters of the people have done it, and this is their hour for rejoicing."

Fast Cameras Make the Essay Possible

The new candid cameras, the Ermanox and the more convenient Leica that was developed a short time afterward, were both products of the German camera industry, and their impact was first felt in German picture magazines, notably the *Münchner Illustrierte Presse* (Munich Illustrated Press). Its editor, a Hungarian-born innovator named Stefan Lorant, seized on the opportunity of the new action pictures produced by the new cameras to convey to his readers a sense of that action—of being there. He also took some bold steps in the direction of further enhancing the effectiveness of these pictures by skillful contrasts in size, mood and organization in their layout on two facing pages, the unit of design that has become basic to all illustrated journalism. His spread on a circus *(above),* made in 1929, shows these forces crudely at work. A candid shot of the people in the crowd straining their necks at high-wire performers pulls the reader into the scene, while more action is detailed in the strip at left. Slower cameras simply could not have produced such pictures, nor given Lorant the chance to use them boldly to tell his sharply realized little stories.

In contrast to the circus spread of the preceding page, here are different pictures and an entirely different mood, but once again a deliberate attempt has been made to organize photographs into something more than just a collection of snapshots. These men are all members of the German Reichstag, shot off guard, cupping their ears, looking bored, exhausted—in short, public figures as they really were, but as they had never before been seen by the public. The magazine is once again the *Münchner Illustrierte Presse*, the year is 1929, the editor is again Stefan Lorant. His layout is jagged and ugly, deliberately so in an effort to intensify the mood he was after: a sense of being right there in the chamber, hit by all the crosscurrents of disputation, thought, personality and prejudice that confuse men trying to run a country. Both these spreads show an advance over *The Illustrated London News* example. Each has taken the bold step of using pictures, not merely in patterns, but in ways calculated to enhance the special quality of the pictures themselves. This step was fundamental to the further development of the photo essay.

Penetrating the Strongholds of the Great

After a stretch in a Nazi concentration camp, Lorant slipped out of Germany in 1934 and made his way to England, where he further refined his techniques in the London *Weekly Illustrated*. In the company of the photographer Felix Man, he had called on Mussolini three years earlier and obtained a series of exclusive pictures of Il Duce in his private offices. (Lorant is the figure, back to camera, talking to the dictator by the fireplace at right above.) The pictures had been published in the *Münchner Illustrierte Presse;* now Lorant presented them to the English-reading public, providing an actual behind-the-scenes visit to the notorious dictator about whose personality and life style the entire world was curious. Both are swiftly captured in the pictures Lorant selected: in the awesome decor of his working quarters, and in the close-in head shots of the man at work. With a story as powerful as this one, Lorant very properly used a much more sober layout style than he had used in the two examples previously shown.

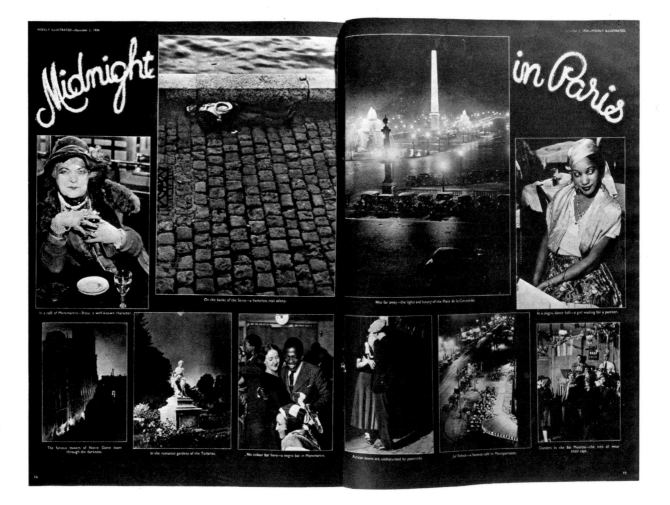

Still experimenting and still developing, Lorant assembled this montage for the London *Weekly Illustrated* in 1934. By employing an overall dark background he strengthened the mood of his story and was able to hold its various bits together better than he had in his circus spread *(page 96),* even though its elements are more varied and the layout more difficult. The spread was extracted from the book *Paris de Nuit,* published one year earlier by the Hungarian-born photographer Brassaï. His sensitive eye roamed from monument to entertainer, from aging tart to cobbled gutter, as he built up, picture by picture, enough pieces to tell a small evocative story about a single place. □

The Photo Essay Comes of Age

The photojournalistic techniques pioneered by Stefan Lorant galvanized the American publishers, particularly when, during the 1930s, some of the best German photographers Lorant had been using came to the United States to avoid persecution by Hitler. The times were right for the launching of an American picture magazine, and by the middle of the decade groups of editors in several companies were hard at work preparing dummies. In 1936 one such group wrote the most famous declaration of intent that has ever been articulated for a magazine:

"To see life; to see the world; to eyewitness great events; to watch the faces of the poor and the gestures of the proud; to see strange things — machines, armies, multitudes, shadows in the jungle and on the moon; to see man's work — his paintings, towers and discoveries; to see things thousands of miles away, things hidden behind walls and within rooms, things dangerous to come to; the women that men love and many children; to see and take pleasure in seeing; to see and be amazed; to see and be instructed."

This was the manifesto for *Life*, whose first issue was on the stands in November 1936. Its success surprised even its editors. Within months it was followed by *Look, See, Photo, Picture, Focus, Pic* and *Click*, to name some that tried to ride the huge but uneasy breaker of pictorial journalism. Only *Life* and *Look* survived.

For its first cover *Life* assigned Margaret Bourke-White, then known chiefly as an architectural photographer, to make a picture of the Fort Peck Dam, which was being built in Montana. She made her cover *(right)*, but she also stayed on to record something else. Around Fort Peck had sprung up a cluster of shanty settlements with their false fronts and dusty rutted streets, their tough migrant workers and scruffy taxi dancers thronging the bars on Saturday nights. Here was something that Americans had not seen for many years — a glimpse of the frontier suddenly reopened. The *Life* editor in charge, John Shaw Billings, spotted the potential in Bourke-White's pictures — the "take," in photojournalists' jargon. And in that first issue of *Life* he laid out the first photo essay in the form known today — organizing several subelements within an overall theme. He emerged not with a small group of pictures but with nine pages of them, shaped into a coherent picture story. The first page of the essay is at far right; two other spreads are shown on pages 102-103.

In the years that followed, *Life* delivered on all of the promises listed in its manifesto — including pictures of shadows taken on the moon — and in the process developed the photo essay to limits undreamed of by its pioneers.

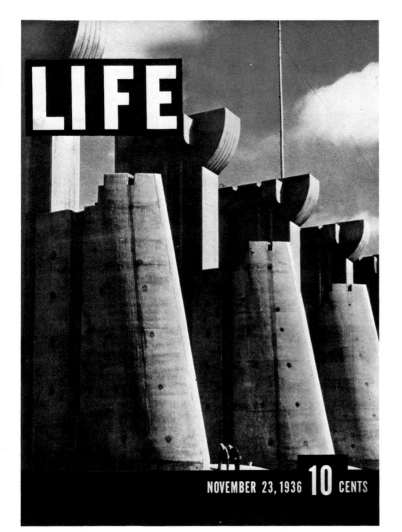

NOVEMBER 23, 1936 **10** CENTS

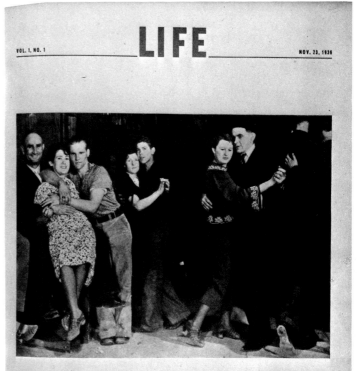

10,000 MONTANA RELIEF WORKERS MAKE WHOOPEE ON SATURDAY NIGHT

The frontier has returned to the cow country. But not with cows. In the shanty towns which have grown up around the great U. S. work-relief project at Fort Peck, Montana, there are neither long-horns nor lariats. But there is about everything else the West once knew with the exception of the two-gun shootings; the bad men of the shanty towns are the modern gangster type of gun-waver. The saloons are as wide open as the old Bull's Head at Abilene. The drinks are as raw as they ever were at Uncle Ben Dowell's. If the hombres aren't as tough as Billy the Kid they are

tough enough—particularly on pay day. Even the dancing has the old Cheyenne flavor. These taxi-dancers with the chuffed and dusty shoes lope around with their fares in something half way between the old barroom stomp and the lackadaisical stroll of the college boys at Roseland. They will lope all night for a nickel a number. Pay is on the rebate system. The fare buys his lady a five cent beer for a dime. She drinks the beer and the management refunds the nickel. If she can hold sixty beers she makes three dollars—and frequently she does.

THE NEW WEST'S NEW HOTSPOT IS A TOWN CALLED "NEW DEAL"

THE COW TOWNS THAT GET THEIR MILK FROM KEGS

A relief project started the new Wild West. But you don't need a government loan to build a house there. For $2 a month you can rent a fifty foot lot in Wheeler from Joe Frazier, the barber over in Glasgow, 20 miles away. Joe had the fool luck to homestead the worthless land on which shanty towns have sprouted. You then haul in a load of grocer's boxes, tin cans, crazy doors and building paper and knock your shack together. That will set you back $40 to $75 more. You then try to live in it in weather which can hit minus 50° one way and plus 110° the other.

Water in the cities of the new Wild West comes from wells, many of them shallow, some condemned—and at that it may cost you a cent a gallon. Sewage disposal is by the Chic Sale system. Compulsory typhoid inoculation is non-existent. Fires are frequent—Wheeler has had 40 more or less this year. Nevertheless the workers here refuse to move to the Army's sanitary barracks. Life in barracks is too expensive; life in the shanty towns too gay. When the Army tried compulsion they wrote to Montana's Senator Wheeler for whom their metropolis was named. They won.

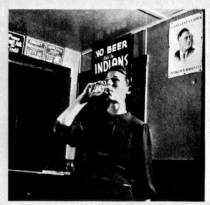

UNCLE SAM TAKES CARE OF THE INDIANS: THE LITTLE LADY, HERSELF.

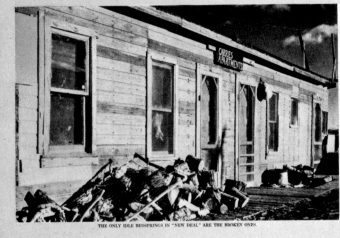

THE ONLY IDLE BEDSPRINGS IN "NEW DEAL" ARE THE BROKEN ONES.

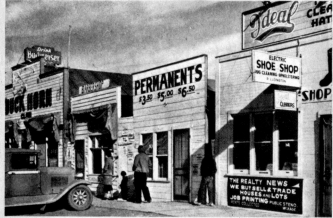

LIFE IN THE COWLESS COW TOWNS IS LUSH BUT NOT CHEAP.

12 LIFE

Nov. 23rd 13

THE pioneer mother can trek in broken-down Fords as well as in covered wagons. And she can crack her hands in the alkali water of 1936 as quickly as in the alkali water of 1849. When the Fort Peck project opened in 1933 the roads of Montana began to rattle with second-hand cars full of children, chairs, mattresses and tired women. Most of them kept right on rattling toward some other hopeless hope. Some of them parked in the shanty towns around Fort Peck. There, their women passengers got jobs like Mrs. Nelson (*right*) who washes New Deal without running water, or tried their feet at taxi-dancing like the girls on the preceding pages, or made money like Ruby Smith on page 15, or gave birth to children in zero weather in a crowded 8 by 16-foot shack like many an unnamed woman of New Deal and Wheeler. The girl at the bar (*above*) who works as a waitress ("hasher") takes her child to work with her because she can't leave her at home. She sits on the bar while her mother kids with the customers. The group on the right, it will be noticed, resembles a statue recently erected to the Pioneer Mother of the old frontier. No statues are expected at New Deal.

MONTANA SATURDAY NIGHTS: FINIS

For the First Time: War as It Really Is

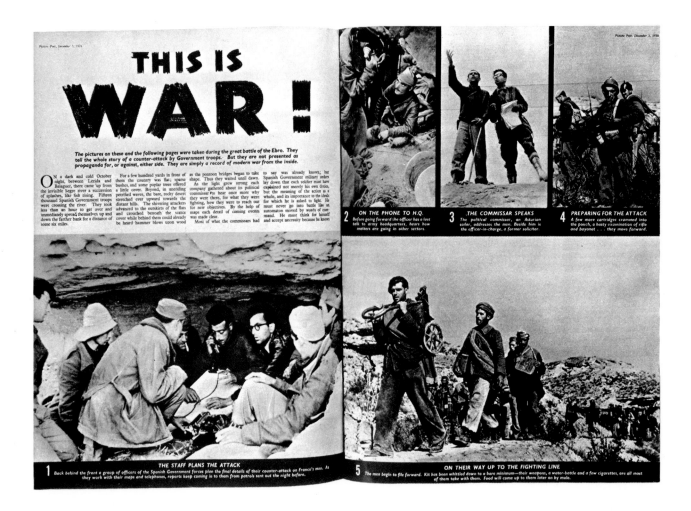

THIS IS WAR !

The pictures on these and the following pages were taken during the great battle of the Ebro. They tell the whole story of a counter-attack by Government troops. But they are not presented as propaganda for, or against, either side. They are simply a record of modern war from the inside.

ON a dark and cold October night, between Lerida and Balaguer, there came up from the invisible Segre river a succession of splashes, like fish rising. Fifteen thousand Spanish Government troops were crossing the river. They took less than an hour to get over and immediately spread themselves up and down the farther bank for a distance of some six miles.

For a few hundred yards in front of them the country was flat; sparse bushes, and some poplar trees offered a little cover. Beyond, in unending petrified waves, the bare, rocky desert stretched ever upward towards the distant hills. The shivering attackers advanced to the outskirts of the flats and crouched beneath the scarce cover while behind them could already be heard hammer blows upon wood

as the pontoon bridges began to take shape. Thus they waited until dawn.

As the light grew strong each company gathered about its political commissar to hear once more why they were there, for what they were fighting, how they were to reach out for new objectives. By the help of maps each detail of coming events was made clear.

Most of what the commissars had

to say was already known; but Spanish Government military orders lay down that each soldier must have explained not merely his own duties, but the meaning of the action as a whole, and its importance to the ideals for which he is asked to fight. He must never go into battle like an automaton moved by words of command. He must think for himself and accept necessity because he knows

2 ON THE PHONE TO H.Q.
Before going forward the officer has a last talk to army headquarters, hears how matters are going in other sectors.

3 THE COMMISSAR SPEAKS
The political commissar, an Asturian sailor, addresses the men. Beside him is the officer-in-charge, a former solicitor.

4 PREPARING FOR THE ATTACK
A few more cartridges crammed into the pouch, a hasty examination of rifle and bayonet . . . they move forward.

1 THE STAFF PLANS THE ATTACK
Back behind the front a group of officers of the Spanish Government forces plan the final details of their counter-attack on Franco's men. As they work with their maps and telephones, reports keep coming in to them from patrols sent out the night before.

5 ON THEIR WAY UP TO THE FIGHTING LINE
The men begin to file forward. Kit has been whittled down to a bare minimum—their weapons, a water-bottle and a few cigarettes, are all most of them take with them. Food will come up to them later on by mule.

The birth of new picture magazines was not limited to America. In 1938 *Picture Post* made its debut in London. Its editor: Stefan Lorant. One of the first things Lorant did was to assign a young Hungarian, Robert Capa, to cover the War in Spain. Capa proved to be a superb photojournalist. He had a great photographic eye, enormous personal daring and a tough, swaggering panache. He

spent these recklessly, covering five wars and becoming a photojournalistic legend during his short life.

All that Capa would become is discernible in his first Spanish War take, part of which is shown here—a counterattack by government troops along the Ebro River in the fall of 1938. it is light-years away from the World War I spread shown on pages 94-95. To begin

with, it tells a story, each picture numbered to make sure that the reader follows its thread. It opens almost like a play, with a briefing in a dugout. The men are not posing for the photographer; they are oblivious of him, too busy to notice him, their faces strained by anxiety and fatigue. The action now speedily builds up: The commander makes a speech to his men, weapons

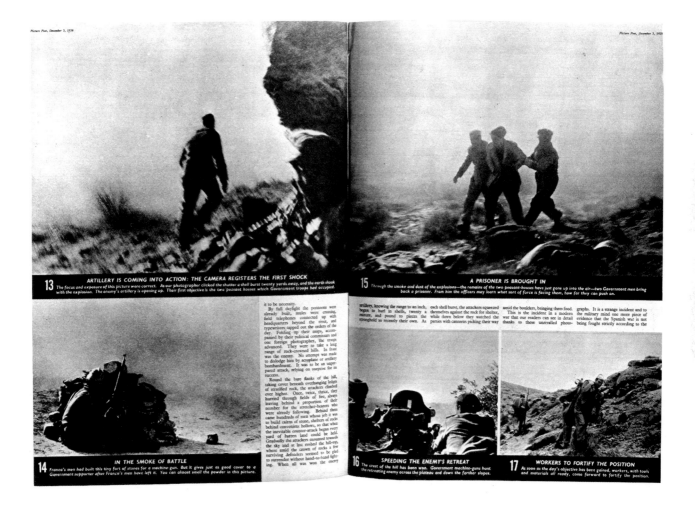

13 ARTILLERY IS COMING INTO ACTION: THE CAMERA REGISTERS THE FIRST SHOCK
The focus and exposure of this picture were correct. As our photographer clicked the shutter a shell burst twenty yards away, and the earth shook with the explosion. The enemy's artillery is opening up. Their first objective is the two peasant houses which Government troops had occupied.

15 A PRISONER IS BROUGHT IN
Through the smoke and dust of the explosions—the remains of the two peasant-houses have just gone up into the air—two Government men bring back a prisoner. From him the officers may learn what sort of force is facing them, how far they can push on.

it to be necessary.

By full daylight the pontoons were already built, mules were crossing, field telephones connected up with headquarters beyond the river, and typewriters tapped out the orders of the day. Folding up their maps, accompanied by their political commissars and one foreign photographer, the troops advanced. They were to take a long range of rock-crowned hills. In front was the enemy. No attempt was made to dislodge him by aeroplane or artillery bombardment. It was to be an unprepared attack, relying on surprise for its success.

Round the bare flanks of the hill, taking cover beneath overhanging ledges of stratified rock, the attackers climbed ever higher. Once, twice, thrice, they hurried through fields of fire, always leaving behind a proportion of their number for the stretcher-bearers who were already following. Behind them came hundreds of men whose job it was to build cairns of stone, shelters of rock behind convenient hollows, so that when the inevitable counter-attack began every yard of barren land could be held. Gradually the attackers mounted towards the sky and at last reached the hill-top, where amid the crown of rocks a few surviving defenders seemed to be glad to surrender without hand-to-hand fighting. When all was won the enemy

artillery, knowing the range to an inch, began to hurl in shells, twenty a minute, and pound to pieces the stronghold so recently their own. As

each shell burst, the attackers squeezed themselves against the rock for shelter, while down below they watched the parties with canteens picking their way

amid the boulders, bringing them food.

This is the incident in a modern war that our readers can see in detail thanks to these unrivalled photo-

graphs. It is a strange incident and to the military mind one more piece of evidence that the Spanish war is not being fought strictly according to the

14 IN THE SMOKE OF BATTLE
Franco's men had built this tiny fort of stones for a machine-gun. But it gives just as good cover to a Government supporter after Franco's men have left it. You can almost smell the powder in this picture.

16 SPEEDING THE ENEMY'S RETREAT
The crest of the hill has been won. Government machine-guns hunt the retreating enemy across the plateau and down the farther slopes.

17 WORKERS TO FORTIFY THE POSITION
As soon as the day's objective has been gained, workers, with tools and materials all ready, come forward to fortify the position.

are lugged into position, and actual fighting starts. Capa is there in the center of it all, catching the jar of an exploding shell, the stumbling rush of a prisoner being led to the rear, the dust, the confusion.

"If your pictures aren't good enough, you aren't close enough," Capa once said. This was war photography of a new kind, to be practiced by other pho-

tographers with increasing grimness and vividness in all the wars that followed. Capa himself continued to get close, swimming ashore with the first assault wave of American troops in Normandy on D-Day and making unforgettable pictures for *Life* of men struggling and dying in the water. Predictably, his own life was ended by a land mine in Indochina in 1954.

An Ordinary Life Examined in Depth

Many photographers honed their talents on the whetstone of World War II. One of the youngest and ablest of them was Leonard McCombe, an Englishman who became a member of the *Life* staff in 1945 at the age of 22. He had already been working as a professional photographer for four years.

McCombe's association with *Life* proved to be pivotal for the photo essay. With the War over, there was an intense desire on the part of everybody to return to the plain business of living and a corresponding demand for picture stories about just plain people. McCombe's special skill lay in his ability to involve himself closely with such people *(pages 133-152)*, sticking with them round the clock, photographing everything they did—until finally they ceased to be aware of his presence and began laying bare all the turmoil, the strains and joys, the bitter moments and the tender ones that go to make up any life. His photo essay on Gwyned Filling, a young woman trying to make a start on an advertising career in New York City, is an acknowledged masterpiece in this genre.

When McCombe and *Life* editor Joseph J. Thorndike got through with the budding career woman, there was nothing about her and her life in New York that readers did not feel they knew. After 12 pages of intimate pictures Gwyned Filling was as vividly real as a sister, a daughter or a wife.

GWYNED FILLING, ALONE IN A CROWD THAT HAS GATHERED TO WATCH A FIRE IN THE CITY, STANDS ON TIPTOE AND TILTS BACK HER HEAD TO GET A BETTER VIEW

THE PRIVATE LIFE OF
Gwyned Filling
THE HOPES AND FEARS OF COUNTLESS YOUNG CAREER GIRLS ARE SUMMED UP IN HER STRUGGLE TO SUCCEED IN NEW YORK

PHOTOGRAPHS FOR LIFE BY LEONARD McCOMBE

In the spring of 1925 in St. Charles, Mo., a housewife named Mildred Filling picked up a newspaper and saw in the society column an odd first name: Gwyned. Because Mrs. Filling was about to have a child, this solved the christening problem, and it now accounts for the fact that an attractive 23-year-old girl alone among the crowds of New York would stop and turn if that odd name were spoken.

Gwyned Filling came to New York last June to begin a career. Because she wanted to feel independent she had borrowed $250 from a local bank rather than from her father, a former city official. She had a large ambition and some training, having just completed a course in advertising at the University of Missouri. With her came her college roommate, Marilyn Johnson, who had taken the same course. For five weeks they looked unsuccessfully for jobs, during which Gwyned's $250 shriveled to $30. But finally she walked down the right street, took the right elevator and entered the offices of Newell-Emmett Co., a large advertising agency which handles the account for Chesterfield cigarets. Gwyned was hired for $35 a week, which disappears quickly in New York.

Because she had already worked her way through college and had learned to make her clothes and to eat breakfast for 15¢, Gwyned got along. With Marilyn, she found an 11x15-foot furnished room in an apartment building on 23rd Street. Although they could scarcely afford the stiff $75-a-month rent, they could find nothing cheaper. Gwyned soon made office friends, including several young men who began to take her out to dinner regularly enough to subtract about $4 a week from her living expenses. An older couple turned over their apartment, empty on weekends, to both girls. This saves no money, but it is a release from the drab clutter of their single room.

After six months Gwyned's salary was raised to $52 a week. She commenced, under careful supervision, to write fragments of advertising copy. She also began to repay, at the rate of $21.93 a month, her borrowed $250. Gwyned's life is interesting and often gay, but beneath the gaiety lie the problems which confront all career girls. How much of her time and nerves must she sacrifice for success? When should she marry, and will she jeopardize her chance by trying to close her eyes to everything but her career? Gwyned has no ready answer, but even as she works she knows she must find one.

CONTINUED ON NEXT PAGE 103

HER DAY BEGINS WITH A FRANTIC RACE AGAINST THE CLOCK

Gwyned has two alarm clocks. Both of them are broken, and thus at 7:30 she is roused by her landlady, Mrs. Bell. Even after 10 months in New York, Gwyned is still occasionally surprised to wake and find herself far from home in a small room and glances hastily across at Marilyn to make certain her friend is there.

Marilyn and Gwyned take their morning baths hurriedly according to a strict rotation schedule, each having the tub first on alternate days. The other placidly waits her turn and reads aloud inconsequential items from the St. Charles Cosmos-Monitor, which is mailed to them daily and remains a firm link with home.

Breakfast is eaten hastily in a restaurant across the street. The 15¢ meal consists of two slices of toast and a cup of coffee. Gladys Hallem, the counter girl, invariably greets Gwyned with, "How are things in St. Charles, Mo. today, baby?" and then gets the girls' food quickly because she already knows what they will order.

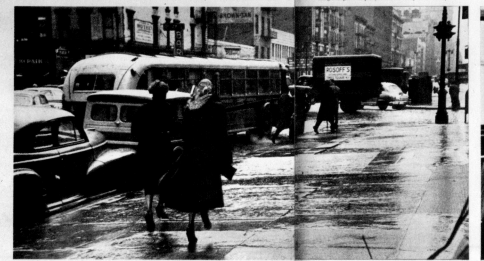

After breakfast the girls race for the bus, which takes them eastward along 23rd Street to Fourth Avenue. Sometimes, when Gwyned is in an economical mood, either by choice or circumstance, she rises half an hour early and walks—or trots —17 blocks to the office, a distance of about a mile. The terrible aimless urgency for speed, which affects all of New York, has already taken hold of Gwyned and Marilyn. Even though another bus will be along within two minutes, the girls scramble down the rain-soaked street, splattering their shoes and stockings with water and grime, in order to make sure they will not be left behind by this one.

When she reaches the office at 9, after her frantic dash to get there on time, Gwyned must often wait patiently until her boss has time to see her. Waiting with her is George Flanagan, a copy supervisor who occasionally supplies reassurance about her work while she musters up courage to show it to her department head.

CONTINUED ON NEXT PAGE

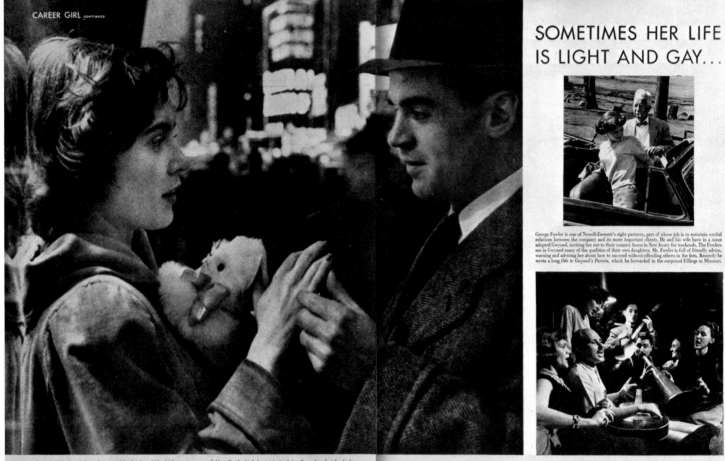

CAREER GIRL CONTINUED

SOMETIMES HER LIFE IS LIGHT AND GAY...

George Fowler is one of Newell-Emmett's eight partners, part of whose job is to maintain cordial relations between the company and its more important clients. He and his wife have in a sense adopted Gwyned, inviting her out to their country home in New Jersey for weekends. The Fowlers see in Gwyned many of the qualities of their own daughters. Mr. Fowler is full of friendly advice, warning and advising her about how to succeed without offending others in the firm. Recently he wrote a long *Ode to Gwyned's Parents*, which he forwarded to the surprised Fillings in Missouri.

One of the brightest spots in Gwyned's New York life is her relationship with Pierre (*second from left*) and Betty Duquesne (*p. 106*), whose large walk-up apartment she occupies on weekends while they are out of town. At the Duquesnes' frequent parties Gwyned is vivacious and carefree among people she might otherwise never encounter: artists and illustrators, musicians and writers. For a few hours she is able to forget the tension of the office and the urgency of her career—there will be time to worry about it in the morning. She laughs easily and adjusts readily to new groups.

Gwyned at 23 has been in love only once, and then briefly—a high-school engagement was quietly called off when she and her fiancé changed their minds. In New York she meets a number of young men who are attracted to her. She has two office acquaintances—Carl Nichols (*above*) and Charles Straus (*p. 112*)—who are handicapped by the fact that they are in professional competition with her. Also, she has made many sacrifices to begin her career and has accordingly surrounded herself with a kind of protective insulation. Even when she is lonely she insists that she wants to work for at least five more years. One evening with Carl she saw a small stuffed cat in a store window. It was a charming toy, Carl bought it for her. Now she is very fond of it and keeps it in her room and silly picks it up and pets it from time to time. She remembers that evening not so much because of what Carl said or how he looked, but because it was the night she acquired the cat.

CONTINUED ON NEXT PAGE

. . . AND
SOMETIMES
SHE CRIES

Gwyned's favorite beau is Charles Straus, with whom she becomes more moody than with others. Charlie is shy and quiet but shows flashes of wit which Gwyned likes and is extremely capable in his copywriting job. Often he quotes long random passages of verse and laughs at Gwyned when she tries and fails to identify them. However, his shyness sometimes irritates her. Despite her wariness of emotional entanglements at this early stage in her career, she occasionally feels a need for masculine reassurance and sympathy. Idly she touches his wrist with her finger while Charlie talks of something far away.

Gwyned has a deep curiosity about New Yorkers and how they behave. Walking about the city she stops when she comes upon one of the street rallies which go on daily. Here she attends a Zionist demonstration, listening with attention because anti-Semitism and Palestine are major topics among her friends.

Gwyned's boyfriends sometimes get a sly going-over at morning gossip sessions in the office. Another subject which is brought up around the coffeepot, presided over by Gwyned's office mate Margery Paddock (*left*), is Gwyned's quick rise from $35 to $52 a week. "You've been here 10 months, Gwyned? Strange, it seems much less. Now, that intelligent, talented Miss Jones down the hall . . . she's been here over two years, and I wonder when they'll give *her* a chance to write some copy. . . ." The gossip does not much disturb Gwyned, who has long since learned to take it as an inevitable by-product of office competition.

After a telephone squabble with Charlie, Gwyned bursts into tears on Marilyn's shoulder. The events which lead up to one of these rare outbursts are as a rule inconsequential. Gwyned is under continual strain because she is anxious to make a success of her career. Tears might be caused merely by the shattering of a tumbler or a cigaret burn on a new dress. In this case it was the simple and harmless vagueness of Charlie Straus. For some time it had been his habit to take her out only on weekends. Therefore she looked forward to such times. On Saturday morning he telephoned but mentioned nothing of his plans for the evening. Later another friend called her, and in annoyance she accepted his invitation to dinner. When Charlie at length telephoned again, this time with a definite plan, it was too late. Gwyned, weeping on Marilyn's shoulder, said she would never speak to him again. She spoke to him again bright and early on Monday morning in the office.

CONTINUED ON NEXT PAGE

The Classic Essay

One of the most brilliant war photographers was the moody young genius W. Eugene Smith, who covered the conflict in the Pacific for *Life* and returned home with much of his face shattered by shellfire. In time he was well enough to work again, and he began turning out picture essays that, for their intensity and photographic beauty, are still unsurpassed.

The mood of "Spanish Village," shot in 1951 and shown here in its entirety, is totally different from McCombe's story on Gwyned Filling. One concentrates on an individual, the other one on life itself. Smith's villagers, in these extraordinary pictures, are clearly individuals, yet they are more than that; they stand for all of mankind—ground down clean and pure and recognizable as archetypes of us all.

120

ON THE OUTSKIRTS

At midmorning the sun beats down on clustered stone houses. In the distance is belfry of Deleitosa's church.

Spanish Village
T LIVES IN ANCIENT POVERTY AND FAITH

The village of Deleitosa, a place of about 2,300 peasant people, sits on the high, dry, western Spanish tableland called Estremadura, about halfway between Madrid and the border of Portugal. Its name means "delightful," which it no longer is, and its origins are obscure, though they may go back a thousand years to Spain's Moorish period. In any event it is very old and LIFE Photographer Eugene Smith, wandering off the main road into the village, found that its ways had advanced little since medieval times.

Many Deleitosans have never seen a railroad because the nearest one is 25 miles away. The Madrid-Sevilla highway passes Deleitosa seven miles to the north, so almost the only automobiles it sees are a dilapidated sedan and an old station wagon, for hire at prices few villagers can afford. Mail comes in by burro. The nearest telephone is 12½ miles away in another town. Deleitosa's water system still consists of the sort of aqueducts and open wells from which villagers have drawn their water for centuries. Except for the local doctor's portable tin bathtub there is no trace of any modern sanitation, and the streets smell strongly of the villagers' donkeys and pigs.

There are a few signs of the encroachment of the 20th Century in Deleitosa. In the city hall, which is run by political subordinates of the provincial governor, one typewriter clatters. A handful of villagers, including the mayor, own their own small radio sets. About half of the 800 homes of the village are dimly lighted after dark by weak electric-light bulbs which dangle from ancient ceilings. And a small movie theater, which shows some American films, sits among the sprinkling of little shops near the main square. But the village scene is dominated now as always by the high, brown structure of the 16th Century church, the center of society in Catholic Deleitosa. And the lives of the villagers are dominated as always by the bare and brutal problems of subsistence. For Deleitosa, barren of history, unfavored by nature, reduced by wars, lives in poverty—a poverty shared by nearly all and relieved only by the seasonal work of the soil, and the faith that sustains most Deleitosans from the hour of First Communion (*opposite page*) until the simple funeral (*pp. 128, 129*) that marks one's end.

FIRST COMMUNION DRESS

orenza Curiel, 7, is a sight for her young neighbors as he waits for her mother to lock door, take her to church.

PHOTOGRAPHED FOR LIFE BY W. EUGENE SMITH

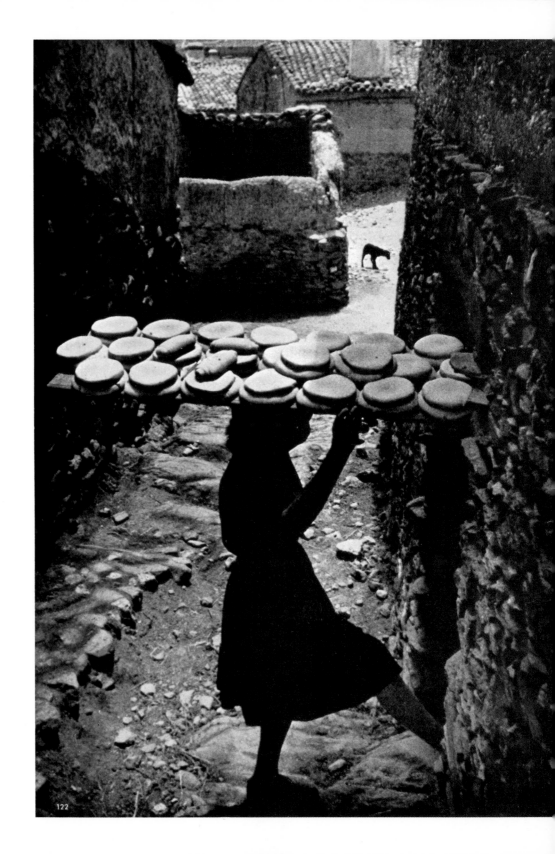

"EL MEDICO"

Dr. José Martin makes rounds with lantern to light patients' homes. He does minor surgery, sending serious cases to city of Cáceres, and treats much typhus.

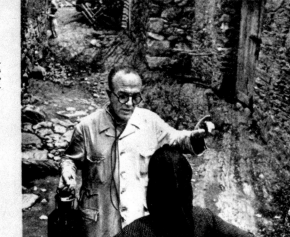

MALL BOY'S WORK

ngest son in the Curiel family,
d Lutero, sweeps up manure
street outside his home. It is
hoarded as fertilizer, will be
the eight small fields the fam-
or rents a few miles out of town.

"SENOR CURA"

a walk, the village priest, Don
69, passes barred window and
d door of a home. He has seldom
in politics—the village was
split during the civil war—but
ministry. Villagers like that.

OUNG WOMAN'S WORK

Curiel's big sister Bernardina,
s open door of community oven,
the village provides for public
least once a week she bakes 24
for the family of eight. The flour
rom family grain, ground locally.

Spanish Village CONTINUED

DIVIDING THE GROUND

At harvesttime many of the villagers bring unthreshed wheat from their outlying fields to a large public field next to town. Here they stake out 5-by-12-yard plots where they spread the full stalks, thresh grain as forefathers did.

HAGGLING OVER LOTS

Sometimes luck gives one family stony ground for threshing, another smooth. This brings arguments since the smooth ground makes for easier threshing—a process begun by driving burros over stalks with a drag that loosens kernels.

SEEDING TIME

Beans planted, the villager presses hard on his flattened plow as it scrapes the dry soil back into furrows. A neighbor woman leads donkeys, one borrowed.

PLOWBOY FOR HIRE

Genaro Curiel, 17, son of man planting beans (*above*), carries his crude wooden plow as he heads for work at a wage of 12 pesetas (30¢) and one meal a day.

WINNOWING GRAIN

With the straw already broken away, wheat kernels are swept into a pile and one of the women threshers tosses them up so the breeze can carry off the chaff.

CONTINUED ON NEXT PAGE

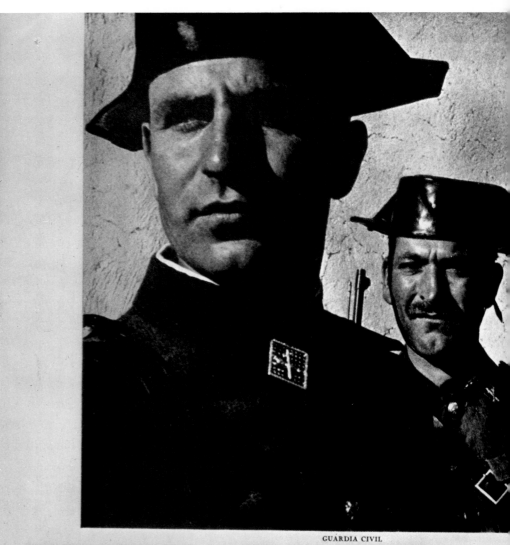

GUARDIA CIVIL

These stern men, enforcers of national law, are Franco's rural police. They patrol countryside, are feared by people in villages, which also have local police.

VILLAGE SCHOOL

Girls are taught in separate classes from the boys. Four rooms and four lay teachers handle all pupils, as many as 300 in winter, between the ages of 6 and 14.

◄— **FAMILY DINNER**

The Curiels eat thick bean and potato soup from common pot on dirt floor of their kitchen. The father, mother and four children all share the one bedroom.

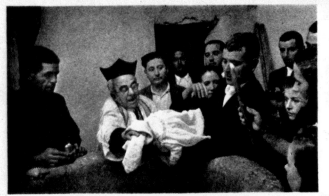

A CHRISTENING

While his godfather holds him over a font, the priest Don Manuel dries the head
of month-old Buenaventura Jimenez Morena after his baptism at village church.

THE THREAD MAKER

A peasant woman moistens the fibers of locally grown flax as she joins them in a
long strand which is spun tight by the spindle (*right*), then wrapped around it.

CONTINUED ON NEXT PAGE 127

117

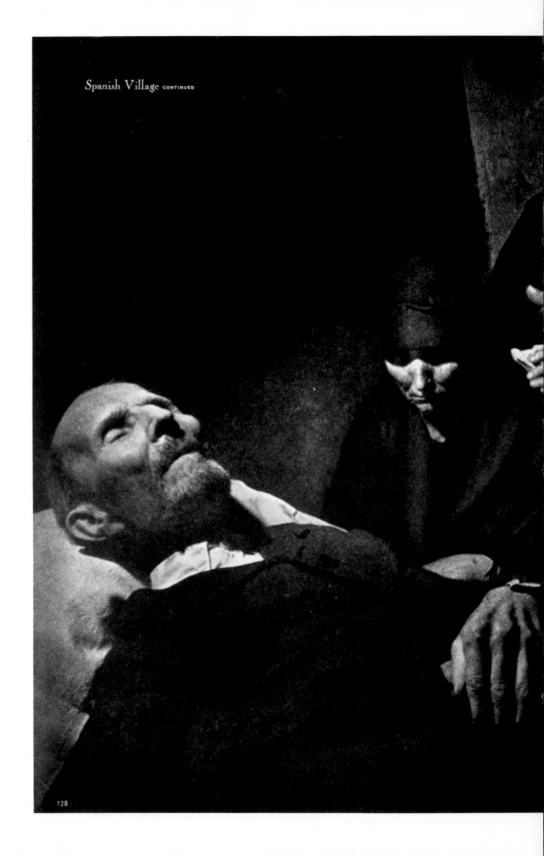

Spanish Village CONTINUED

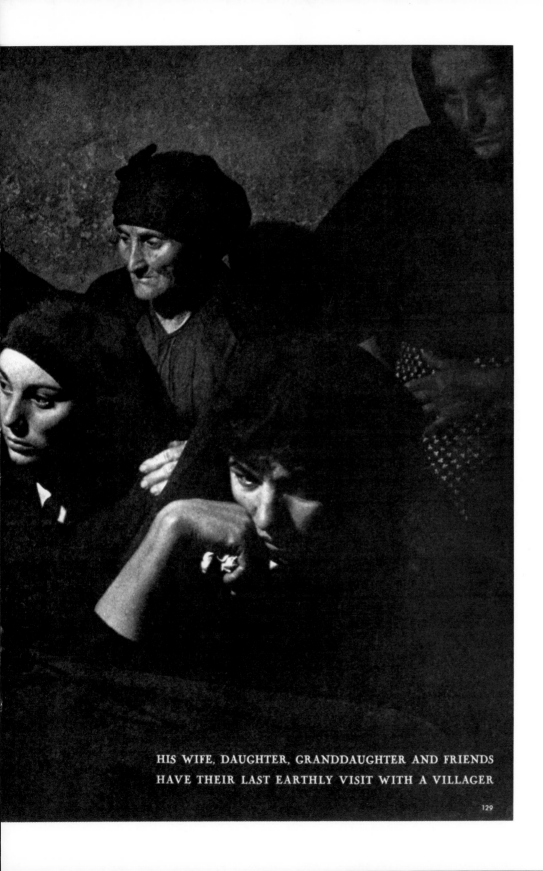

HIS WIFE, DAUGHTER, GRANDDAUGHTER AND FRIENDS
HAVE THEIR LAST EARTHLY VISIT WITH A VILLAGER

129

Exploring the World of the Social Outcast

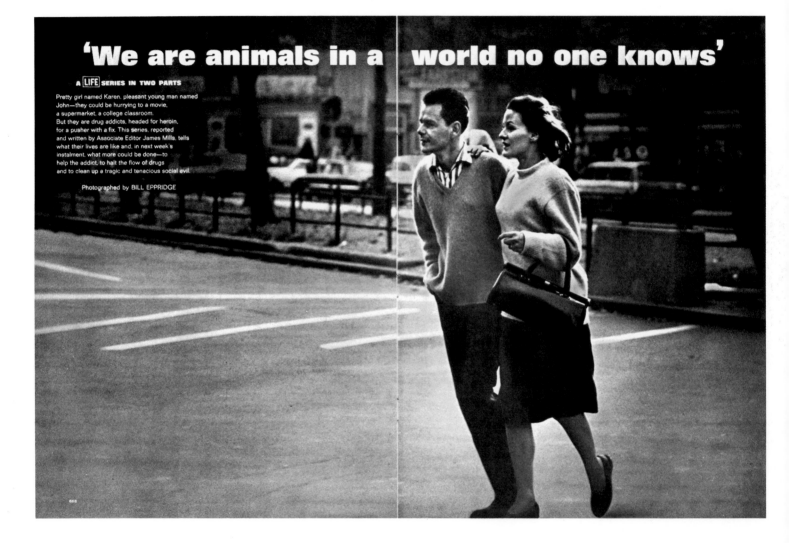

'We are animals in a | world no one knows'

A **LIFE** SERIES IN TWO PARTS

Pretty girl named Karen, pleasant young man named
John—they could be hurrying to a movie,
a supermarket, a college classroom.
But they are drug addicts, headed for heroin,
for a pusher with a fix. This series, reported
and written by Associate Editor James Mills, tells
what their lives are like and, in next week's
instalment, what more could be done—to
help the addict, to halt the flow of drugs
and to clean up a tragic and tenacious social evil.

Photographed by BILL EPPRIDGE

If ordinary lives can produce drama in photo essays, why cannot extraordinary ones produce more? This question has led photographers into many seamy corners of crime, social injustice and decay. In 1965, when the drug problem was still largely unknown to the bulk of Americans, *Life* shocked its readers with an incisive two-part essay on a couple of youthful heroin addicts, photographed by Bill Eppridge. Eppridge followed the McCombe technique of round-the-clock intimate observation of two attractive, apparently normal young people whose private lives were a careening horror. His pictures catch the mood. They are raw, nervous, full of twitchy movement and desperate emotion—most of them shot in a hard, uncompromising light, a glare straight from hell.

John out of jail: 'Don't play with my brains!'

Meeting Karen his first day out of jail (above), John bawls her out for not writing. Later in a hotel (below) he gets affectionate, his drug-free days in jail having restored desires dulled by heroin.

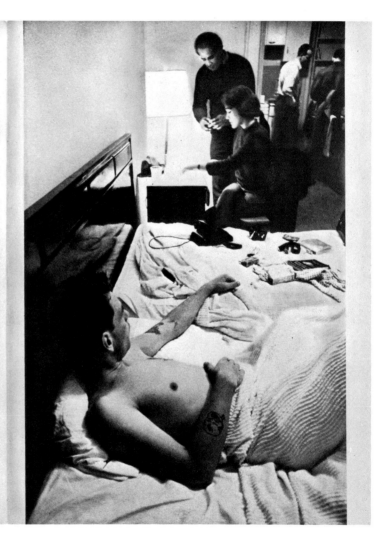

Go ahead and shoot it all up! You're a pig junky, just like you always were and always will be!" Karen screams at John as he takes a shot (above) minutes after his release from jail. Before he was arrested he had hidden 30 bags of heroin in a hotel hallway. Just after meeting Karen, he retrieved his stash, collected some friends and went to another hotel to "turn everyone on" —give them all heroin. In jail, off heroin, his body lost its dependence on the drug, and he uses it here not to fight off withdrawal, but only to get a high. But Karen still has a physical need for the drug and is furious at him for not giving it all to her. He shouted back at her, "Don't bug me, Karen! Don't play with my brains!" All 30 bags were gone by that night. A friend went for more and returned with a connection from Harlem, whom Karen paid off (right). Frightened that the men in the room were about to rob him of his drugs and money, the pusher was in a rush to get paid and did not complain about being photographed. Nevertheless, since his identification might encourage him to retaliate against John and Karen, his face has been retouched.

70

121

The deadly overdose: 'You got to fight it, Billy!'

One of the junky's natural enemies is the overdose, the "OD"—a shot that unexpectedly contains more heroin than his body can survive. In these pictures, taken while Johnny was in jail, Karen works to save the life of a young addict named Billy. Her expressions (right) mirror the danger, hope and final victory of her two-hour struggle. Billy collapsed in a hotel room after swallowing five Doriden tablets and then mainlining a shot of heroin. Though he is nearly unconscious, Karen holds him on his feet and keeps him walking.

Open your eyes, Billy. Try to wake up. You took too much stuff, Billy. Don't go to sleep—you might not wake up. You got to fight it, Billy. Do you hear me, Billy? You got to fight it, Billy? Billy!? Exhausted and hot from walking him around the room, Karen has dumped him into a chair and removed her sweater. Then, afraid that if he sits down too long he will slip into a fatal coma, she walks him some more. Finally, she sits him down in a chair again and shoots into his ear. He begins to come around. "That Doriden is something," she explains. "It makes you feel like you were almost clean, almost like you'd never had any heroin before. And then you take the heroin and, man, it really sends you."

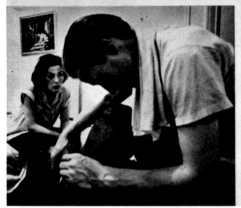

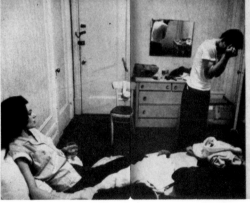

Still only half-conscious, Billy sits with a cigaret in his hand and a wet towel thrown over his neck. Now that he can walk by himself, Karen—who herself had had a shot of heroin—rests on the bed with a glass of water. Billy begins to mumble, finally gets out a complete sentence: "Man, that was a good bag." He was lucky it wasn't better. Almost every day in New York City an addict dies of an overdose, some sold intentionally by pushers who think the addict has been "stooling" to detectives. Sometimes these "hot-shot" contain no heroin at all, but rat poison. Addicts call this type of hotshot a "ten-cent pistol" because the poison costs a dime but is as effective as a gun. Junkies may be quite informal about disposing of OD'd friends. Karen once heard a strange sound ("it was like shhhhh, shhhhh") outside her hotel room. When she looked through she saw two junkies dragging a body down the hall.

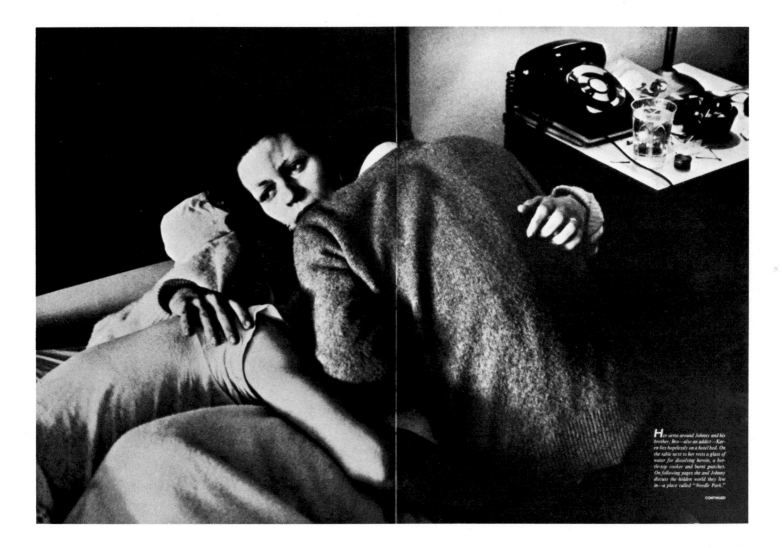

Her arms around Johnny and his brother, Bro—also an addict—Karen lies hopelessly on a hotel bed. On the table next to her rests a glass of water for dissolving heroin, a bottle-top cooker and burnt matches. On following pages she and Johnny discuss the hidden world they live in—a place called "Needle Park."

CONTINUED

123

The Photo Essay and the Design Artist

The preceding pages have traced the development of the photo essay from "just pictures" put together any which way, through small editorial ideas realized by photographers, to larger ones, to the final emergence of a distinct art form of great editorial complexity and sometimes profound emotional and esthetic impact. At the peak to which Leonard McCombe and W. Eugene Smith brought it, the photo essay was strongly influenced by "story"; thus in its published form it necessarily reflected the ideas and tastes of the editor who commissioned it and saw it to press. Modern photo essays that emphasize the purely pictorial elements of a story frequently are shaped by another hand, that of the designer, the graphic artist responsible for the appearance of the completed layout. A fine example of this may be found in Brian Brake's exquisite essay on an Indian monsoon.

There is not much intellectual content in Brake's pictures, and only the sketchiest kind of a story line—the suggestion of seasonal cycle: destructive drought, redeeming rain. What they do have is mood and beauty; they are drenched with both. It is up to the designer to extract as much of both as he can through emphasis on the most atmospheric pictures in his layout.

Brake's photographs so attracted editors that they were published in four picture magazines: *Life* in the United States, *Paris-Match* in France, *Queen* in England, and *Epoca* in Italy. Later, The Museum of Modern Art in New York had an exhibition that included the four different layout treatments of the same set of pic-

tures. Two of those treatments, one made for *Life* and another for *Paris-Match,* are partially shown on pages 126-129; the *Life* layout lacks two spreads, the *Match* layout lacks one.

When one considers the almost limitless possibilities—Brake's take included more than 500 shots and 110 were offered to *Life*—what seems remarkable is that the different designers ended up with stories that were very much alike. They did not choose exactly the same photographs but they almost did, as the sampling shows.

Is this so remarkable? Not really, not even that identical pictures were chosen by *Life* and *Match* for full pages or double spreads, or that each designer chose the same opening photograph and the same ender. Photographs of transcendent beauty or originality will assert their claim on any skilled designer, as will the logic of their ideas. In short, the photographer—by what he does, by the nature of the pictures he delivers—is able to influence the ultimate layout of a photo essay more strongly than most photographers will admit.

The 22 pictures at right were all used in the layouts seen on pages 126-129. Before turning the page, you might study the photographs to see how you would have laid out the story—which pictures you would have made large, which small, how arranged and how cropped.

Once again, the real impact of these layouts is lost by their being reproduced so small. To give an idea of the effectiveness of the originals, one picture, given a full page in both *Life* and *Match,* is shown almost original-layout size on page 130.

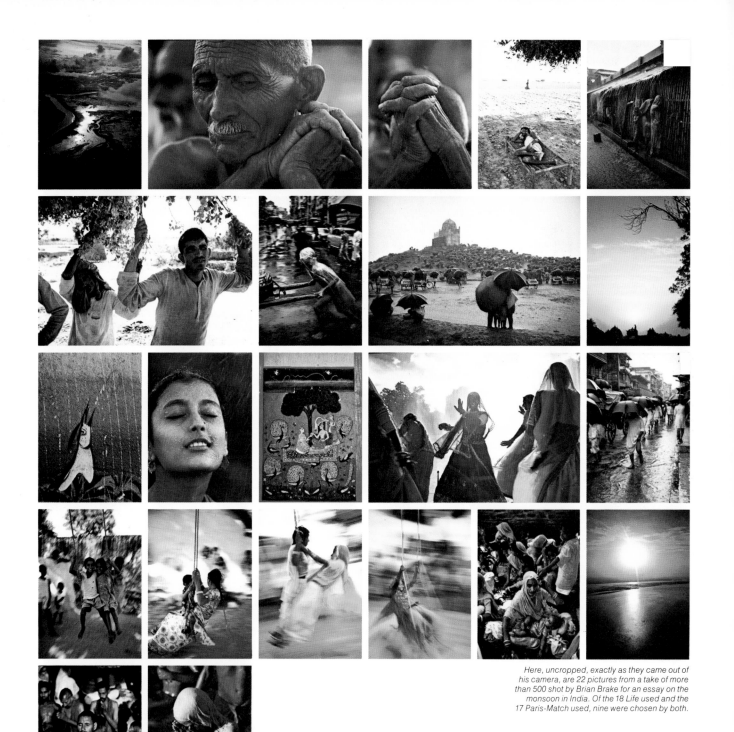

Here, uncropped, exactly as they came out of his camera, are 22 pictures from a take of more than 500 shot by Brian Brake for an essay on the monsoon in India. Of the 18 *Life* used and the 17 *Paris-Match* used, nine were chosen by both.

How Two Different Designers Laid Out the Same Story

Brian Brake's "Monsoon" as It Appeared in *Life*

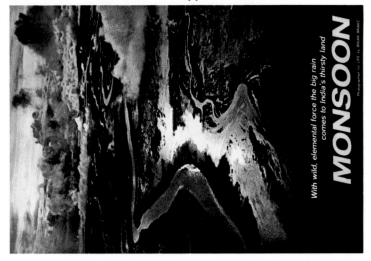

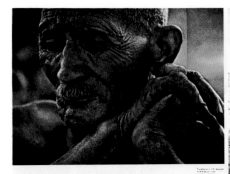

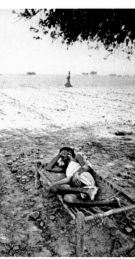

Brian Brake's "Monsoon" as It Appeared in *Paris-Match*

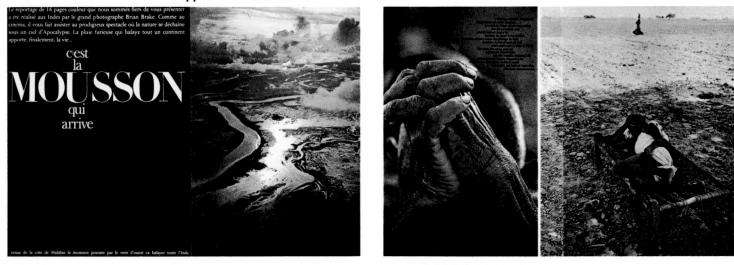

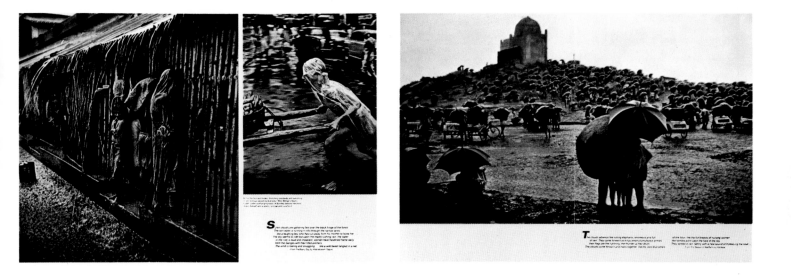

S torm clouds are gathering fast over the black forest.
The rain waters a-running in rills through the narrow lanes...

from The Rainy Day by Rabindranath Tagore

T he clouds advance like ruling elephants, limitless and full
of rain. They come forward as kings among tumultuous armies,
their flags are the lightning, the thunder is their drum...

from The Power of the Rain by Kalidasa

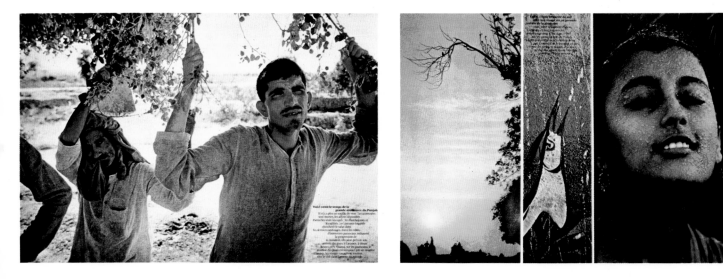

Voici venir le temps de la
grande sécheresse du Punjab...

Life

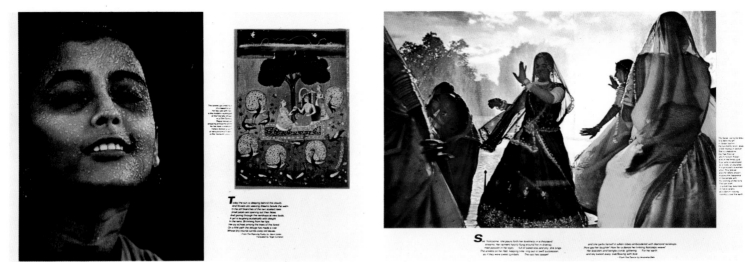

Paris-Match

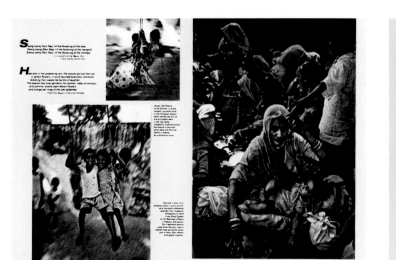

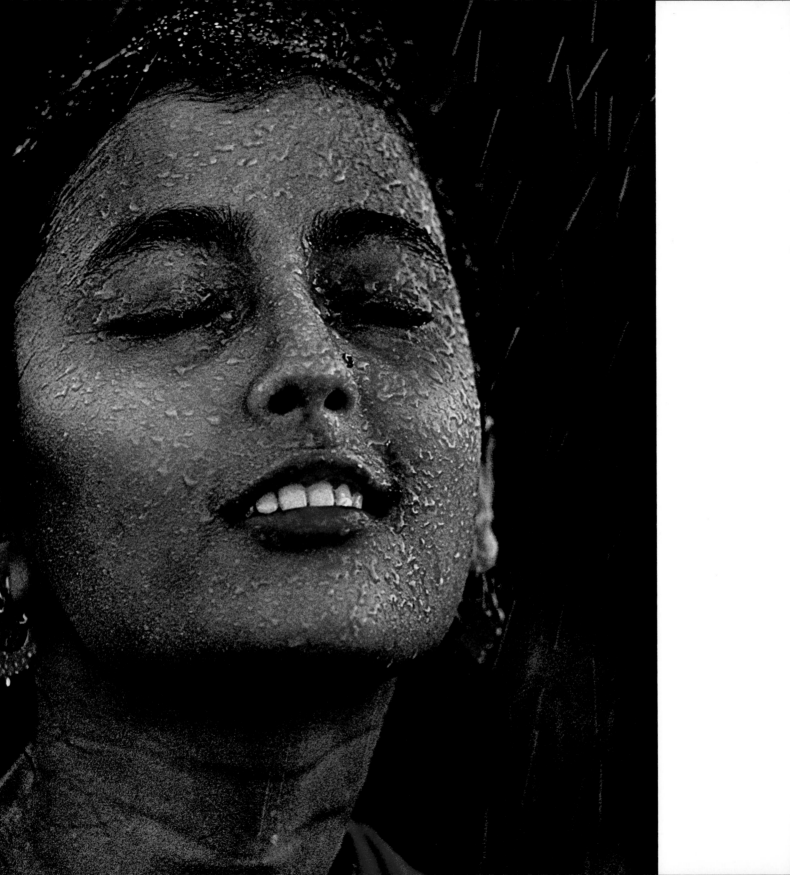

The Professional Assignment

ALFRED EISENSTAEDT: *Leonard McCombe*, 1964

Photojournalist at Work—A *Life* Photographer's Own Account

Alfred Eisenstaedt once described photojournalism as the act of finding and capturing "the storytelling moment." But to perform this deceptively simple task, photojournalists need an extraordinary range of talents and abilities. They must have the instinctive eye for narrative that enabled Margaret Bourke-White, in her first photo essay in *Life (pages 101-103),* to bring back a revealing documentary on the hardscrabble life of dam builders at Fort Peck, Montana. They must have the nose for a story that led Susan Meiselas to decamp alone for Nicaragua—without an assignment and speaking no Spanish—to cover the revolution that overthrew the regime of dictator Anastasio Somoza; her photographs of the war-torn country earned her the 1979 Robert Capa Gold Medal. They must have the stamina and drive that keeps David Burnett on the go photographing the boat people in Malaysia and Mormons in Utah, football in California and Texas, baseball in Ohio and Minnesota. They must be able to elbow their way through crowds, as Harry Benson did at a rally for Robert Kennedy in California, and keep their wits when the crowd panics—as it did after the deadly pistol shots rang out. Despite the turmoil and emotion of the moment, Benson snapped several telling photographs of Kennedy's assassination. Most important of all, photojournalists must understand people and have a talent for portraying their personalities and emotions—for essentially it is people who make good picture stories.

This kind of sensitivity is probably the strongest quality in the work of Leonard McCombe, the former *Life* photographer who on the following pages explains how he went about his job. McCombe's responsiveness illuminates the first of his picture essays to appear in *Life,* a story he shot as a young British photographer in Berlin at the end of World War II. In the aftermath of hostilities, thousands of German refugees were pouring into the Berlin railroad station on top of boxcars—sick, starving, unwanted, and totally unnoticed by most press photographers. McCombe documented their plight in photographs, which he sold first to the London picture weekly *Illustrated.* Henry Luce spotted them, pronounced them the year's best, bought them for the October 15, 1945, issue of *Life,* and ordered that McCombe be hired immediately. McCombe, then 22, became the youngest photographer on the *Life* staff.

McCombe had always been a prodigy in photojournalism. Born on Great Britain's Isle of Man in 1923, he took up photography at the age of 16 after abandoning an earlier ambition to paint. (His art teacher, in a moment of pedagogical sarcasm, had told him to give up painting and buy a camera.) Within two years, in 1941, McCombe was submitting photographs to London's *Picture Post.* During World War II he covered the London blitz and the Normandy invasion, and earned such a reputation as a war photographer that he was elected to the Royal Photographic Society.

At *Life,* McCombe continued to search for the different, more evocative and

more significant picture story. This probing type of photography exposed him to all the hazards and hardships that face every photojournalist. In Texas in 1949, while doing a photo essay on cowboys, McCombe returned to the office with the nine-rattle tail of a snake that had been beaten to death a foot in front of him. In Buenos Aires in 1951, while covering Argentine dictator Juan Perón's shutdown of the opposition newspaper *La Prensa,* he was arrested and jailed by secret police, and grilled nonstop for 25 hours until United States and British officials helped to negotiate his release.

But most assignments pose gentler obstacles. Many of the problems are technical: how to get pictures in light that seems too dim, how to find expressive camera angles. More often they are the human problems that McCombe, with his talent for discovering the human elements in a story, solves so well.

In one assignment shortly before he left *Life,* McCombe's sensitivity to people enabled him to develop a story that on the surface seemed impossible to photograph. The editors of *Life* had asked him to shoot an essay on a children's day-care center in Cambridge, Massachusetts. The center was noteworthy because it was one of the first of a number of new child-care facilities around the country to be sponsored in part by industrial firms. KLH, a manufacturer of high-fidelity sound equipment and now located in California, had started it in 1968 for employees with children under school age. Money was obtained—including a three-year, $324,000 grant for operating expenses from the U.S. Children's Bureau—a building next to the KLH factory was renovated and a staff was recruited. Here, apparently, was a perfect example of business and government cooperating to bring about a needed social reform.

But when McCombe arrived at the day-care center, he discovered that the facts had changed. KLH, caught in an economic squeeze, had dropped its support of all but eight of the center's 60 children. The others either paid private tuition or received help from various outside sources.

For McCombe, the deepest frustration was the fact that the pictures the *Life* editors had presumed could be found—ones that would demonstrate an obvious tie-in between the center and big business—just were not there. But by following his natural instinct for ferreting out the human drama, McCombe managed to bring back other, more evocative photographs that the editors could use to tell their story. How he did it is shown in the account, written by McCombe and illustrated by his pictures, that begins overleaf.

Rescuing an "Impossible Project"

Following is Leonard McCombe's story of his "impossible project":

Nearly every assignment seems bewildering when you start—and these pictures showed it. My job was to cover a day-care center in Cambridge, Massachusetts, sponsored at the time by KLH Research and Development Corporation, Inc. It seemed at first glance that there was nothing to photograph: a back lot *(opposite),* a row of swings and a sand-box. Some small children were playing in groups, and some young teachers were playing with them *(above).* But pictorially it seemed very unexciting.

This is the way it usually happens. You come in cold to an unfamiliar situation, where nobody knows you. The scenes you had imagined often turn out to be nonexistent. "What's going on?" you ask yourself. "Where's my story?" It's like being on the outside of a shop window looking in. Somehow you have to break through the glass.

I looked around for a way to tell the story. There wasn't even a large sign saying "KLH." None of the teachers seemed interested in helping me; they were too busy with their charges. "We had a photographer here last week," one said. "All he did was order us around." From the very start, it looked like an impossible project.

Looking, Listening and Probing for a Story

I saw two ways to approach the problems I faced, and I decided to try them both. First, I would set up the shots that *Life* wanted, hoping to relate the KLH factory and the day-care center *(right)*. I found one of the mothers who worked for KLH, posed her for one picture at her job on the assembly line *(right, below)* and then waving at her 4-year-old daughter from a window of the KLH factory building that overlooked the center's playground *(right, above)*. But as soon as I had taken the pictures I knew that they would look contrived.

Posed pictures never seem to work for me, so I knew I would have to try the second approach: talk to as many people as possible, delving as deeply as I could into the life at the center, in the hope that some special angle would turn up. I went to the center's director, Kate Bulls LaFayette, but she was so busy telephoning *(opposite, above left)* that she had very little time at first to devote to my problems. She was friendly though, and I tagged after her several days in a row, listening and taking photographs as she talked with children and teachers in her office *(opposite, below left)* and the play yard *(opposite, right)*. I did not think the pictures would run, but just the act of shooting them —of framing Kate's face in the viewfinder—helped me understand her intense, forceful personality. I was still groping, but I was beginning to get the feel of the assignment.

An Emerging Quality of Tenderness

Unsatisfied with my attempts to manufacture pictures to order, I resolved to follow my instincts, shooting as many rolls as I had to, hoping to catch something meaningful. I reached the center early in the morning. A light rain was falling. The first person to appear was a social worker, who had bicycled three miles through the drizzle with his son *(opposite, left)*. Then I noticed how eager all the children were as they arrived *(opposite, right)*. How many kids in Amer-

ica really *want* to go to school? As I photographed them, I wondered what was so special about the center that made the children so anxious to come. As the day wore on, I began to pick up clues that helped explain that special quality of the center. I noticed moments of unusual tenderness between the children and the teachers *(above)*. Out of sheer good feeling, a student teacher would pick up a little girl and hug her. Another teacher sat

quietly on the asphalt of the playground, cuddling a little boy in her lap.

That night in my hotel room, I realized that a theme was emerging. After a day's shooting, I try to reconstruct each episode I have taken during the day, and to pick out the ones that seemed most meaningful. All my best shots, I felt, showed the remarkable tenderness that existed between the children and their teachers. Now I knew that I had found one theme for the story.

Finding a Way to Dramatize the Theme

In telling a story I use my camera the way a writer uses a typewriter. I take pictures to build a setting and plot. Most of all, I try to develop characters —to make people come alive.

The first character I discovered was five-year-old Jessica Morse, portrayed here in her many moods. I had photographed her by chance on the first day; she sat crying angrily at the edge of the playground (opposite). Soon she acquired a personality. Jessica was not only tempermental, but also intelligent, exuberant and talented. I photographed her pouting as a teacher tried to comfort her (opposite, right); painting pictures and smiling at her accomplishment (above); and confidently striding out of school at the end of the day with her mother (right).

I had now found a way to dramatize the close rapport between the children and their teachers. For the teachers knew exactly how to respond to Jessica's particular needs and turn her energies toward something positive.

Some of the assignment's initial frustrations had now begun to disappear. The teachers and children started to accept my presence. When a strange photographer first appears to take pictures, most people stop what they are doing and stare. This is particularly frustrating, because I like to catch people in an unguarded, characteristic moment. So I try to be as unobtrusive as possible, usually beginning an assignment with a single 35mm camera in order not to frighten people with a lot of complicated equipment. By now the people at the center had lost their self-consciousness, and I was able to take the kind of spontaneous photographs I wanted.

Catching the Story of a Little Boy

Other personalities intrigued me. One three-year-old boy seemed shy. I first noticed him sitting alone in a corner playing with a hose *(left)*. While his class was in session I watched him —and photographed him—standing by himself on a box in front of a window, swinging his leg *(opposite, left)*. A placard above his head gave the photograph its unusual composition, and his preoccupied expression seemed to tell the essence of his story. The teachers had been striving to bring him out of himself. Eventually he began to make friends with Evie, a little girl his own age, who talked to him, flirted with him and hugged him *(opposite, right)*. "This school is exceptional," his mother said. "My little boy is learning to depend on people—not just to finger paint, but really to trust and share himself. He feels secure here and has such attachments to other children, especially to Evie. He's had to come out of his shell." I began to sense even more strongly how important the center could be in helping children develop.

I also realized something important about the way my assignment was developing. Good photojournalists become totally involved in the story. They empathize with the characters; they develop a point of view and feel a strong desire to express it. I sometimes get so wrapped up in a story that at night I dream about it. I was now beginning to feel this way about the center. Perhaps it was because I have three sons of my own, or perhaps it was simply the drama of watching the children's personalities unfold. In any case I was determined to capture this drama on film so others could understand and sympathize with it as well.

Watching for the Quiet Adventures

For the complete picture of the center I wanted to record all the children's different activities. I took roll after roll of kids eating lunch *(left),* taking naps *(opposite),* cavorting about on swings, building castles out of blocks. And I noticed something else about the center. Almost every activity was used as a subtle way of teaching something. At meals, for example, there was a spill-proof milk pitcher that helped even the little girl in the picture at left learn how to pour her own milk.

Photographing nap time was tricky. The teachers did not want to let me do it at first because they were afraid the clicking of the camera shutter would keep the children awake. Even after I had talked them into it, technical problems cropped up. There was almost no light, for example, since the blinds had been pulled down. I tried using a strobe in one shot, but I knew while taking it that the picture would be no good. I hate using strobes because they intrude into the picture, often giving a harsh, artificial light that destroys the air of reality I try to convey. So I went back to natural light. This meant opening my camera to the widest f-stop, and shooting at such a slow shutter speed that I had difficulty keeping the camera steady. A tripod was out—it would only have added another distraction and have kept the children from settling down to sleep.

The nap pictures never really satisfied me, and I went back the following day to get better ones. Finally I caught a scene that seemed to epitomize the soft, human quality I was looking for —the picture opposite of a teacher stroking a little girl's back to make her relax—and I felt I had what I wanted.

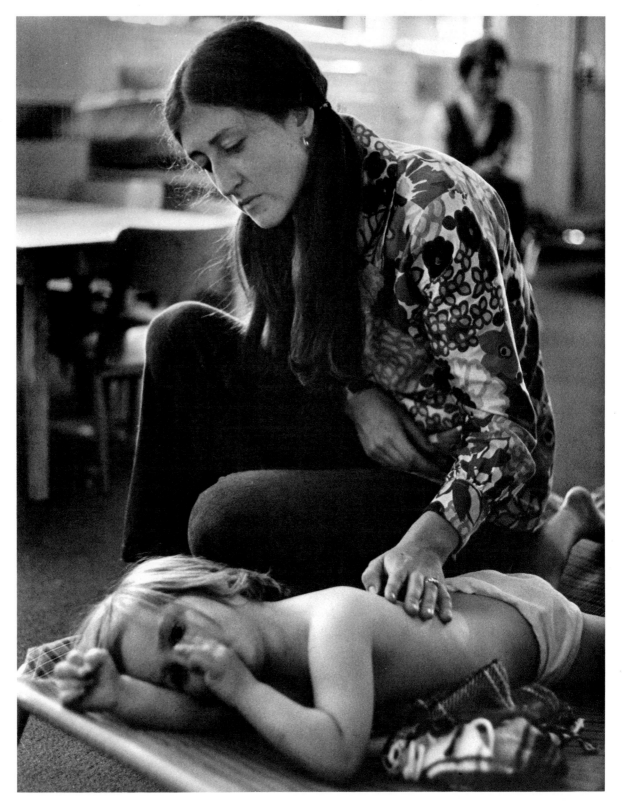

Recording a Scene of Mutual Trust

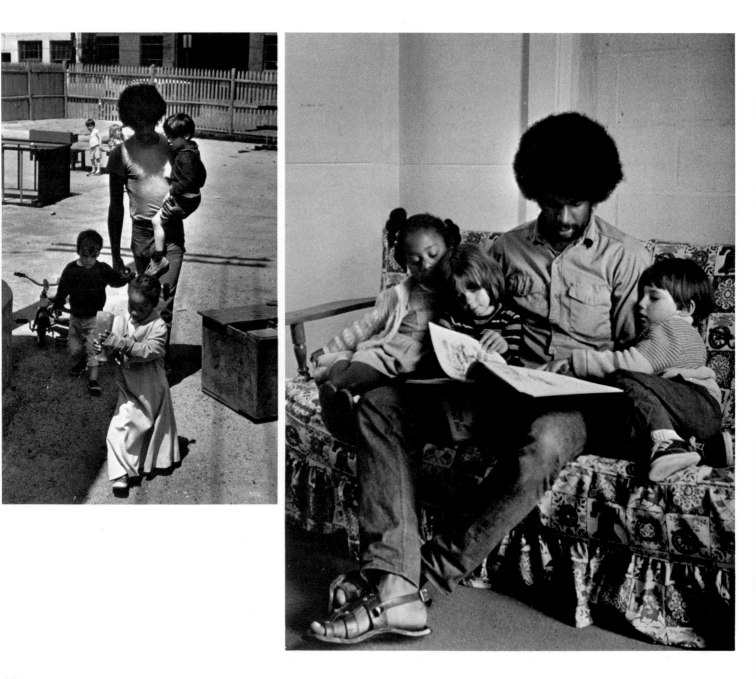

One of the things that made the center so special, I felt, was the extraordinary sensitivity and dedication of the teachers. I particularly noticed a man with blue jeans and sandals and a huge Afro haircut. His name was Bill Smith, and the children—and their parents—had a deep and total trust in him that I tried to express in the pictures on these pages. The youngsters would cluster around him, holding onto his hand, clutching at his trouser leg or snuggling against him on the couch while he read stories (opposite, right). He could induce them to do whatever he wanted—even to leave the playground to go to class (opposite, left) or to wash their hands before lunch (right, above).

Bill Smith seemed to have an unusual gift for understanding each child's personality. I photographed a meeting between parents and teachers one evening after school (right, bottom), and listened as he explained some of the inevitable problems that several children were having in growing up. Afterward he told me that the success of the center resulted from a sense of trust. "Parents entrust their babies to us," he said. "The kids trust us to be absolutely honest with them. When we are, they are." Bill Smith's young charges exuded this feeling of trust in the pictures I was able to get of them as they followed him around the center.

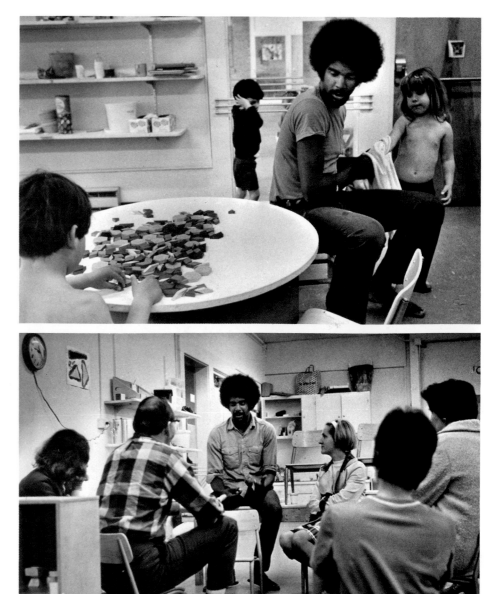

A Final Success Story

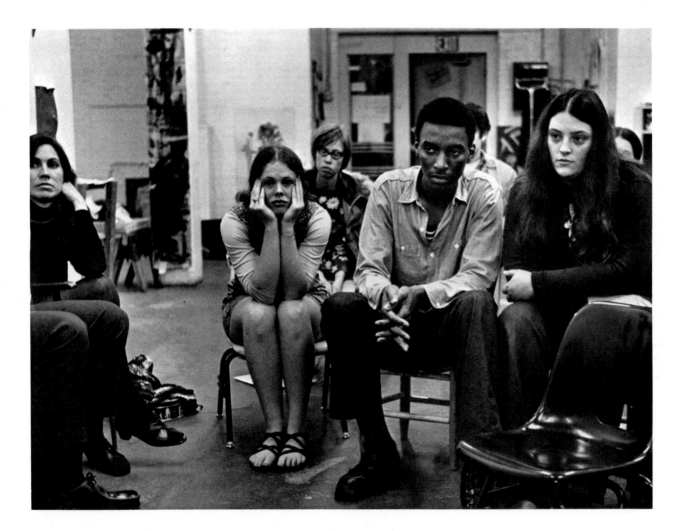

I took my last pictures at a parents' meeting *(above)*. I hoped to capture the enthusiasm that fathers and mothers felt for the center. And, by luck, I managed to dramatize this very point by tying up the threads of an episode I had photographed earlier — pictures indicating the relationship of a teacher to both mother and child *(opposite)*.

Technically, the parents' meeting was very difficult to photograph. I had to climb over people to get the right camera angles, and I made so much noise that I finally took off my shoes. Also, I had to use very slow shutter speeds in the dim light, and I was constantly worried that I might jiggle my camera and blur my shots.

But in one picture I felt I had caught the deep concern of a mother and father *(at right, above)* over their son. Earlier I had photographed the mother embracing one of the teachers, while her young boy looked on *(opposite, right)*. I had no idea what it meant, but it seemed like a significant moment. Then I had photographed the teacher, Mrs.

Lorraine Lee, who was playing a dulcimer *(above)*. At the meeting, I learned that the boy, who had been unhappy, was now far better adjusted, largely because Mrs. Lee and other staff members had broken through to him. It was exactly the kind of success story that explains why the center had become such a valuable social institution.

Result: An Essay with a Twofold Purpose

Director Kate LaFayette, left, watches thoughtfully as ——— the day care center's children share morning snacks

Big business tangles with day care problems

Not far from the shadow of dark factory walls Jessica Morse tilts crazily on a swing, lively children grab for orange juice and apples, and little Bobby Cunningham (right), at 7 in the morning, races to his teacher. Some children their age, were it not for the KLH Child Development Center in Cambridge, Mass., might have been cooped up in an apartment with—or even without—a parent. To them, from 6:45 to 5:30, the center is not only a school but a comfortable daytime home, never to be confused, the center's teachers say, with a parking lot for kids.

The need for day care centers is critical and growing: six million children under 6 have mothers who have jobs, but there are only 640,000 places in licensed centers to accommodate them. KLH, maker of high-fidelity sound equipment, started this center two years ago as an experiment in industrial sponsorship. Designed to provide all-day year-round care for children 2½ to 6, its purpose was to make jobs possible for blue-collar

workers who, without day care arrangements, might have to stay home with their children and subsist at a poverty level. The workers' children, paid for by them and KLH, were later joined by others whose parents could pay all of the $37.50 weekly cost, and by children of welfare families, paid for by the state. The center set out not only to offer a sound program of preschool education, but to serve as a pilot model for industry at large.

Now the center's original two-year HEW grant has expired. Ironically, the general economic pinch has cut down on the number of children KLH can support. This year all but 10 of the school's 60 children come from either middle-class or welfare families; 15 are from MIT's staff. But this mixture of backgrounds is proving a real success and, with or without funds from HEW and KLH, the center expects to continue at full steam. "We are probably ahead of our times," says Director Kate LaFayette, "but we represent something that is desperately needed."

Photographed by

LEONARD McCOMBE

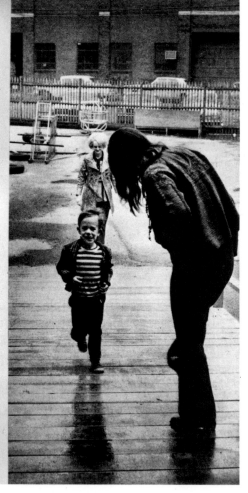

My photographs of the KLH Child Development Center ran for three spreads in *Life,* on July 31, 1970, with my by-line on the first spread *(above).* Looking back on it, I found that I had put in 40 difficult, frustrating man-hours; I had shot a total of 1,500 negatives (far too many, it seems in retrospect); I had to cope with some nasty technical and journalistic hurdles. I had been able to give only the barest suggestion of the connection between the day-care center and industry that the editors had asked for. But the editors used the text to describe the relationship, and the financial problems, between the center and KLH; and they used my pictures in a way that was also fundamental to the story—to make clear in human terms why the center itself is an important social institution. *Leonard McCombe* ☐

152

Techniques of Photojournalism

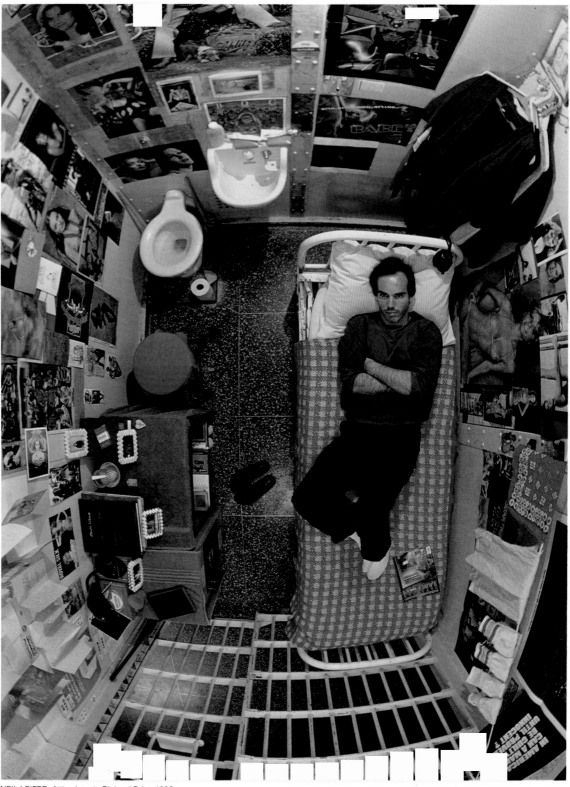

NEIL LEIFER: *Attica Inmate Richard Eder,* 1982

Being Prepared for Anything

When it comes to taking pictures of fast-breaking news events, there is no instant replay. A photojournalist who swings the camera a split-second too late cannot ask football players, rioters, assassins or crashing airplanes to back up and take it from the top. And unlike reporters, who can scribble notes as an event unfolds and rely on their memory to flesh out the final story later, photographers have to get it all on film the first time: Their notes *are* the final story. Quick reflexes and an eye for the telling vignette thus are essential attributes for success.

The best photojournalists share another attribute, less glamorous but equally vital: being prepared. The fastest reflexes and surest eye are useless if a photographer has run out of film or has the wrong lens for the shot. And, as *Time* photographer Dirck Halstead can attest, the right film is critical. When Halstead was assigned to cover a speech by President Reagan at the Washington Hilton Hotel one drizzly day in March 1981, he loaded three cameras with indoor film. As it turned out, of course, the story that day took place outside, when would-be assassin John Hinckley opened fire as the President left the hotel. Fortunately Halstead had a fourth camera, loaded with daylight film, and although he was bitterly disappointed that his position did not allow him to get any photographs of Reagan himself when the firing began, he did manage to record more than 30 frames of the wild action surrounding the assassination attempt *(pages 178-180)*. Some might call it luck, but what it boils down to is planning and foresight, based on experience; Halstead had loaded daylight film "just in case."

As photographic technology grows increasingly sophisticated, the planning takes a greater degree of mastery. Photojournalists must understand the fine points of a wide array of lenses, films, camera features and darkroom processes if they want to have the greatest flexibility on the job. The decision to shoot in color, for example, rests on a number of factors, not the least of which is the effect a photographer wishes to create. *Life* photographer Larry Burrows *(pages 60-61)* was partial to Ektachrome film because he felt that the muted greens and browns it produced came closest to the true tones of the jungle in Southeast Asia. Michael O'Brien, on the other hand, deliberately created a mildly surreal atmosphere in his portrait of an old stone-carver *(page 162)* by shooting at dusk with Kodachrome film and using a fill flash on the man's face.

Lenses and other camera accessories also present photojournalists with necessary choices, and having the right equipment can mean the difference between getting a so-so shot and getting one that lands on the front page— as did Ian Bradshaw's picture of a streaker at a rugby match *(pages 56-57)*. Bradshaw, who had been using a 500mm lens to cover the game, had just switched to a 200mm lens when the naked young man materialized on the field. Brad-

shaw's timing in changing lenses was a matter of luck, but having the right lens at hand was not. Similarly, a 300mm telephoto lens and a motor-driven camera enabled Charles A. Robinson to record a series of shots of a fatal accident at an auto race in Indianapolis *(pages 174-175)*. Without the telephoto, Robinson would have been too far away to get usable pictures; without the motor drive, the rapid sequence would have been impossible.

Other aspects of preparedness— choice of camera position, for example— fall into the harder-to-define realm of creative impulse. Photographers on assignment to do magazine features generally have more time to plan their shots and can give freer rein to their imaginations, but even photographers with less leisurely deadlines can exploit unusual camera angles *(pages 166-167)* or lighting *(pages 164-165)* to add impact to their work.

Time photographer Neil Leifer is one who is always on the lookout for the unexpected view. When his magazine decided to do a long feature on American prisons, Leifer took his camera into six state prisons and a federal penitentiary over the course of a year. All of the shots that ran in the magazine were black and white except one, the photograph of prisoner Richard Eder in his Attica cell *(page 155)*. To get it, Leifer mounted a camera with a full-frame, 16mm fisheye lens to a tripod head that was fastened to a board. The board was then taped to the ceiling of Eder's cell, and Leifer used a remote-control unit to trip the shutter. The photo session took six hours— Leifer shot it over and over with three different combinations of film and light— but the resulting fly's-eye view of the claustrophobic cell made the magazine's cover. □

The Intricacies of Light and Film

Light and film are the photographer's palette and canvas, and the photojournalist who wants to be able to create the broadest range of effects must be conversant with all their possibilities. These two portraits of the same subject by Sebastian Milito emphasize how a change of photographic materials can radically alter the mood of the final image.

For the near picture Milito used a fast 35mm film with a relatively coarse grain that blurred subtleties of tone and accentuated contrasts of light and dark. For the picture opposite he sought a softer image with a slower film having a finer grain. In addition, Milito shot this picture with 4 x 5 rather than 35mm film, which meant that for reproduction here, the first picture had to be enlarged more than the second, further accentuating its graininess. As a final step, Milito developed the first negative with a high-speed developer to increase its contrast even further, but for the second picture he used a developer that provides normal contrast. The results: one image, harsh and belligerent, that gives an impression of dark brooding menace; another with pleasant detail that seems more benign.

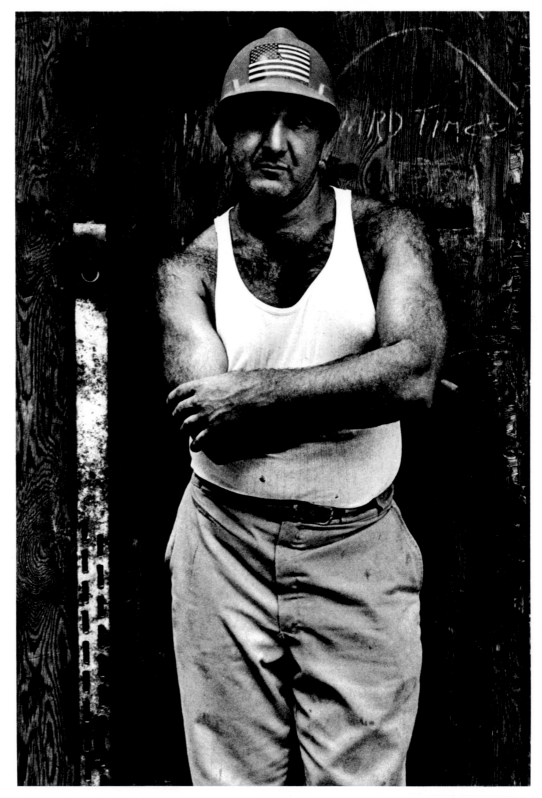

This photograph was taken with a Nikon F, using a 50mm (normal) lens and fast film. The coarse grain accentuates the shadows under the workman's helmet, making him look unshaven. These elements have been further accented by use of a contrasty, fast developer and by enlargement of the original to about seven times the size of the negative.

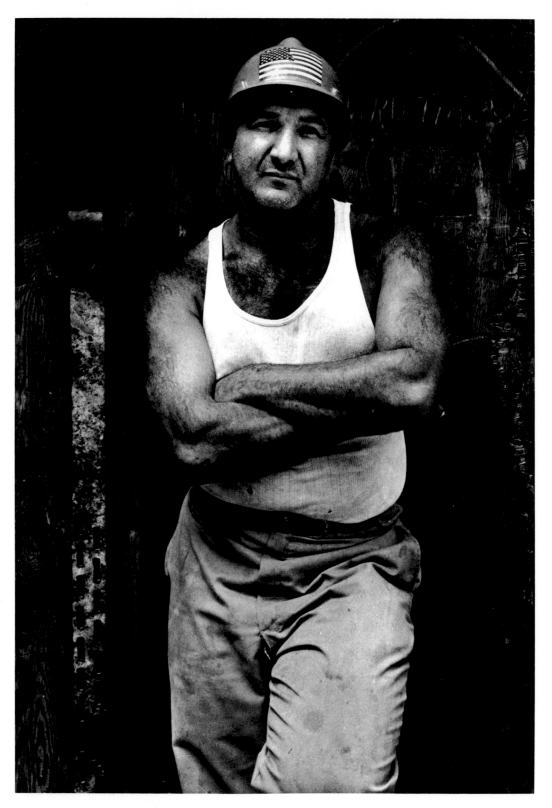

For a softer result, the photographer uses a Burke and James 4 x 5 view camera, a 150mm lens (normal for that camera) and a film only about half as fast as that used for the picture on the opposite page. The enlargement was moderate—twice negative size—retaining middle-gray tones and delicate detail. The immediate impression that this picture gives is far less menacing than that of the one opposite.

Color: Yes or No

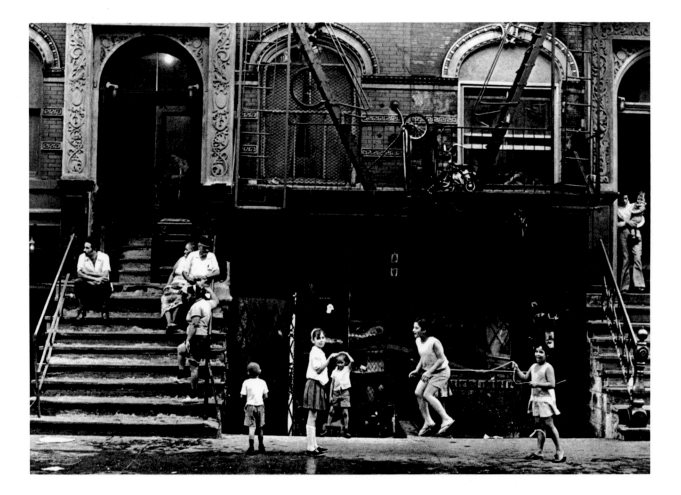

Color is so weighted with meaning that even slight alterations—attained by the use of filters or by deliberately overexposing or underexposing—can change the point of a picture. But before the photographer manipulates color, he or she has a more profound editorial decision to make: whether or not to use color at all. In this pair of pictures—a street scene on New York's Lower East Side— a black-and-white shot brings out the

squalor of the setting and emphasizes the drabness of lives led there. The same street shot in color becomes a lively, almost festive place.

Freelance Marcia Keegan made both pictures on assignment for this book in order to emphasize just this point. Her own feeling is that her pictures persuade too much—the black-and-white shot is too drab; the color too gay. The truth, she thinks, lies somewhere in between.

Shot with a Nikon F and its normal 50mm lens, Marcia Keegan's black-and-white scene is depressing. What hits the viewer is the dirty street, the littered steps, the decaying buildings, the anonymous people resignedly sitting. The one lively note, the rope-jumping girls, is almost lost in the general tawdriness of the scene.

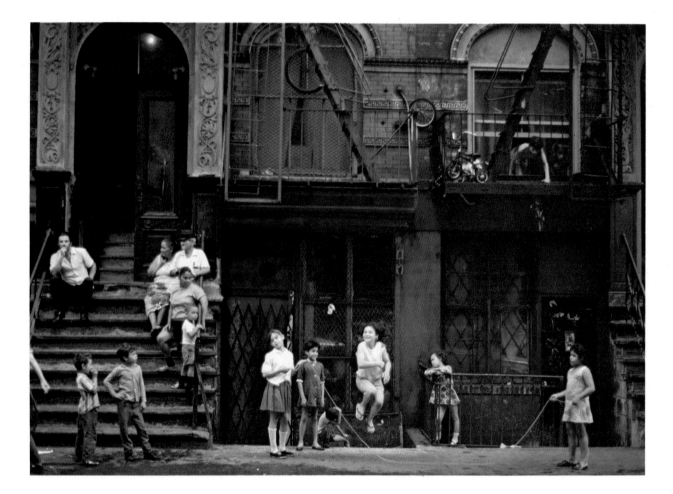

Color warms up the whole scene instantly. A pillar of deep, rich red glows in the center of the picture, and the buildings take on warm shades of blue and green. The people, no longer apathetic, have sprung to life against that colored background by adding several small flickering notes of color themselves.

The Dramatic Effects of Low Light

Once the decision is made to shoot in color, the choice of film, filters and lighting will determine how closely the colors of the finished image correspond to what the photographer had in mind. Shooting color in dim light can present special problems, especially if the photographer has esthetic reasons for not overilluminating the subject.

In the photograph at right, part of a portfolio on the American South taken by Michael O'Brien on assignment for *GEO*, the muted light is an important element of the intended atmosphere. The subject, Harrison Mayes, is a former coal miner who has devoted his life to carving stone crosses — some weighing as much as 1,400 pounds — and then installing them along roadways throughout the region. The gargantuan task fulfills a vow Mayes made when he was a young man in the hospital, praying for his recovery from a near-fatal mining accident. O'Brien used a spot flash to illuminate the face of his subject in the fading natural light.

The picture on the opposite page was made by Enrico Ferorelli deep in an Ontario mine, where daylight is only a dim memory from the surface world. To show the mine just as miners see it, Ferorelli decided against any supplemental lighting. Instead he used high-speed color film, and made the shot by the miners' own limited artificial light.

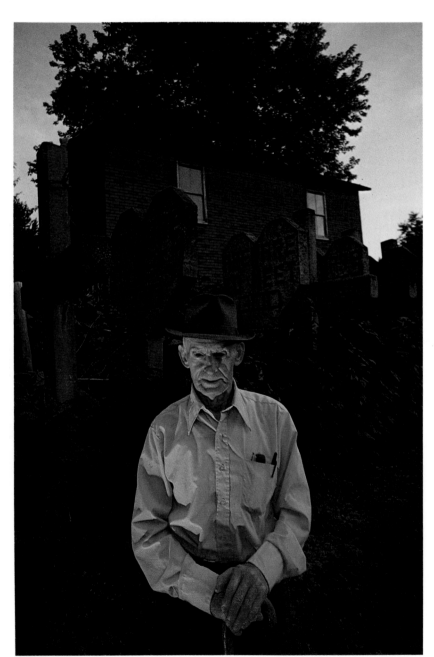

Low natural light, fill-in flash and a hay-colored filter impart a spiritual glow to this portrait of a weathered stonecarver and an array of his massive, hand-hewn crosses. Michael O'Brien used an incident-light meter and a Polaroid test shot to calculate the exposure: f/5.6 at 1/8 second.

MICHAEL O'BRIEN: *Harrison Mayes*, 1981

ENRICO FERORELLI: *Ore Mine, Timmins, Ontario*, 1979

The only available light 3,000 feet below the
surface of the earth was the reddish gleam of the
miners' helmet lamps and the glare of unshielded
overhead bulbs. Enrico Ferorelli wanted to capture
the miners at work without burning out the
overhead lights by overexposing. Using high-speed
Ektachrome 400 film and an exposure setting of
f/1.2 at 1/15 second, he was able to record the
details of the scene while at the same time
preserving the authentic gloom of the mineshaft.

Photographing a routine line-up of recruits in a gym at the Great Lakes Naval Training Center in Illinois, Wirtz made the inadequate window lighting work to his advantage. He deliberately underexposed the shot, then used high-contrast developer and paper to lose intermediate gray tones —rendering his subjects in slivers of light.

Because he knew that Henry Kissinger's profile ▶ would be recognizable, Kennerly set his exposure for the lights of Jerusalem in the background, creating a sharp silhouette of the man and making heavy verticals of the window —graphic elements that seem to symbolize the strength needed to negotiate an accord between Egypt and Israel.

MICHAEL WIRTZ: *Parade Rest*, 1977

DAVID HUME KENNERLY: *Henry Kissinger in Jerusalem,* 1975

It is often possible to heighten the interest of a black-and-white picture by eliminating details and increasing contrast until a representational image edges toward abstraction. This technique can add new visual appeal to a potentially banal subject, as in the picture opposite of military trainees, or change a frequently photographed subject into a dramatic symbol, as with the portrait above of Henry Kissinger. The necessary manipulations can be done when the photograph is being taken—David Hume Kennerly, for example, decided not to compensate for backlighting, and Michael Wirtz took his exposure readings from highlights only—or in the darkroom with high-contrast developer and printing papers. □

Camera Manipulations

Changing the position of the camera can sometimes significantly alter the nature of a picture. Both of these shots by Harald Sund were taken inside the vegetable building of Tokyo's Tsukiji Market, where auctioneers wholesale fish, fruit and other produce to buyers for stores and restaurants. The numbered card on each buyer's hat identifies his or her business affiliation. For both views, Sund used a 35mm camera on a tripod, a 100mm lens, Kodachrome 25 film and no flash;

ambient light came from overhead skylights. But the picture seen on this page — shot from an angle that encourages the viewer to notice the vegetable cartons — is about a specific activity in a specific place. In the photograph opposite, the emphasis is on people's faces: Where they are and what they are doing become secondary considerations.

One photograph makes a straightforward statement that can be interpreted at a glance; the other offers a more interest-

ing visual experience, raising questions rather than answering them. Who are the figures with their backs to the camera? What is their relationship to the black-capped throng in front of them? When the scene is viewed from the side, individual faces are almost irrelevant, but pointing the camera head on at the buyers transforms them into subjects in a group portrait. Now individual expressions — intent, animated, sleepy — become crucial elements in the picture.

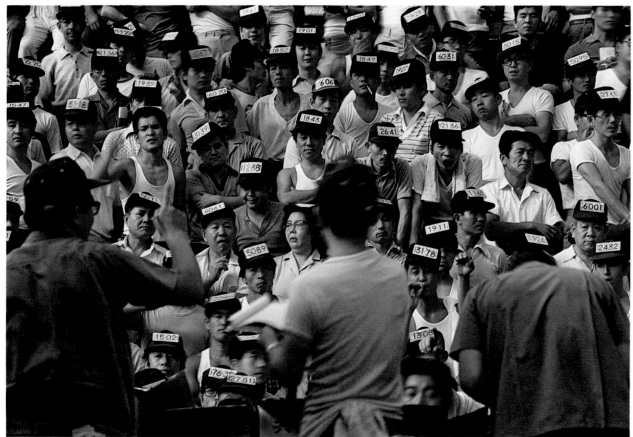

HARALD SUND: *Tsukiji Market,* Tokyo, 1975

◀ The photograph at left is pure reportage, with an emphasis on the market setting. Although it is not clear exactly what is being sold, the merchant-customer relationship between the people in the upper right corner and the crowd on the other side of the row is immediately apparent.

By repositioning his camera, Sund conceals the cardboard cartons, and the nature of the activity being photographed is no longer evident. The people themselves — a sea of faces packing the frame, each crowned with a number-coded cap — have become the point of the picture.

PAUL CHESLEY: *Humpback in Prince William Sound,* 1979

Automatic Exposure

A change of camera positions almost always requires adjusting for changes in lighting or depth of field. The difficulty is compounded when the photographer is tracking subjects moving into and out of light and shadows or constantly changing position relative to one another.

Thanks to advances in microelectronics, computerized cameras now handle technical exposure chores automatically, leaving the photographer to concentrate on composition and to seize key moments when they come along. A camera with shutter-priority automation requires that the photographer choose the shutter speed—to freeze action, for example; then the camera picks the aperture that will give proper exposure according to the illumination measured by a built-in light meter. With aperture-priority automation, the photographer can choose an aperture for greater depth of field, say, and the camera will select the shutter speed. With fully automatic cameras, the camera sets both aperture and shutter speed; the only thing the photographer does is focus and shoot.

Whatever the form of automation, most cameras allow the photographer to override the system for full manual control. For the picture at left, taken in Alaska's Prince William Sound, Paul Chesley used a camera with shutter-priority automation and a 300mm telephoto lens from 150 feet away to freeze the juxtaposition of kayakers against the mammoth, graceful flukes of a diving humpback whale.

On the first clear day after a month of rain, a humpback whale cavorts in Alaska's Prince William Sound, watched by a pair of kayakers in their fragile craft. Photographer Paul Chesley prefocused on the kayakers and set the shutter speed at 1/250 second, stopping the whale's scalloped flukes in mid-dive and the kayakers in mid-stroke.

Closing In

The close-up is a useful technique for guiding and shaping the viewer's perceptions. By eliminating from the picture frame all but one component of a scene, the photographer creates a symbol for the whole. If the technique is to be more than just a gimmick, however, the photographer must be able to select an element that, with efficiency and subtlety, sums up the meaning of the larger scene.

For a *GEO* story on the life of the so-called Asian community in East Africa, Dilip Mehta wanted to convey the unassimilated stance of his subjects—born in Africa but devoted to the traditions of India, their ancestral home. By taking a close-up of a bride's jeweled and painted hands, Mehta presented a detail not just from one wedding ceremony, but from an entire, stubbornly preserved way of life. The shot works so well because hands readily signify a whole individual and because this particular detail reveals smaller details of distinctively Indian design. □

DILIP MEHTA: *Hands of an Indian Bride,* 1979

On her wedding day, an Indian bride awaits her husband-to-be, her hands laden with rings, chains and bracelets and painted with traditional, intricate patterns in henna dye. Dilip Mehta moved around in the courtyard where the ceremony was held and got very close to the bride for this shot. He focused on her hands because they are "symbols of being 'tied down' and at the same time they are beautiful."

Using Narrative Sequences

There are some news stories that cannot be summed up in a single image; they must be told with a sequence of pictures that support and enhance each other. A motor-driven camera and lenses of different focal lengths can be extremely useful in obtaining such sequences. Most often thought of as a tool for recording very fast motion by shooting multiple frames per second *(see pages 174-175),* a motor drive can also be used to narrate dramas that unfold more slowly.

Covering the aftermath of an earthquake in Osoppo, Italy, for London's *Sunday Times,* Bryan Wharton set the motor drives on both his cameras for single frames, rather than nonstop bursts, to free himself from having to advance the film after each shot. He could thus keep his eye to the viewfinder, keying on the soldiers digging through the rubble and on an old man who had kept a 30-hour vigil for news of his only son, who had been inside the quake-leveled house.

Wharton created a rhythm for his photo sequence by alternating between the two cameras, one with a wide-angle lens, one with a zoom. A long shot of the search party at work is followed by a close-up of the discovery of the missing son's protruding hands. Wharton pulls back once again to focus on the waiting father, then moves steadily closer as the old man's fear mounts and finally gives way to an outpouring of grief.

The large photograph opposite of a father grieving at the death of his only son in an earthquake might have stood by itself; but it is the narrative sequence —the search, the discovery of the son's body, the mounting anxiety and ebbing hope— that gives the final image its full impact. "It is not futile to look for the one picture that tells the story," Bryan Wharton says, "but you have to be extremely lucky. The other pictures put it into context."

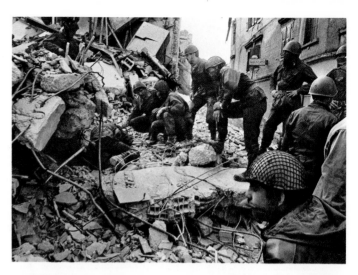

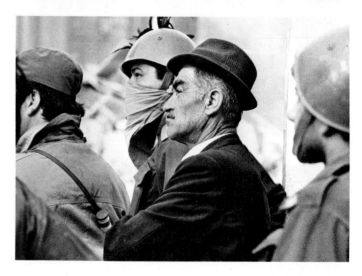

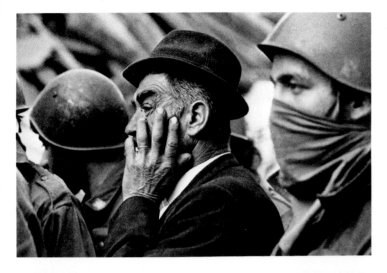

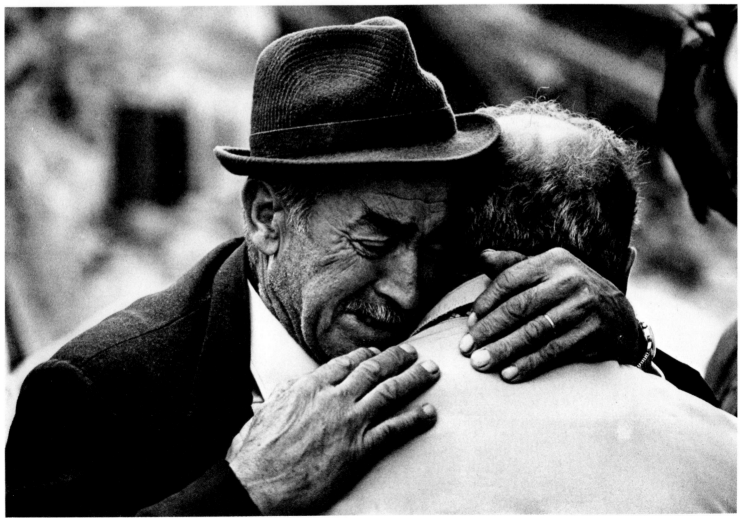

BRYAN WHARTON: *Earthquake in Osoppo, Italy,* 1976

The Indispensable Motor Drive

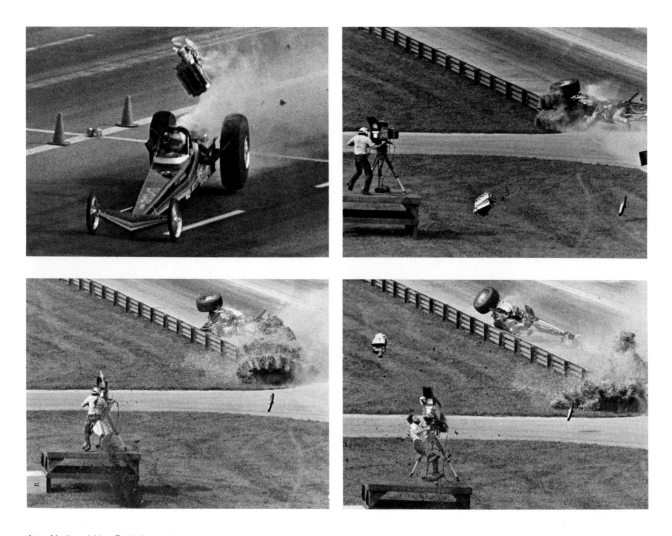

At a National Hot Rod Association drag race in Indianapolis, a TV cameraman was filming from a point 250 yards off the track. When the engine of one race car blasted its supercharger loose *(top, left)*, the cameraman kept his eye on the tumbling vehicle—completely unaware that the blower from the supercharger had become a lethal missile that was about to strike him from behind *(bottom, left)*.

Charles A. Robinson, on assignment for the Associated Press, was taking pictures of the race with a 300mm telephoto lens from a three-story tower about a fifth of a mile away when the accident occurred. With his motor-driven camera set for three frames per second, he panned toward the cameraman when he saw the piece of car machinery flying in that direction. The accident was over in a matter of seconds. Five of Robinson's shots are reproduced here, considerably enlarged from his 35mm negatives. As with the sequence on the preceding pages, the impact of the final image is markedly strengthened when the viewer is able to watch the action unfold. □

As a dragster engine blows its supercharger and the car hits the guardrail, TV cameraman Joe Rooks trains his camera on the action, unaware that the heavy blower has taken deadly aim at his position (opposite page). On its final bounce, the blower struck Rooks in the back, knocking him to the ground. He died en route to the hospital.

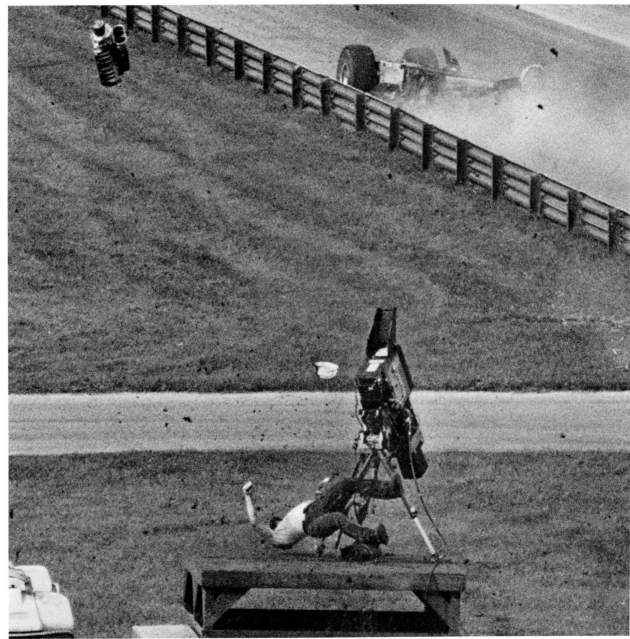

CHARLES A. ROBINSON: *Fatal Mishap*, Indianapolis, 1979

Cropping for Impact

The cropping process begins in the view-finder, when the photographer chooses a single fragment from the vast panorama of reality. News photographers try to frame their shots so as to exclude the extraneous; but further cropping—by the photographer in the darkroom or by the editor in the newsroom—often heightens the impact of the original image.

Frequently the pace of events compels the photographer simply to "get it on film" without paying overmuch attention to composition. Other times, however, a photographer may unavoidably be positioned at some distance from the action, and have the wrong lens on his camera for the desired close-up. This was the situation that confronted Hugh Van Es during the scramble to evacuate the last Americans from Saigon in April 1975. The roof of a building in which the Alliance Française had its office had been designated an evacuation point, and dozens of people had gathered there to wait for the U.S. helicopters. Van Es was assigned to watch the proceedings from a balcony outside the Saigon office of United Press International. The balcony commanded a clear view of the other roof; but it was 1,000 feet away, and Van Es had only a 300mm lens. When the chopper landed and the rush of evacuees began, Van Es shot six frames, chagrined that he could not get sharper pictures.

A comparison of his full-frame shot and the cropped version that *Life* ran shows how judicious cropping can strengthen an image. In spite of its graininess, the photograph captures the desperate atmosphere of the final hours of America's long involvement in Vietnam.　□

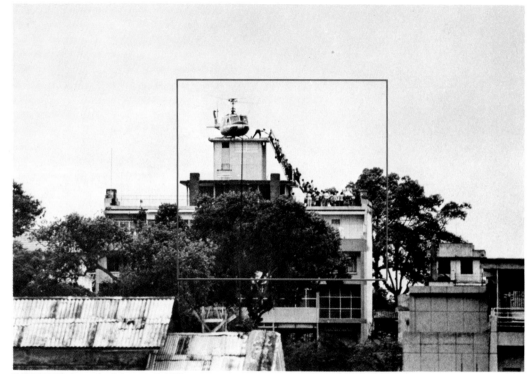

HUGH VAN ES: *Evacuating Saigon, April, 1975*

The clutter of buildings in the foreground of the uncropped photograph distracts the eye from the column of people swarming up a ladder on the distant rooftop. Cropping focuses attention on the helicopter and the throng of would-be passengers—while retaining enough treetop and building detail to make it clear that this action is being played out high above the ground.

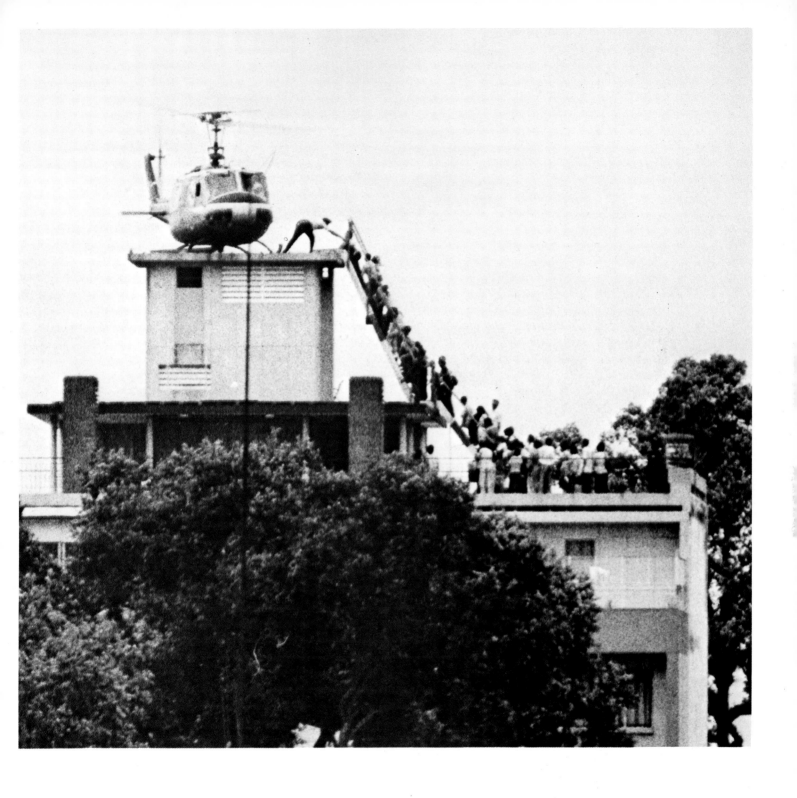

Getting It on Film

Few events rivet public attention so completely as an attempt on the President's life—and few events so challenge a photojournalist's readiness for the unexpected. On March 30, 1981, Dirck Halstead, on assignment for *Time,* was one of three press "pool" photographers assigned to cover a speech Ronald Reagan was giving at the Washington Hilton Hotel. Three of his four cameras were loaded with indoor film; only one held daylight film, to record the standard President-waving-to-crowd shots outside; and although that camera had a 35-75mm zoom lens and a flash unit, it had no motor drive.

Halstead was across the street from the President's limousine when John Hinckley opened fire. The 33 frames reproduced here show how his eye followed the ensuing moments of chaotic action. Because he had no motor drive, each picture was a deliberate shot—but things were moving so fast that Halstead had no time for careful composition, no way to be sure where in the melee the telling visual moment was to be found. He simply kept shooting until his film ran out. Not until the film was developed was it apparent that frame No. 11, shown on page 180, summed up the entire event.

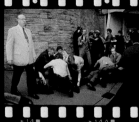

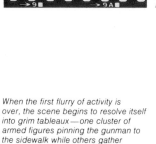

By now Halstead has zeroed in on some of the actors in the scene of fear, pain and confusion: presidential aide Michael Deaver in a crouch (No. 5), White House Press Secretary James Brady lying wounded (No. 6) and John Hinckley being seized (No. 7).

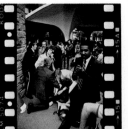

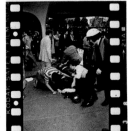

When the first flurry of activity is over, the scene begins to resolve itself into grim tableaux—one cluster of armed figures pinning the gunman to the sidewalk while others gather around his victims.

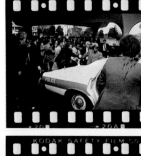

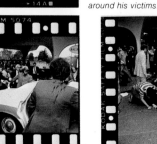

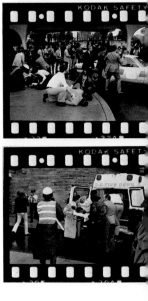

Between the departure of the police and the arrival of the ambulance, Halstead had several minutes to shoot these frames—from three different angles—of the wounded on the ground and armed agents standing guard.

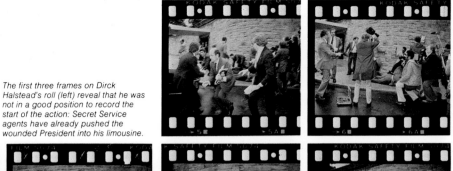

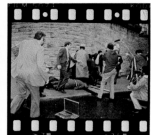

The first three frames on Dirck Halstead's roll (left) reveal that he was not in a good position to record the start of the action: Secret Service agents have already pushed the wounded President into his limousine.

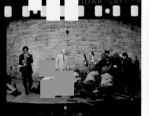

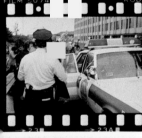

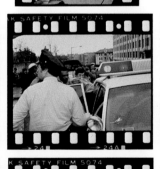

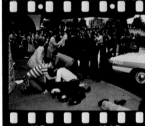

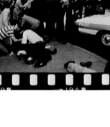

Halstead keeps taking pictures, changing his position for a fresh view of the scene. Time seemed to slow down, he said: "What in reality is 10 seconds feels like it is a minute."

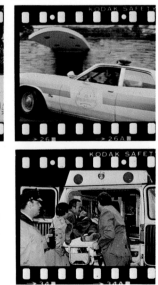

A new element enters the picture with the arrival of a police car. Halstead turns to focus on that as the handcuffed Hinckley is brought forward and loaded into the car by the men who have been holding him.

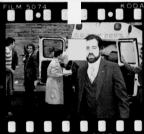

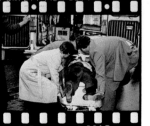

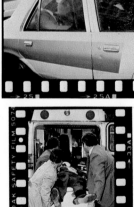

The photographer's coverage of the deadly drama concludes with these shots of Secret Service Agent Timothy McCarthy and White House Press Secretary James Brady being lifted into the ambulance.

179

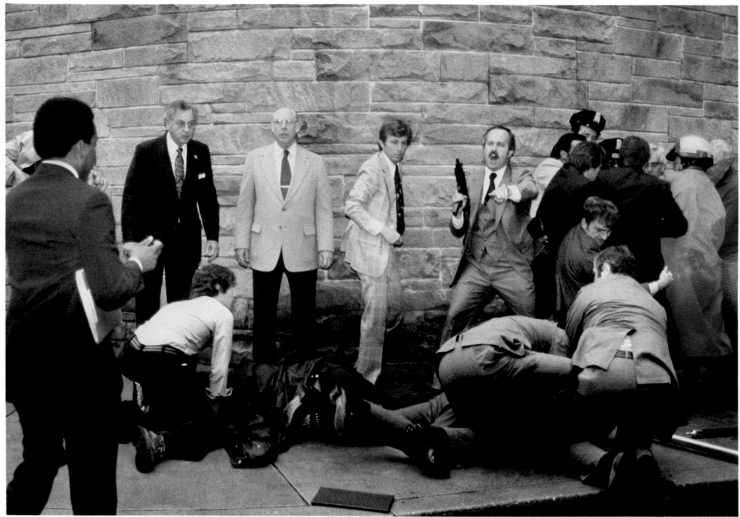

DIRCK HALSTEAD: *Attempted Assassination of President Reagan, March 30, 1981*

*In the heat of the crisis, Dirck Halstead said later,
all a photographer can do is "keep his eye on the
viewfinder and just keep rolling." But afterward
an editor was able to discern a single moment that
seemed to encapsulate the terrifying episode:
men standing in stunned disbelief, others aiding
James Brady, and still others holding down the
would-be assassin while a Secret Serviceman with
a submachine gun shouts orders.*

EVELYN HOFER: *Tools for a Picture Story*, 1970

Making Personal Pictures Tell a Story

The techniques developed by professional photojournalists, particularly those used in the creation of the picture essay *(pages 91-130),* turn out to work surprisingly well for the amateur photographer. They not only make shooting pictures more interesting, but also make the results more useful and enjoyable — to everyone who sees them. Many amateurs' albums are a deadly bore, containing every picture ever taken, printed all the same size and pasted down in the order in which they were taken. But albums don't have to be so dull. By applying the photojournalist's techniques of planning, editing and organizing, the amateur can create an album whose pages resemble those of a magazine layout — with photographs arranged in varying depths and widths to tell a story whose meaning will be apparent to a viewer at a glance.

The essence of those techniques lies in the word "story" — yet the story need not be of world-shaking importance. Amateurs cannot record voyages to the moon, but they can convert a drawerful of old snapshots into a touching account of a family member's life, and they can elevate the usual humdrum snapshots of a historic site into an impressionistic recollection of a past long gone.

To do so, however, amateurs must do what the professionals do: plan out the essay they want to produce. This can be done even if the story must be created from an existing collection of old pictures, but it is easier to plan in advance, looking ahead to photographs that will be needed to tell the story and then going out to shoot them. Not that the pictures for a photo essay are posed; they are, rather, anticipated.

Professional photographers come armed to an assignment with a shooting script, prepared by editors after considerable research into the story idea and consultation with the photographer. Such scripts may be detailed and elaborate. Consider a hypothetical picture story: one on a fire company. The script might call for several different kinds of pictures: major shots that will establish the framework of the narrative (views of the firehouse and close-ups of individual firemen working on the engines), transitional pictures that can be used to guide the viewer from one idea to another (the hook-and-ladder tearing out of the firehouse en route to an alarm), action pictures that convey the drama of fire fighting (the burning building, a fireman overcome by smoke), pictures that bring the story to a conclusion (the exhausted firemen drinking coffee back in the firehouse).

The amateur's shooting script need not be so detailed. To prepare a picture essay on the Cub Scouts' visit to the zoo, for example, the photographer might jot down in advance a few essential shots — the Scouts boarding the bus, the stop for lunch. Beyond that, the amateur — like the professional — must remain flexible as the action unfolds, taking additional pictures the script may not call for. The tearful boy who drops his ice-cream cone, for example, is a gift no alert photographer should miss. But the script is necessary to keep the photogra-

pher on the track and to guarantee a story with a beginning, a middle and an end—a series of related photographs that become a single, storytelling entity.

In pursuit of this goal, the professional does not scrimp on film. Neither should an amateur, for film is the cheapest part of the equipment. Holding back and waiting for the perfect shot is a sure way to miss the tearful Cub Scout. But there are other reasons to take many pictures. Some inevitably turn out wrongly exposed, out of focus or awkwardly composed.

Even if every shot is technically and artistically praiseworthy, a large selection is still necessary. In pictorial storytelling, taking the photographs is only the beginning. The negatives that the photographer brings home are the raw materials for a second creative process: choosing pictures to be used; deciding which are the major ones, which the minor; and arranging them in a layout to communicate the story.

The basic tool in this process is what is known as the contact sheet or proof sheet, a positive of negatives printed actual size. With a magnifying glass and marking crayon, or grease pencil *(page 183),* the photographer then examines the tiny prints, choosing those that make a contribution to the narrative. The next step is deciding which to enlarge to emphasize major points in the story, which to print small for use as transitions to link sections of the story together. Selected shots can then be divided and grouped by a number or letter key to create episodes within the story. Each episode will usually occupy a spread of two facing pages, so the viewer can grasp their meaning as a unit. If the photographer-turned-editor-and-art-director has done a good job, the spreads then become the basic elements that, one after another, carry the narrative to its conclusion. □

Photojournalism for Amateurs
From a Family Album

Picture stories do not have to be shot from scratch. Some of the best are created by selecting photographs from existing sources. Professionals frequently create such "pickup" essays by searching out the best relevant pictures in photographers' files.

The amateur has equally rich sources that are much closer to hand—family albums and boxes of pictures gathering dust in the attic. Disorganized, unsorted, pasted—good and bad alike—into the albums just in the order the rolls were taken, they tell no story. Yet, a judicious selection laid out to a predetermined story line can become an evocative essay on a family's past, as shown by the pickup essay on the following pages, constructed from cluttered family-album pages like the four shown at right and opposite.

Born in 1887 into a prominent New York family, Kate Louise Knapp Vondermuhl grew up in the city, summered in Connecticut, married, traveled, and became the mother of three and the grandmother of five before her death in 1955. On pages 188-191 the story of that life emerges, as layout and design focus on photographs drawn from several Knapp-Vondermuhl albums. The variations in image sizes were introduced by picture selection (some of the photographs were snapshots, others professional cabinet prints) and by cropping with scissors. Judicious arrangement then changed Kate Vondermuhl from an anonymous figure lost in an album hodgepodge to an individual seen in the era in which she lived.

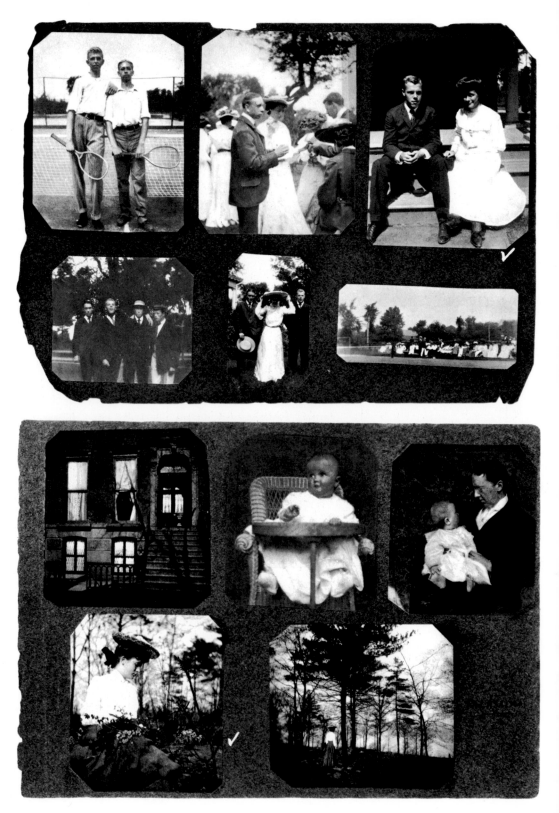

A sample of pages from the photo albums of the Knapp and Vondermuhl families displays the eclectic nature typical of such collections. The pictures checked are those that were selected for the essay on the following pages; each photograph clearly showed the principal character in the story and marked a significant point in her life.

A Life Retraced in Old Photographs

Mother's birthplace, 1887

Mother at 3, with friend

Her brood increases

Fourth-grade chums, 1896

A young lady of 11

Easter finery, 1893

Primping at the Litchfield Club

Picking posies on the Palisades

Pa Richards

Mother and a beau, about 1903

Seventeenth Summer

Mother dressed for a Sunday call, 1908

Wedding day, November 11, 1911

Father and Mother, and George Jr. makes three, 1912

And Kitty makes four, 1915

In our new home on 79th Street

...nice, 1926: The Grand Tour

Our first plane ride, Basel

Those chic long dresses, 1934

The first grandchild, 1938

Reproducing the Flavor of History

The photographs brought home from most trips are all too familiar: children posed on the steps of the Lincoln Memorial, the view from the hotel window, the White House from outside the gate —pleasant to have as souvenirs, but essentially without meaning except to photographer and family. A picture essay put together with an imaginative story line can, however, give character and meaning to the scenes that have been brought back from trips.

The pictures on this and the following pages show what can be done if picture taking is planned in advance. The destination of the trip was Mystic Seaport, a restored 19th Century whaling village in Connecticut, and the intent was to re-create history, to show the town as it might really have looked a century ago. Ordinarily, however, Mystic is jammed with people; it is not only a popular tourist attraction but a favorite port of call for cruising pleasure boats. The photographer, Evelyn Hofer, solved the problem in two ways: by arising early to take some of her pictures before anyone else was abroad and by concentrating on details in other pictures, from which people are necessarily excluded.

The picture essay begins with a scene-setting spread: a big overall view of Seaport Street that includes the full-rigged ship *Joseph Conrad* and the little shops huddled along the cobblestone street by the waterfront. With no people in contemporary clothing in sight, the mood is established: The years are rolled back, and the viewer is invited to take a tour of the old seaport as it appeared in the 19th Century.

From the beckoning sweep of the opening picture on the preceding spread, the camera moves in as the Mystic essay develops. At top the photographer has caught the quiet pace of old Mystic — and two aspects of its life — in a view of a narrow street with Fishtown Chapel in the background and the tavern to the right. Below is a detail of the front porch of a private residence, in which only an air conditioner intrudes into the 20th Century. Opposite, the viewer is brought still closer, seeing another detail of a flower-hung porch, an invitation to come inside the house — and, again, to turn the page to the next spread of the album.

The camera moves closer and closer, taking the viewer further into 19th Century Mystic, looking at left into the parlor of Thomas Greenman, a prominent shipbuilder. Here, the initial problem faced by the photographer solves itself; anachronistic tourists cannot intrude because they are not allowed to enter certain areas of restored rooms such as these. The absence of people makes the illusion complete, and reemphasizes the story line; behind the viewer, it might be imagined, stand the shipbuilder and his lady, bringing tea. Below, the printer of the Mystic Press seems to have just stepped out; he might return in a moment to take an ad announcing next week's seamen's benefit.

A detail from the Mystic ropewalk, which plaited the lines of the seaport's ships, the close-up above unifies the spread, and simultaneously reinforces the story of a seaport. At bottom, the one-room schoolhouse awaits the end of recess; at right, a detail of a pedal on a printing press, imaginatively enlarged from a negative, brings home the craftsmanship and simple design of the machines of old New England.

A Day in the Life of a Three-Year-Old

Undertaking the kind of picture essay that photojournalists call "a day in the life of . . ." is one of the most effective ways to create a revealing composite portrait of a person. The number of waking hours in the day ensures convenient limits, restraining even the most perfectionist photographer from dragging the project out indefinitely while waiting for exactly the right shot. More important, the time limits serve to shape the essay and give it unity; even if the subject never leaves home or takes part in any important activity, there is a natural story line as he or she moves through the day.

This principle is amply demonstrated in the picture essay beginning on these pages. Photographer Tom Tracy recorded a series of moments in an ordinary day in the life of his three-year-old son Tommy—and in doing so, captured the child's ebullient spirit.

As with any subject, a picture essay on a person requires advanced planning, especially of key story-telling shots. But when the subject is an energetic and unpredictable preschooler, film and equipment should be specially selected with flexibility in mind. For this enterprise Tracy used a hand-held Nikon with a choice of four lenses—28mm, 85mm, 105mm and 55mm macro. The shots in the kitchen *(opposite),* for example, were made with the 55mm macro lens. An automatic flash, either bounced or direct, guaranteed sharp indoor shots using the Kodacolor II 100 film.

The tight close-up of Tommy (opposite) not only gives the viewer a good look at him but, as the first shot in the essay, it clearly establishes that he is the subject of the pictures that follow. In deliberate contrast to this quiet portrait, the pictures at left form an active story-telling sequence that shows Tommy starting the day by helping his mother prepare breakfast. The series also vividly demonstrates the three-year-old's capacity for quicksilver shifts in emotions, from the intent concentration required to pick up a banana slice with a fork (upper left) to the howl of pain when he accidentally touches the griddle (upper right). Relieved curiosity comes as he watches his mother's ministrations (lower left), followed by affection as he bestows a grateful kiss.

Five shots selected from several rolls of film reveal the nonstop diversity of Tommy's day outdoors. At far left, he accompanies his mother to pick up the mail (top), throws his baby brother into a tearful rage by splattering him with water (bottom) and does a looping, wet ballet with the hose. On this page he zooms off on his scooter as shadows lengthen, and tries his hand at landscaping with his toy bulldozer.

At the end of his day, Tommy revels in a soapy bath and then, energies finally spent, curls up to sleep. Although the shots seem simple enough, photographer Tom Tracy took certain steps to enhance the essay's story line and visual impact. Bubble baths, for instance, are only an occasional treat—and here Tracy made sure the tub was brimful. Then, since none of the evening shots of Tommy sleeping were effective enough, Tracy chose to end the essay with a shot taken by filtered daylight during Tommy's noontime nap.

Pieces of Reality 206

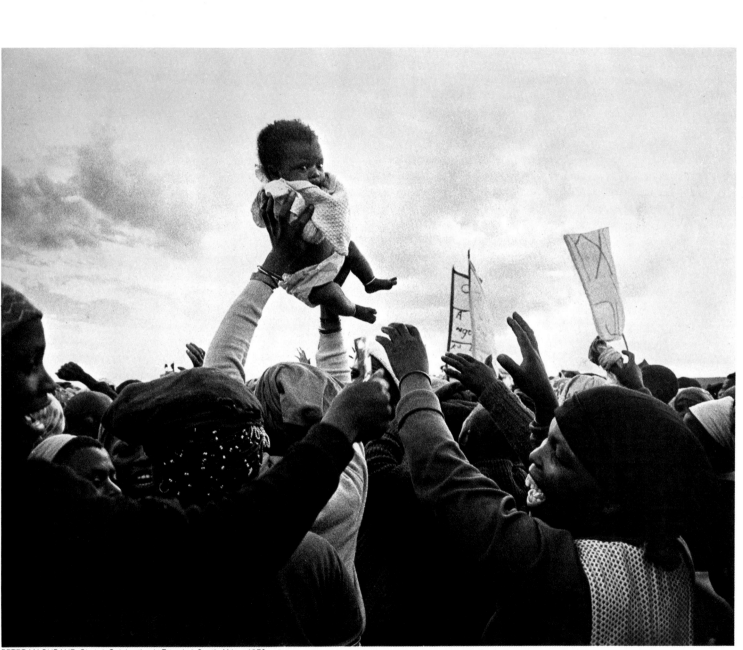

PETER MAGUBANE: *Church Celebration in Transkei, South Africa*, 1976

Pieces of Reality

Some of the most affecting and memorable images produced by photojournalists emerge from stories about everyday life. In the course of covering a couple's golden wedding anniversary *(page 213),* or photographing a boy at his piano lesson *(page 211)* or a woman sitting on a porch *(page 224),* a photojournalist somehow makes a picture that distills the essence of love, childish innocence, old age. *Time* photographer Ralph Morse calls such photographs "pieces of reality"— portrayals of moments or states of being that are universally familiar. Recording these moments is part luck, part skill and part passion. Almost all of the images on the following pages were made by men and women who brought to their work both keen intelligence and deep involvement with their subjects, committing themselves and their unquestioned technical abilities to the task of getting pictures that told the story as well as possible.

Brian Lanker's portrait of a new mother moments after giving birth *(pages 208-209)* is one example of how skill, involvement and commitment can produce a photograph that has a value beyond its immediate purpose. Lanker's paper, the Topeka *Capital-Journal,* had run a story about natural-childbirth classes, showing the exercises that husbands and wives learned to prepare themselves for the birth. But it seemed to him that stories like this had so far all missed the point: "They missed showing the birth," Lanker said, "missed showing the two of them— mother and father— together." So the photographer set out on a self-assigned mission to find a couple who would be willing to let him photograph the delivery of their baby. After spending six months visiting natural-childbirth classes, he found Jerry and Lynda Coburn, and preparation for the story could begin. The staff at the *Capital-Journal,* meanwhile, knew little of the project. "I was playing it low key because I had no idea of what kind of photographs might come from this story," Lanker said. But as Lynda Coburn's due date approached, he made sure always to leave someone in the newsroom with a phone number where he could be reached if the call came. So caught up were the Coburns in helping Lanker get his story that, when her contractions began, Lynda Coburn called the photographer before she called either her husband or her doctor.

Lanker had already scouted the delivery room to take light readings and figure out shooting positions, lenses and camera settings, so when the time came he was able to work almost automatically. It was just as well: "I don't remember actually seeing the images and then clicking the shutter, as I usually do on assignments," Lanker said. "Things were happening too fast, and the camera just became an extension of my eye." Afterward, he had qualms about how well he had covered the situation. But he had no cause for concern— the results of his work that day won him the Pulitzer Prize. "I was so elated and so involved with the whole idea of birth and this birth in particular," Lanker recalled later, "that by the time the baby was born, I really felt like it was mine."

W. Eugene Smith was another photojournalist who went against the journalistic principle of detached objectivity. Smith involved himself in every story he worked on, and the story of Minamata village in Japan was no exception. In 1956 an epidemic of unexplained illnesses and crippling birth defects among inhabitants of the fishing village was tentatively determined to have been caused by mercury in the fish that were a staple of the villagers' diet. The mercury was being dumped into the waters of the bay by a chemical company, but the company refused to be held responsible for the tragedy. Smith and his wife, Aileen, who was fluent in Japanese, moved to the village in 1971 and lived there for three years. As journalists, they were harassed by agents of the company, and Smith was badly beaten. But the Smiths persevered, and in 1975 their book, *Minamata,* was published. The Smiths jointly received the World Understanding Award for their work, and Gene Smith was awarded the Robert Capa Gold Medal for "photography requiring exceptional courage and enterprise." One image from the book appears on pages 222-223, a stark testimony to the strength of human compassion.

A similar compassion emerges from almost every photograph taken by renowned photographer Larry Burrows, who spent nine years covering the war in Vietnam for *Life* before he was killed in action in 1971. Too honest a journalist not to examine his motives in taking pictures of other people's suffering, Burrows concluded that his job as a news photographer required that he deliver accurate pictures of news events; he only hoped that what he did "would penetrate the hearts of those at home who are simply too indifferent." Before he died, Burrows produced scores of images, like the two on pages 218 and 219, that managed to be artistically fine without ducking the harshness of reality—reaching the heart even as they pleased the eye.

Photographs that linger in the memory may address any part of the broad spectrum of human emotions, of course. Ernst Haas made the picture that appears on pages 214-215 at a joyful celebration in the Himalayan fastness of Bhutan. Drawn by its isolation and the loveliness of its landscape and people, Haas spent 10 years exploring the territory and was eventually allowed to photograph aspects of the people's lives ordinarily closed to Westerners. Because he insists on devoting so much time to a project, Haas does not consider himself a photojournalist in the conventional sense. "I reject hectic facts," he says, "and try to go beyond."

It remains true, nevertheless, that a photograph is taken in a split second, not over 10 years—regardless of how much preparation has gone before. Whether the subject is dancing swiftly past the camera or is immobile with despair, the photographer must be quick to catch the gesture, the expression, the slant of light that transforms an ordinary moment into what Lou Stoumen calls an "ordinary miracle."

BRIAN LANKER: *The Moment of Life*, 1972

Exhausted and exhilarated, a woman laughs with joy as the hot, wet weight of her newborn daughter is placed on her belly. Brian Lanker, who made this portrait for the Topeka Capital-Journal as part of a story on natural childbirth, was so caught up in the excitement of the moment that, he says, "to this day I do not remember making the photographs I took."

Barefoot and grinning, a boy races down a dusty lane propelling a hoop made from a bicycle rim. South African Peter Magubane made this image of childhood's irrepressible imagination and energy in Soweto, a black township near Johannesburg that was the site of bloody riots in the 1970s.

A young boy accompanying himself on the piano ▶ throws back his head to sing as his beaming music teacher listens. Peter Magubane photographed this zesty solo in Sophiatown, near Johannesburg.

PETER MAGUBANE: *A Simple Toy*, 1977

PETER MAGUBANE: *A Music Lesson*, 1956

RALPH MORSE: *Love on D-Day*, 1944

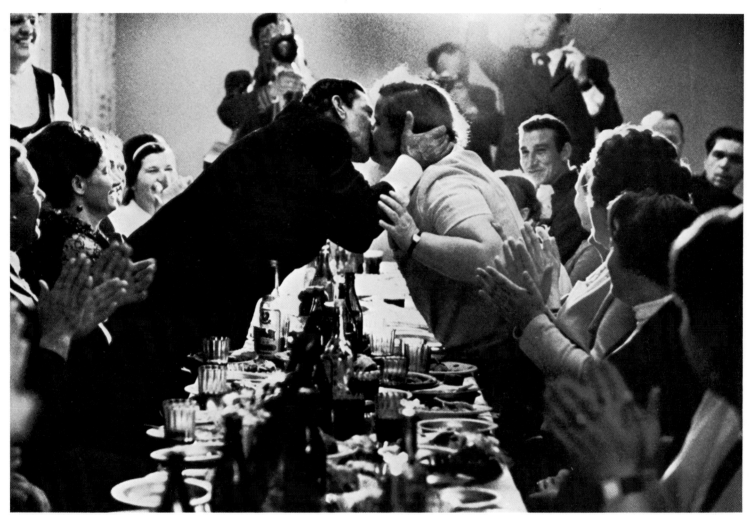

VSEVOLOD TARASEVICH: *The Golden Kiss*, 1974

◄ *A young English woman and an American G.I. lie locked in each other's arms in London's Hyde Park. Ralph Morse shot this gentle portrait of youthful romance as part of a Life assignment to show the mood of London on the eve of D-Day in 1944.*

Leaning across the banquet table, a gallant husband embraces his startled wife as friends and fellow workers in the Soviet oil fields applaud. The couple was celebrating their 50th wedding anniversary at a party in a Siberian village.

ERNST HAAS: *Dance of Buddhist Monks*, 1974

In a packed stadium in Thimpu, the capital of Bhutan in the eastern Himalayas, Buddhist monks in festive regalia swirl through an ancient ceremonial dance. The blurred figures in this photograph by Ernst Haas convey the rush of spirit that animates celebrations the world over.

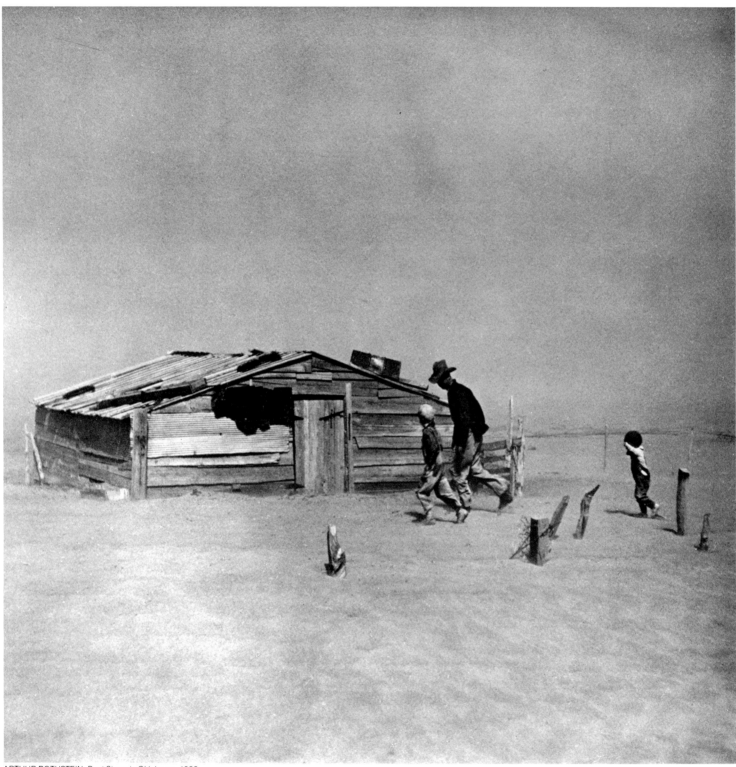

ARTHUR ROTHSTEIN: *Dust Storm in Oklahoma,* 1936

◄ *Hunched against the wind that has scoured the topsoil from his drought-stricken land, an Oklahoma farmer hurries his two sons toward shelter in a tin-roofed outbuilding. Arthur Rothstein, on assignment for the Farm Security Administration to portray the effects of the Depression on farmers, recorded the scene in a picture that summed up the hardship suffered by the inhabitants of the Dust Bowl.*

In a campground in California, complete despair is written on the faces of an Oklahoma couple who had gambled on finding better land in the Golden State —and lost. Dorothea Lange, working for the Farm Security Administration, found the family living in a makeshift tent under a eucalyptus tree.

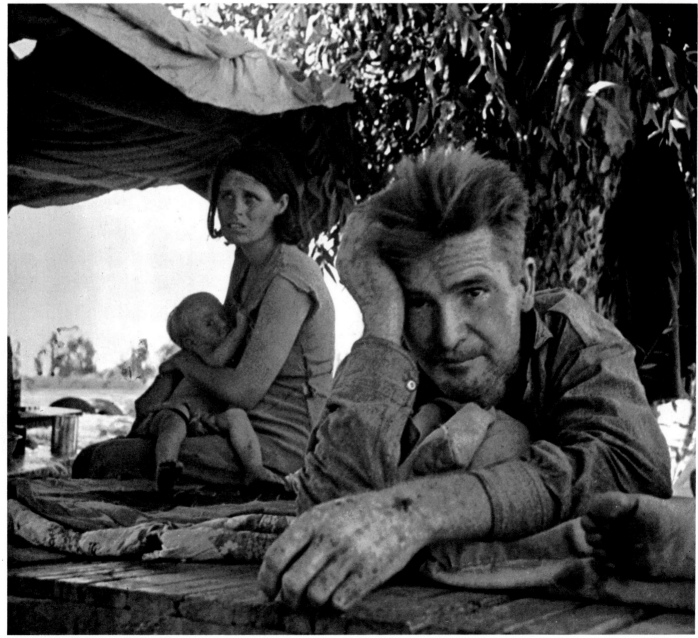

DOROTHEA LANGE: *Oklahoma Family*, 1936

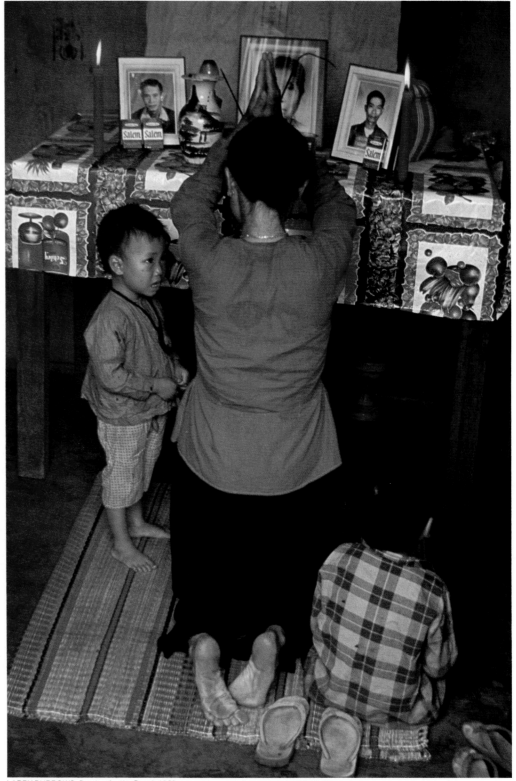

Before a household shrine adorned with candles, photographs and precious cigarettes, a South Vietnamese woman and her children mourn the husband and father killed by the Viet Cong. Award-winning photographer Larry Burrows took the picture in Pleiku for a story in Life about the Vietnam War.

LARRY BURROWS: *Praying for the Dead*, 1969

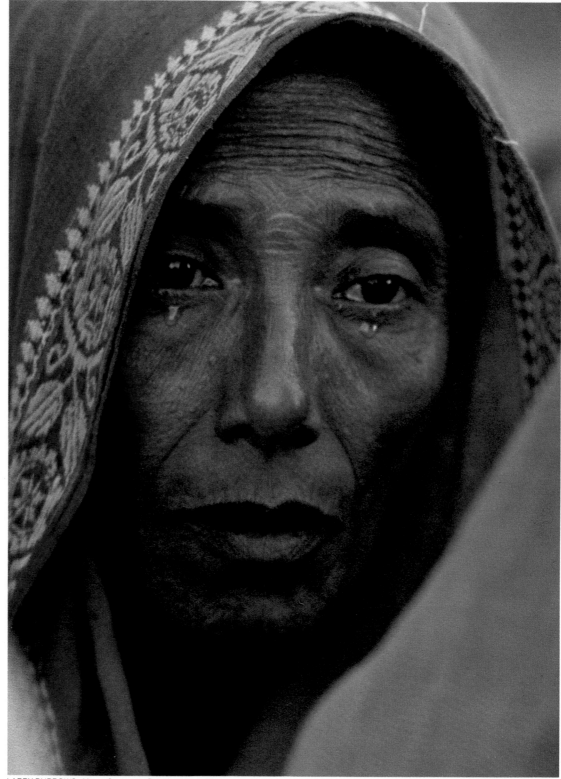

Larry Burrows' photograph of a grieving woman with eyes that stare unseeing from a weathered face catches the essence of tragedy. In November 1970, the woman's village was devastated by a cyclone that destroyed 367,000 homes and killed more than half a million people in Bangladesh.

LARRY BURROWS: *After a Cyclone in Bangladesh, 1970*

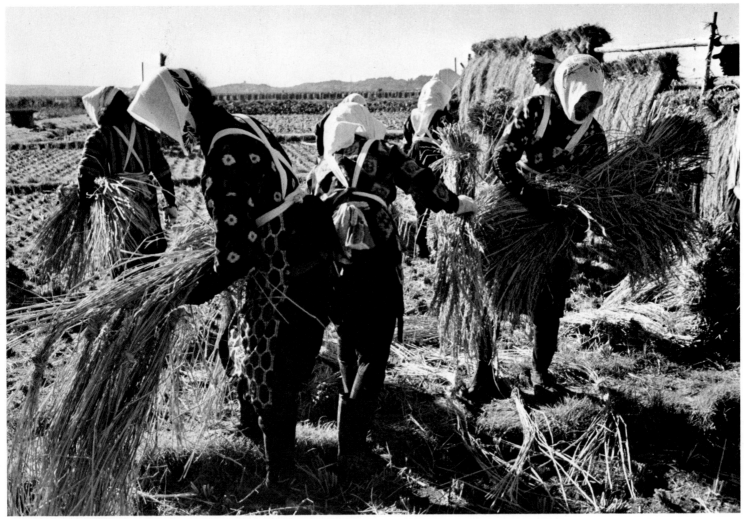

IHEI KIMURA: *Harvest 1952*

In a scene little changed through centuries, Japanese farm women bundle sheaves of rice and set them on racks to dry in the fields. Photographer Ihei Kimura made this picture in Hachiro-gata, a rice-producing center in northern Japan.

Brawny arms flex and strain in a classic portrait of ▶ men at work. Jakob Tuggener, who was passing by a Rhine shipyard at Basel, knew he had made an expressive shot. But only in printing it did he perceive "the force vibrating from that photograph."

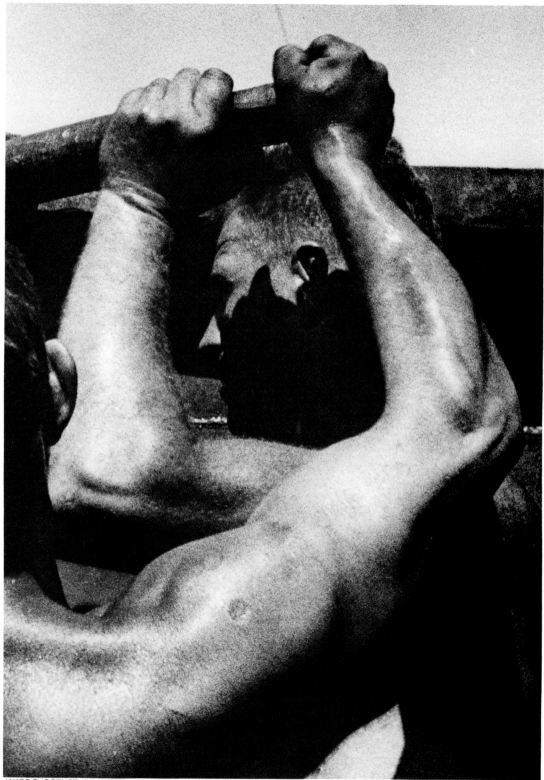

JAKOB TUGGENER: *Arms,* 1947

In the Japanese village of Minamata, a mother tenderly bathes a daughter congenitally maimed by mercury contained in fish caught in waters polluted by industrial wastes. Photographer W. Eugene Smith made this stark portrait of suffering and tenderness for a book-length project he and his wife, Aileen, undertook to report the tragedy.

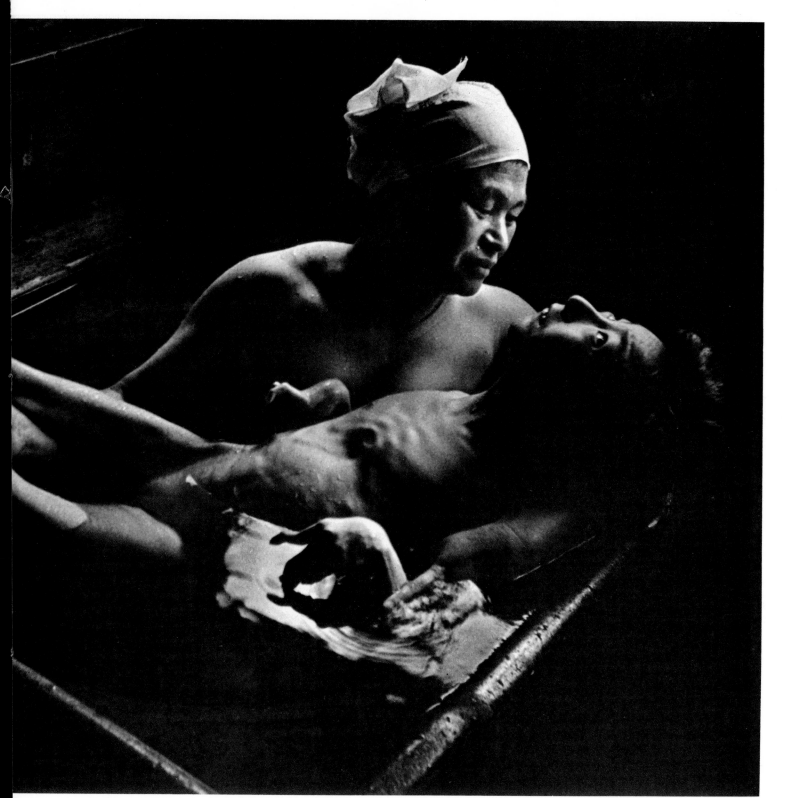

W. EUGENE SMITH: *Minamata, Japan,* 1971

An old woman clutches a doll and savors a reverie of childhood while sitting on the porch at a home for the aged in Wallingford, Connecticut. Abigail Heyman made this picture for a special issue of Life entitled One Day in the Life of America, to illustrate how nearly a million elderly people passed the day.

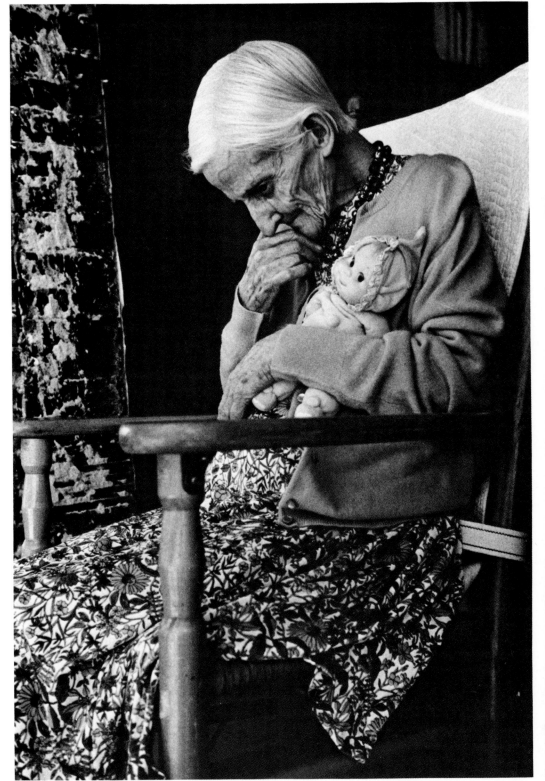

ABIGAIL HEYMAN: Getting Old, Dreaming Young, 1974

Bibliography

General

De Maré, Eric, *Photography*. Penguin Books, 1968.
Gernsheim, Helmut, *Creative Photography: Aesthetic Trends 1839-1960*. Faber and Faber, 1962.
Gernsheim, Helmut and Alison, *The Recording Eye: A Hundred Years of Great Events as Seen by the Camera*. G. P. Putnam's Sons, 1960.
Neblette, Carroll B., *Photography: Its Materials and Processes*. D. Van Nostrand, 1962.
Whiting, John R., *Photography Is a Language*. Ziff-Davis, 1946.

History

Baldwin, Sidney, *Poverty and Politics: The Rise and Decline of the Farm Security Administration*. University of North Carolina Press, 1968.
Darrah, William Culp, *Stereo Views: A History of Stereographs in America and Their Collection*. Times and News Publishing, 1964.
*Goldston, Robert, *The Great Depression: The United States in the Thirties*. Bobbs-Merrill, 1968.
McWilliams, Carey, *Ill Fares the Land: Migrants and Migratory Labor in the United States*. Little, Brown, 1942.
Mott, Frank Luther, *American Journalism: A History 1690-1960*. Macmillan, 1969.
Newhall, Beaumont, *The History of Photography from 1839 to the Present Day*. Doubleday, 1964.
Phillips, Cabell, *From the Crash to the Blitz*. Macmillan, 1969.
Pollack, Peter, *The Picture History of Photography*. Harry N. Abrams, 1958.
Raper, Arthur F., and Ira De A. Reid, *Sharecroppers All*. University of North Carolina Press, 1941.
*Taft, Robert, *Photography and the American Scene: A Social History 1839-1889*. Dover, 1964.

Biography

Editors of *Life, Larry Burrows: Compassionate Photographer*. Time Inc., 1972.
Eisenstaedt, Alfred, *Witness to Our Time*. Viking, 1966.
Eisenstaedt, Alfred, and Arthur Goldsmith, eds., *The Eye of Eisenstaedt*. Viking, 1969.
Horan, James D., *Mathew Brady: Historian with a Camera*. Crown, 1955.
Juergens, George, *Joseph Pulitzer and the New York World*. Princeton University Press, 1966.

Special Fields

*Benson, Gigi and Harry, *Harry Benson on Photojournalism*. Harmony Books, 1982.
Edey, Maitland, *Great Photographic Essays from Life*. Little, Brown, 1978.
†Editors of Time-Life Books, *The Best of Life*. Time Inc., 1973.
Edom, Clifton C., *Photojournalism: Principles and Practices*. Wm. C. Brown, 1976.
Evans, Harold, ed., *Pictures on a Page*. Holt, Rinehart and Winston, 1978.
*Faber, John, *Great News Photos and the Stories behind Them*. Dover, 1978.
Ford, James L. C., *Magazines for Millions*. Southern Illinois University Press, 1969.
Leekley, Sheryle and John, *Moments: The Pulitzer Prize Photographs*. Crown, 1978.
†Magubane, Peter, *Magubane's South Africa*. Knopf, 1978.
*Mark, Mary Ellen, *Falkland Road*. Knopf, 1981.
*Meiselas, Susan, *Nicaragua: June 1978-July 1979*. Pantheon, 1981.
*Namuth, Hans, *Pollock Painting*. Agrinde, 1978.
National Press Photographers Association, University of Missouri School of Journalism, *The Best of Photojournalism, 5: People, Places, and Events of 1979*. University of Missouri Press, 1980.
Rhode, Robert B., and Floyd H. McCall, *Press Photography: Reporting with a Camera*. Macmillan, 1961.
Rothstein, Arthur, *Photojournalism: Pictures for Magazines and Newspapers*. Chilton, 1965.
*Rothstein, Arthur, John Vachon, and Roy Stryker, *Just before the War: Urban America from 1935 to 1941 as Seen by Photographers of the Farm Security Administration*. October House, 1968.
Schuneman, Raymond Smith, *The Photograph in Print: An Examination of New York Daily Newspapers, 1890-1937*. University Microfilms, University of Minnesota, 1966.
Smith, W. Eugene and Aileen M. Smith, *Minamata*. Holt, Rinehart and Winston, 1975.
*Stoumen, Lou, *Ordinary Miracles*. Hand Press, 1981.
†Steichen, Edward, ed., *The Bitter Years: 1935-1941: Rural America as Seen by the Photographers of the Farm Security Administration*. Doubleday, 1962.

Magazines

Benedek, Yvette E., "Stanley Forman." *American Photographer*, January 1979.
Breithaupt, Frank, "A Job of Stresses." *News Photographer*, August 1981.
Burrows, Larry, "Vietnam: 'A Degree of Disillusion.'" *Life*, September 1969.
Clarke, Gerald, "Freezing Moments in History." *Time*, December 28, 1981.
Durniak, John, "The New Wave of Picture Agencies." *Popular Photography*, November 1980.
Editors of *Life*, "Coming of Age." *Life*, January 1979. "Horizons of a Pioneer." *Life*, March 1968. "Pakistan." *Life*, December 1970.
Heyman, Harriet, "Eleven American Poets." *Life*, April 1981.
Kunhardt, Philip B., Jr., "Editor's Note." *Life*, April 1981.
Life Special Report, "One Day in the Life of America." *Life*, September 1974.
Livingston, Kathryn, "The Shooting of the Shooting of the President." *American Photographer*, June 1981.
Moffett, Hugh, "The Pros." *Life*, December 1966.
Moore, Thomas, "The Saint." *American Photographer*, September 1980.
Shaman, Harvey, "Insight: David Burnett." *Popular Photography*, December 1980.

*Also available in paperback
†Available only in paperback

Acknowledgments

The index for this book was prepared by Karla J. Knight. For the assistance given in the preparation of this volume, the editors would like to express their gratitude to the following: Juergen Arnold, German Federal Railroad General Agency for North America, New York City; Hal Buell, Associated Press, New York City; Peter C. Bunnell, The Museum of Modern Art, New York City; Cornell Capa, International Center of Photography, New York City; Howard Chapnick, Black Star Publishing Co., Inc., New York City; Rich Clarkson, *Denver Post*, Denver, Colorado; John Durniak, *The New York Times*, New York City; Maitland A. Edey, Vineyard Haven, Massachusetts; Alma Eshenfelder, Marine Historical Association, Mystic, Connecticut; Virginia Ewalt, Marine Historical Association, Mystic, Connecticut; George Fry, Willoughby-Peerless Camera Stores, New York City; John Furbish, Lenox, Massachusetts; Mary Green, KLH Child Development Center, Cambridge, Massachusetts; L. Fritz Gruber, Photokina, Cologne; Helen M. Hinkle, New York City; T. T. Holden, The Singer Company, Rochester, New York; Charles A. Hulcher, Charles A. Hulcher Co., Inc., Hampton, Virginia; Peter Hunter, Press Features, Amsterdam; André Kertèsz, New York City; Gerard LeLievre, *Time*, New York City; Stefan Lorant, Lenox, Massachusetts; Tom Lovcik, The Museum of Modern Art, New York City; William Lyon, UPI News Pictures, New York City; Grace M. Mayer, The Museum of Modern Art, New York City; Robert Pledge, CONTACT, New York City; Charles Rado, Rapho Guillumette, New York City; Jens Risom, New York City; Ira Sacher, Willoughby-Peerless Camera Stores, New York City; Cheryl and Melvin Sparks, New York City; Humphrey Sutton, New York City; John Szarkowski, The Museum of Modern Art, New York City; Valerie Vondermuhll, Litchfield, Connecticut; Phyllis Wise, McLean, Virginia.

Picture Credits

Credits from left to right are separated by semicolons, from top to bottom by dashes.

COVER: Nakram Gadel Karim/El Akhbar/Gamma-Liaison.

Chapter 1: 11: United Press International. 13: *The Illustrated London News,* courtesy New York Public Library. 14: Mathew Brady, courtesy Library of Congress. 15: *Harper's Weekly,* courtesy New York Public Library. 16, 17: Photographs by Alfred Eisenstaedt for *Life.* Drawing by Nicholas Fasciano. 18, 19: *Daily News,* courtesy New York Public Library. 22, 23: Claus Bienfait, Bonn/Actionpress, Hamburg. 24: H. S. "Newsreel" Wong, courtesy United Press International. 25: Huynh Cong Ut for Wide World Photos. 26, 27: United Press International; Donald McCullin, London. 28: Toshio Sakai for United Press International. 29: David Douglas Duncan from *War Without Heroes,* Harper & Row. 30, 31: Sal Veder for Wide World Photos. 32: Bill Eppridge for *Life.* 33: Yasushi Nagao, courtesy United Press International. 34, 35: Nakram Gadel Karim/El Akhbar/Gamma-Liaison. 36: Edward Clark for *Life.* 37: © Keystone Press Agency, Ltd. 38, 39: Al Muto for United Press International; Harry Benson for *People.* 40, 41: Chip Hires/Gamma-Liaison; Charlie Nye/Eugene *Register-Guard.* 42: William W. Dyviniak, courtesy Wide World Photos. 43: I. Russell Sorgi for Buffalo *Courier-Express.* 44, 45: Mitchell C. Abou-Adal/Worcester *Telegram.* 46: George Silk for *Life.* 47: Roger Bockrath for San Rafael *Independent-Journal.* 48, 49: Stanley Forman/Boston *Herald American.* 50, 51: Joe Marquette for United Press International. 52: Nat Fein for Wide World Photos. 53: Morris Berman for Pittsburgh *Post Gazette.* 54: Sy Friedman for NBC. 55: Arthur Fellig ("Weegee"). 56, 57: Syndication International/Photo Trends. 58, 59: Hans Wendt/Gamma-Liaison. 60, 61: Larry Burrows for *Life.* 62: © Harald Sund. 63: © John T.

Barr/Gamma-Liaison. 64: © David Hume Kennerly/Gamma-Liaison. 65: © 1982 David Burnett/CONTACT. 66, 67: Henry Groskinsky for *Life.* 68: Neil Armstrong/NASA. 69: C. Trainor, B. Reinke, A. G. Montanari/*Miami News.* 70, 71: Ian Berry from Magnum, Paris; Heinz Kluetmeier for *Sports Illustrated.* 72: Tony Triolo for *Sports Illustrated.* 73: Heinz Kluetmeier for *Sports Illustrated.* 74, 75: David Burnett from CONTACT. 76: Interphoto. 77: Margaret Bourke-White for *Life*—Tom McAvoy for *Life.* 78: Valerie Wilmer, London. 79: © Martha Hartnett/*Los Angeles Times.* 80: © Hans Namuth. 81: © 1967 John Loengard for *Life.* 82, 83: Wide World Photos; Richard Corkery/New York *Daily News.* 84, 85: Mary Ellen Mark/Archive. 86, 87: © 1981 Annie Leibovitz from CONTACT; Harry Benson for *Life.* 88: Snowdon.

Chapter 2: 91: Erich Salomon, © Peter Hunter, Press Features, Amsterdam. 94: Courtesy *The Illustrated London News,* December 12, 1915. Copied by Paulus Leeser. 95: Courtesy *The Illustrated London News,* November 16, 1918, and Humphrey Sutton. The photographs on pages 96 through 99, 104 and 105 are from the Collection of Stefan Lorant and are copied by Paulus Leeser. 96: Felix Mann for . *Münchner Illustrierte Presse,* 1929, courtesy Suddeutscher Verlag, Munich. 97: *Münchner Illustrierte Presse,* 1929, courtesy Suddeutscher Verlag, Munich. 98: Felix Mann for *Münchner Illustrierte Presse,* 1930-1931. 99: Brassï from Rapho Guillumette for *Weekly Illustrated,* December 1, 1934. 101 through 103: Margaret Bourke-White for *Life.* 104, 105: Robert Capa from Magnum for *Picture Post,* May 3, 1938. 106 through 109: Leonard McCombe for *Life.* 110 through 119: W. Eugene Smith for *Life.* 120 through 123: Bill Eppridge for *Life.*

125: © Brian Brake from Rapho Guillumette. 126 through 129: © Brian Brake from Rapho Guillumette. Top layout, courtesy *Life,* bottom layout, courtesy *Paris-Match.* 130: © Brian Brake from Rapho Guillumette.

Chapter 3: 133: Alfred Eisenstaedt for *Life.* 136 through 152: Leonard McCombe for *Life.*

Chapter 4: 155: Neil Leifer for *Time.* 158, 159: Sebastian Milito. 160, 161: Marcia Keegan. 162: Michael O'Brien/Archive. 163: Enrico Ferorelli/Wheeler Pictures. 164: *Suburban Trib Photo* by Michael Wirtz. 165: David Hume Kennerly, The White House. 166, 167: © Harald Sund. 168, 169: Paul Chesley/ASPEN. 170, 171: © 1982 Dilip Mehta from CONTACT. 172, 173: Bryan Wharton, London. 174, 175: Charles A. Robinson/Wide World Photos. 176, 177: Hugh Van Es for United Press International. 178 through 180: Dirck Halstead for *Time.*

Chapter 5: 183: Evelyn Hofer. 186 through 191: Courtesy Valerie Vondermuhll. 192 through 197: Evelyn Hofer. 198 through 202: Tom Tracy.

Chapter 6: 205: From *Magubane's South Africa* by Peter Magubane. Copyright © 1978 by Peter Magubane. 208, 209: Brian Lanker. 210: Peter Magubane. 211: From *Magubane's South Africa* by Peter Magubane. Copyright © 1978 by Peter Magubane. 212: Ralph Morse for *Life.* 213: Vsevolod Tarasevich from Novosti. 214, 215: Ernst Haas. 216: Arthur Rothstein. 217: Dorothea Lange. 218, 219: Larry Burrows for *Life.* 220: Ihei Kimura, Tokyo. 221: Jakob Tuggener, Zurich. 222, 223: W. Eugene Smith. 224: © Abigail Heyman/Archive.

Index *Numerals in italics indicate a photograph, painting or drawing.*